Location and Postproduction Sound for Low-Budget Filmmakers

This book covers everything you need to know to master the fundamentals of location sound recording and postproduction sound in a comprehensive one-stop guide.

This user-friendly book provides real world situations to analyze the many kinds of location recording configurations and postproduction scenarios and offers easy-to-adopt, budget-conscious solutions to some of the most common issues that arise when working with sound. Chapters cover the theory of sound, preproduction with a sound emphasis, microphone selection, testing equipment, how to boom and mix on set, synchronization and time code, and editing sound while doing a picture cut in a traditional picture software platform. Additionally, the book discusses bringing a project into a Digital Audio Workstation and explores basic sound design, dialogue editing, Automated Dialogue Replacement, Foley, sound effects, music for film, re-recording the final mix, and outputting sound to finish a project. Accompanying examples allow readers the opportunity to try out the various techniques and drills on location, in postproduction, or both.

Aimed at students, early career and independent filmmakers, as well as those considering a vocation in location and postproduction sound, *Location and Postproduction Sound for Low-Budget Filmmakers* makes achieving great sound attainable for all, and is an invaluable tool for anyone wanting to better understand the art of film sound.

Michael Tierno is a former Miramax Story analyst and an independent writer/director/editor of feature films. He is author of the best-selling book *Aristotle's Poetics for Screenwriters* and has made four feature films including *Turn Back Night*, a sci-fi comedy. He is Associate Professor of Film Production at East Carolina University.

Location and Postproduction Sound for Low-Budget Filmmakers

Michael Tierno

Routledge
Taylor & Francis Group

LONDON AND NEW YORK

First published 2020
by Routledge
2 Park Square, Milton Park, Abingdon, Oxon, OX14 4RN

and by Routledge
52 Vanderbilt Avenue, New York, NY 10017

Routledge is an imprint of the Taylor & Francis Group, an informa business

© 2020 Taylor & Francis

All Chapter 10 sample media can be found at:
https://www.michaeltierno.com/link-23

Library of Congress Cataloging-in-Publication Data
A catalog record for this title has been requested

ISBN: 9780367354251 (hbk)
ISBN: 9780367354244 (pbk)
ISBN: 9780429331305 (ebk)

Typeset in Goudy
by Wearset Ltd, Boldon, Tyne and Wear

Contents

Acknowledgments

Writing a book like this is a lot like making a film; it involves the hard work and commitment of a lot of people trying to help you accomplish your vision. Along those lines I first wish to thank Routledge for believing in the book and helping me develop it to become so much more than I could ever have done on my own. I'm very grateful that Simon Jacobs brought in the project; Emma Tyce helped develop it and finally Alyssa Turner steered it through production. Along the way I received a lot of great reads on the manuscript but I especially want to thank Kira Summers and Korey Pereira for their extensive notes and insights. I also want to thank East Carolina University, the school where I teach, because they provide me with a solid platform to research sound and make films. I thank all my students over the years; too numerous to name, but you have made this whole experience exciting and fun and having your active minds and passion to inspire me has been priceless. I would like to thank my art director Jennifer Woolard for her tireless work making great infographics, and my assistant art director Matt Barnhart who came in at the last minute and helped with key manuscript preparations.

Of course, love to my friends and family for listening to me babble excitedly about films over the years, some of which they have no interest in ever seeing! Finally, I want to thank my ultimate family member, my wife Judy Quinn, the love of my life, my best friend, co-producer of films, editor, and most fun person to be with ever.

Preface

Tom Hanks plays a soldier in *Saving Private Ryan* (a sound design masterpiece) where he and his men find themselves in a dangerous situation, facing certain death by approaching Nazi tanks. They don't have much in the way of fire-power to fight them off. But Hanks' character is a schoolteacher who recalls having read the army manual where it talked about "sticky bombs," bombs you can improvise using rags and gasoline to attach to tanks as a way to blow them up.

I never forgot that scene because to me, that is the perfect analogy to what reading a book about the filmmaking process should be. It can never duplicate the experience of being in the field and making films in terms of learning how to do it. But it can give you a lot of great ideas. That said, welcome to *Location and Postproduction Sound for Low-Budget Filmmakers*, a manual to help you through the battlefield of filmmaking, with regard to sound.

Disclaimer: you cannot learn how to make great sound in film by reading a book any more than you can plow a field by churning it in your mind. I'll return to this later, but for now, welcome to a unique journey through location and postproduction sound for filmmakers written by a filmmaker who has a passion for sound and a lot of experience producing sound with a variety of budgets, crews, technicians, etc. This manual is set up a little bit differently than most books on sound or even filmmaking in general, so let me explain.

In Chapter 1, I give you some background as to what kind of journey you're likely to go on as a filmmaker who has to produce great sound and might be hampered by lack of experience and/or a low budget. Chapter 2 gives you the basics of technical language that you need to understand as background to be able to produce great sound in film. Chapter 3 is an overview of what your goals in recording location dialogue are, since this is the beginning of the process. Chapter 4 is an overview of location recording microphone basics, and Chapter 5 talks about the many different kinds of location recording configurations you might attempt when shooting your film. Chapter 6 is probably the most technical chapter, and introduces filmmakers to a unique way of testing your gear and its recording capabilities. This chapter is also a foundational chapter for learning how to listen to recorded sound. Chapter 7 helps you prepare for a production sound recording. Chapter 8 provides the basics of booming and location

recording and mixing techniques. Chapter 9 talks about some technical issues you have to be aware of on set, including time code. Chapter 10 uses a feature film I recently shot, *Turn Back Night,* as an example to discuss various scenarios of location sound recording.

In Chapter 11, we move into the postproduction process, with a brief overview focusing on workflows and all the various jobs that need to be done in sound postproduction, jobs normally delegated to teams of professionals. But in this chapter, I assume that you will be a one-person band, doing everything that's required. In fact, if there were an overarching theme to the entire book, it's that as an independent filmmaker, we need to know how to do *everything*.

Keeping in that tradition of knowing how to do everything, Chapters 12 and 13 talk about what sound postproduction happens in the picture editing stage and there's even a discussion about *staying* in your picture application to finish sound postproduction. Chapter 14 looks at moving your project from your picture editing application to a DAW (Digital Audio Workstation) like Pro Tools, Logic Pro X, or Adobe Audition. Chapter 15 is a mini review of the complete sound postproduction process as a way of touching on all the points of sound postproduction. The remaining chapters drill down a little deeper to specific aspects touched on in Chapter 15, including those specifically on dialogue editing, ADR (Automated Dialogue Replacement) and Foley (humans making sounds in sync with the picture like footsteps/clothes rustling). Finally, in Chapter 21, "Putting it all together," I do a very short mix showing the whole process again.

There are links to demos and folders that contain practice media so you can try out some of the exercises on your own. Most of the specimen examples come from the feature film I made, *Turn Back Night.* It stars Holly Anne Williams, Chris Chirdon (*The Marvelous Mrs. Maisel*), Joe Veale, Jenna Haimes, and Mia Russo. The plot is about Jane Jones who is a cyborg hunter and has to track down a "breaker," a cyborg who is supposed to self-terminate but doesn't. I picked a science fiction film as an example because I thought it would provide a lot of opportunities for interesting sound design. It's easier for me to make sound a character in a film when dealing with science fiction.

To shoot my film, I hired a professional sound crew because I wanted the benefits of having their expertise to provide background information for the book and recent samples with up-to-date technology. Doing so afforded me an experience filled with current professional practices with an eye toward accumulating greater insight into demonstrating principles of sound production for independent filmmakers.

Here is some information about callout boxes:

TECH TALK – Deployed when I wish to go a little deeper into technical aspects of a concept I'm discussing.

SOFTWARE/GEAR AGNOSTIC – When talking about aspects of sound production and postproduction, it's hard to avoid referencing software and specific gear in some cases. However, I strived not to make the book about any specific software but rather to focus on universal good practices of sound production. All of these principles apply to your location sound recording, editing, and final sound mixing (or "re-recording," as it's often called), regardless of the software and gear that you are using.

GEARHEAD ALERT – It's impossible to be a filmmaker and not be a little bit of a gearhead. When necessary, I call this tendency out with some explanations about why I'm going deeper into gear and how what is being disclosed should point to universal principles about sound recording, rather than gear lust.

FOSSIL RECORD – No one at this stage should care too much about how things *used* to be done in regard to sound recording and sound postproduction. That said, when I do call out differences from the old analog days it's to try and illuminate what about the modern digital ways of doing things might be at a cost because sometimes recording and sound postproduction is too simple and we have lost a certain reverence and deeper understanding for these processes.

A word about the practice media samples

There are a lot of practice media examples in this book. At times there's a line that will say, "Play Clip," etc. This pertains, of course, to those of you reading the book in electronic format. Clinking the link will take you directly to the site that houses the sample media.

For other media examples, my website (www.michaeltierno.com/sound-book) contains other samples that pertain to the chapter/example you are reading about so that you can go deeper with your practice and experimentation if you so desire.

To conclude, I wish to return to my original point: that you cannot learn to make great sound by reading books. The only way you're going to make great sound is to practice making films that utilize the kind of sound you wish to get better at making. The process is like learning to play a musical instrument, getting great at a sport, or learning to dance. You have to do it a lot to be good at it.

So with that in mind, I welcome you to your battlefield manual to guide you through the sound production process, *Location and Postproduction Sound for Low-Budget Filmmakers*.

1 The modern filmmaker

You're directing your first film, and tomorrow is the first day of shooting. Maybe it's a student film, maybe it's an indie feature, or even a calling card short. Or perhaps you're an actor making your own web series pilot, or you are a special effects artist wanting to show off your craft in the context of a specific narrative. Whatever the end product that you are making, I assume you are reading this book because you don't know a lot about sound, nor do any of your associates, but you are sensing it might be very important to your project. In fact, you might be starting to realize that both location and postproduction sound are crucial to the success of your project, but you don't know where to begin to make sure it's done well.

You've come to the right place. Take comfort in the fact that you are not alone as a filmmaker faced with this problem. But you very well might be alone dealing with this situation on your project. So I'm here to help you through the sound-producing aspect of your film, not merely the science and theory about sound (although that's going to be part of it). My approach is to offer you practical information to help you *apply* some of the theory you will read about, in an effort to help you focus on the key actions and practices you must take to ensure great sound quality on your film projects.

I'll give you a way to make ready an environment for creating good sound on a set and in postproduction and show you ways to bring whoever is doing sound on your film up to speed. And if you are lucky enough to be working with a seasoned professional, this book will help you learn to communicate with him or her. To achieve this elevated level of sound production, you don't need to know a lot of theory. But you *do* need to understand a few fundamentals and practice them over and over until you are fluent with sound technique so you can execute these principles on a set, in postproduction, and/or teach someone how to execute them for you.

When you found this book, online or in a bookstore, you will quite possibly have seen that there are many other books on film sound. Some contain a lot of technical information, some are useful for shooting and posting sound, and many would be useful if you were going to redesign your own sound recorder from scratch. Other books are for those who have their sights set on becoming sound professionals, and some talk about the physics of sound. All of these are

worthwhile texts, and I've included some of these types of information in this book, but just enough to give you what you need to know in order to produce great sound for your film.

That said, I don't want to confuse anyone. Location sound recording, sound editing, and sound mixing are rigorous art forms, employing skilled artists as talented and professional as great cinematographers and (often life-saving!) editors. If you strive to work in the sound disciplines specifically, this book can help you, but I'm writing more for a filmmaker faced with a common scenario: you have to produce a film and don't have the budget for skilled sound crew. My task isn't to minimize the role of professional sound practices, but to expose you to what these practices are and help you find ways to incorporate them into your filmmaking regardless of the budget. My aim is to distill knowledge from these masters into precise workable information so you can produce your films with great sound and realize your project the way you've been dreaming of!

It's likely you'll have a host of willing participants to help in many film-making departments – except for sound. You might have people begrudgingly willing to do sound for you, but they aren't *excited* about it the way they are about participating in other departments. Sound always seems to be an after-thought for independent filmmakers.

This deficiency in sound often extends to how filmmakers prepare for shoots. I've seen students do elaborate testing for cinematography for their films that includes storyboarding, shooting stills, bringing the camera to the set with actors for blocking, lighting, wardrobe, furniture, available light, and preparation for visual effects. But these same diligent filmmakers don't test for sound. Film-makers should *always* bring a recorder to the test site and "roll tape" to record location sound as part of any preproduction testing. When prepping any film, go to your shooting environments and test record sound. You'd be amazed how it will help you prep your shoot. When I was an undergraduate, I filmed in my childhood home. There was a highway across the street. When we began rolling sound, we noticed how loud the traffic from the highway was. Now, if we had had a professional sound recordist, they would've figured out how to mitigate the noise. But living in the house all those years had caused me to "tune out" the background noise. The Nagra recorder I used, however, was merciless. It heard and recorded *everything*.

TECH TALK – A prominent playwright-turned-Oscar®-winning film writer/director I know was interviewed, and he stated that he wished he knew more of the technical lingo about filmmaking so he could more easily talk to his crew and give them directions. As a writer/director, you might know the language of acting, writing, and directing, but some of the technical aspects of filmmaking might not be ready at hand for you to discuss. This book will help you understand the fundamentals of sound as well as be able to talk to and direct your sound crew.

Speaking of machines, it is important to realize that we as humans tend to "tune out" noise and have selective "hearing." You must always be aware of this trait so you're not deceived and can learn to override this skill and record good location dialogue. Your ears are selective in the same way that your naked eye is selective. But machines like cameras and digital sound recorders are *not*. They are stupid – and at the same time comprehensive. You must learn how to listen to dialogue through headphones because your ears will deceive you in this way, too. You must listen with an ear toward knowing whether or not the recording *machine* is picking out the dialogue in a usable fashion, and this skill is not intuitive. It is a skill that has to be learned and practiced, which coincides with *understanding* what headphones do to dialogue while also knowing the headphones are cutting off your naked ears' skill at sifting through noise to pick out desired sound. This is why sound crew must *always* wear headphones. Knowing how to monitor location dialogue through headphones, however, takes a lot of practice.

Sadly, many filmmakers on a budget only pay attention to sound when it's bad or not usable, most likely when it's too late. And fixing sound in postproduction is no joke. It's difficult to do it right, especially on a budget and with actors not used to "looping" (recording ADR or Automated Dialogue Replacement). That is, if you can even round up your actors again, not to mention matching their looping with their onset performances. Many filmmakers will not budget for sound postproduction funds and will not give ample time for the sound editorial process. How many times have I experienced students making thesis films who spend months editing then turn around and try to "fix sound" in a day! This wrong thinking is due partially to the fact that the ease of digital filmmaking prevents us from understanding sound as a separate process in itself, one that deserves the same attention and focus as cinematography, much as it did in the old days. But more old analog film war stories later.

So if sound is, as George Lucas believes, 50 percent of the effect of the film, why isn't it treated as such in low-budget projects? Festival programmers have told me time and again that bad sound is the easiest disqualifier of submitted films. That's why the goal in low-budget filmmaking shouldn't be to "grab sound" in any old way with the thought of "fixing it later." The goal in location sound should be to create an environment where the sound recordist is an active crew member rather than a passive technician. This approach will feed nicely into the second part of the sound equation (there's three), the sound postproduction process, which actually begins on set and extends into sound *editing*. That the sound *edit* process is a separate process in itself is something many filmmakers don't get. And finally, the third phase of the process, the final mix, is a concept many filmmakers know nothing about, yet it is vital to a film's success. All of these will be covered and demonstrated in the follow pages, including offering filmmakers ways of practicing with accompanying materials.

Maybe now it's time to discuss the cringeworthy term "audio." Many of you are used to the concept of "audio" and the idea of "audio capture" rather than of "sound recording." Am I merely picking a fight over semantics? No! Audio is

just that "on" switch on a camera. It's an add-on, an afterthought, and it suggests passivity on the part of the recordist. We have a course in our Film and Video Production area at East Carolina University called "Cinematography and Audio Capture," much to my chagrin. At the time of the course's creation, there was no stand-alone sound course, so sound got rolled into the camera class. This leads to (or enables) "audio" recording to be treated as a passive endeavor rather than an active filmmaking job for a crew member to contribute. Sound recordists, sound editors, and sound mixers must be active cocreators in a film for it to be successful. Thinking of sound as "passive audio recording" is pervasive in a lot of low-budget filmmaking, so it's good to start thinking that the sound recording (and posting) in your film should require the respect and attention that cinematography gets. If you don't do so, you're headed for failure.

There's another explanation for the hierarchy of picture over sound. Films conspicuously have a "look" to them, but it's harder to think of films that have a "sound." If you research, you'll see that some great cinematic films have specific kinds of sound design, and there are notable sound masters with whom you can identify because of how they handled their soundtracks. David Lynch comes to mind on the sound/directing side, and Walter Murch does on the sound design side. Yet, when we think of a film we liked or disliked, we tend to recall visuals before sound. It's how our brains work; we're visual creatures.

That's because sound is invisible. You can measure sound, but you do not see sound, and sound technique is often meant to be "invisible" to the audience, as is most editing in commercial cinema. In fact, as you'll see in our sections on dialogue editing, painstaking work is done to keep attention away from the dialogue track and the changing shots, and a lot of work is done to make shot changes (and by extension) microphone changes inconspicuous, otherwise you'll be taken out of the story. If you notice the dialogue track as a recorded element in a film, the dialogue editor, and in some ways the sound recordist, have failed.

On a related academic note, there's a branch of film theory called "suture," which postulates that Hollywood movies are designed to "suture" the viewer into the psychological experience of the film so that the audience forgets itself and is "entertained." Audience members, myself included, pay to hand over our brains to movies for the time the film runs; we want the filmmakers to suture us into the experience. If bad sound takes us out of the experience, we become bored, distracted, and frustrated. There are instances when sound is designed to call attention to itself, to be a "character" in the film, or to be mixed conspicuously, as in the case of Jean Luc Godard, who sometimes mixes his films so that even though a scene is indoors it sounds like we're outside listening as the traffic noise is loudly intermixed with indoor room tone. Sometimes Godard will even turn off the sound completely for no apparent reason. These techniques cause the film's sound to bring attention to the artifice of the film itself and takes us out of the fictional experience of the story to remind us we're watching an artificial world, a technique called distanciation. But the fact that he's turning off

the sound in the middle of a scene to break the spell of the film underscores how important sound design is to the overall magic of the cinematic effect on an audience.

Toward the end of this book, we'll talk about different ways sound can be used as a character and used to produce the many different effects just described, to go beyond using sound to invisibly serve the story. But you must first understand the basics of how sound serves picture and story and how to make sound invisible to the viewer before you learn to make it conspicuous or "visible."

Let's return to the issue of why sound isn't treated with the seriousness that cinematography is. Send ten cinematographers to shoot a scene, and you will get ten distinct looks/shots, etc. Send ten location recordists to shoot the same scene, and there might be variances in how they record the dialogue, but the objective would be the same for all ten recordists: come back with clean intelligible dialogue with good signal-to-noise ratio, recorded "on axis." Period.

TECH TALK – To record sound "on axis" means you record it directly into the front capsule of the microphone to ensure the full range of vocal frequencies get recorded.

The sound editorial and mix process of the scene to follow will have conspicuous differences in how they turn out, depending on the artist doing the sound editing and mixing. But, as a whole, the differences will be fewer and less conspicuous than the different ways cinematographers handle a scene. When a cinematographer shoots a film, his or her visual style is immediately apparent to anyone who screens the dailies. But a location sound recordist is just recording a foundational sound element that will become a strand in a postproduction process, a raw piece (dialogue) that will be a key part of final mix. The recordist has no other goal but to record this very critical element of the film correctly, and the results won't vary much from one recordist to another. But if the recordist gets it wrong, he or she has seriously compromised the quality of the end product, ruining 50 percent of the movie's effect, the sound. And with bad sound, you have no movie!

At first, good location recording technique is counterintuitive to untrained ears. And the concept of "audio capture" has hurt filmmakers because "capturing" infers that the craft of recording sound is passive. "Audio" is a term that should not be used by serious filmmakers because "audio" is something I record at a wedding or my softball game. There are no Oscars® for "best audio" or "best captured audio." Most film students I've taught don't care as much about sound as they should. It's an afterthought, a burden, a grunt job. It's not completely their fault; many film academics don't know how to give sound its due attention. When I was making the web series *The Smart Rocks*, I asked a student to operate boom, and he complained that he wasn't going to "be a grunt." It was as if I asked him to sweep the floors! The truth is that booming is a craft that should be treated with as much respect as cinematography.

FOSSIL RECORD – As a teenager, I worked for Magno Sound in New York City. This production house did a lot of postproduction sound, including Woody Allen's *Annie Hall* and *Manhattan*. I worked in the sound transfer department. Try and imagine what this was like … there were rooms where transfer technicians would take magnetic sound recordings (¼ magnetic tape) and rerecord or *transfer* it to 35 mm sound stock so editing could commence. It was an expensive process and it took time and a skilled transfer technician to do it right. I would sit in the messenger pen and listen to Woody Allen dialogue being transferred take after take. It was exciting. But my point is that there was something about the entire process of analog filmmaking, especially how it created the need for separate, special attention to sound production, that made you automatically take it all the more seriously. This tedious workflow, along with shooting negative film and waiting for it to be developed by a lab (not to mention the expense of it all), was a part of the rigor that went into making a film that is missing today. It's easier to make films now, and that's mostly great, but with this ease of production the care you should take with the sound process is often overlooked. The task of this book will be to help guide you in mitigating this deficiency and **to** focus on creating an environment to produce great sound in your film.

So back to the film you're about to shoot. You definitely won't have enough time to do what you need to do with sound in the traditional way. You might have a wide variety of levels of experiences in your crew members, different levels of actors, good and bad locations (not to mention ones you're stealing), and on various days different crew operating sound, even at times using different sound equipment. None of this is ideal but none of it means you have to come away with bad sound. But you, the filmmaker, must be in control and have oversight of the sound element in your film, probably more than seasoned master directors with funded Hollywood films have to worry about, because they will have monster sound recordists on their shoots and a skilled, well-paid sound postproduction team to finish. And this control that you as the filmmaker must have *starts* with working sound into preproduction, all the way through to the final mix. You *can* produce great sound on your film as a low-budget filmmaker, and I'm here to help you understand how to look at and approach film sound differently and bring it more front and center stage without losing focus on everything else you're trying to concentrate on to achieve your vision.

To be a filmmaker these days is not to be only a director because usually you're wearing too many different hats to just direct. Don't get me wrong, you still *have* to direct … you just have to do a lot of other things as well. Today's low-budget filmmakers are producer/director/editor/sound editors and mixers – in other words, *consummate* filmmakers: they have to get the production ball rolling, direct the film, and wind up being the sole filmmaker having to finish the postproduction process including sound. It's literally 50 jobs rolled into one. But it doesn't have to feel like 50 jobs if you have a realistic map of the process, designed with the independent filmmaker in mind.

Most films we go to see are made by teams of skilled artists and technicians and the director functions more like the conductor of an orchestra. As an independent filmmaker you might find that you'll have your hands filled with every aspect of filmmaking in a way a Hollywood director doesn't.

For example, picture editing in today's modern digital world involves knowing a lot about sound and, in fact, doing some baseline sound editing. I spoke to one picture editor who said that films often come in with some of the sound editing work already done. This can include setting up the dialogue tracks, the cross fades, etc. Panning might be done as well as equalization.

So, think about sound as something that is not separate from the other aspects of filmmaking but deeply integrated with them. This book covers aspects of sound you have to think about as a low-budget filmmaker. It is intended to be a guide to the other 50 percent of filmmaking that effects the audience.

2 Tech concepts you need to understand

Bit rate or bit depth? Frame rates, dithering and Q? Milliseconds and amplitude. Sound is a very technical art that requires some background on how it works in order to be able to manipulate it for creative effect. Below are some key terms and concepts you need to learn.

Sound is a form of energy. It's invisible to our eyes. And it should remain unnoticed or invisible in film if the soundtrack is designed right. Sound is meant to blend into the experience for the most part and not call attention to itself. If you notice sound editing, the process (and sound editors) have failed.

Occasionally, there are brilliant sound design moments in a film, like David Lynch's *Eraserhead* where the strange world he creates is supported by the unique soundscape of the film and this collage of aural images is meant to call attention to itself. But most sound design in film *supports* the image and blends into the entire experience. Our job as filmmakers is to capture and manipulate sound using the tools available to us and create an experience that an audience member can relate to, understand and lose themselves in. Most of the time when you notice sound it's because it's bad.

Frequency

Sound is a pressure variation (a wave) that has two main components: frequency and amplitude. Frequency is the speed of the pressure variation; it is measured in cycles per second or Hertz (Hz). The frequency measures the number of cycles completed in a second. The more cycles that are completed, the "higher" the sound. The less cycles per second, the lower-pitched the sound. High frequency sounds are violin strings, glass breaking, beeps, shrieks, etc. The typical speaking voice falls in the midrange, while low frequency sounds are represented by thunder, bass guitar, etc. A phone will allow the pass-through of only high frequency sounds hence that thin tinny sound. Typical house walls will let low frequency sounds pass through leaving out the highs. Think of when you are in your apartment and hear a car drive by with loud hip hop playing, and all you hear is the deep muffled bass passing through the walls. And that sound must have air to travel and reach our ears. There really is no sound in outer space, and yes, no one can hear you screaming. Except the movie audience.

Theoretically, some sounds can have single frequencies or *fundamental* frequencies. Think of a tuning fork being struck and ringing out what is known by sound recordists as a pure "440 A note." This means that the wave that produces this sound vibrates at precisely 440 times per second.

But even this ringing sound will have "overtone" frequencies. The sounds that most filmmakers deal with will have multiple frequencies. A human voice can *range* from 85–255 Hz and one person's speech will fall somewhere within this range. It's useful to know that speech is delivered in a frequency package or *band of frequencies* that can be further manipulated to emphasize certain frequencies within the band and to lower others. Understanding this will become important when we consider how and why we need good "signal to noise" – we need a lot more desirable sound (signal) to undesirable sound (background noise). See Table 2.1 for examples of typical sound frequencies.

Table 2.1 Chart of some typical sound frequencies

Sound	Frequency
tornado	1–5 Hz
refrigerator	0.5–2 Hz
clapping	2 Hz
blue and fin whales	17–30 Hz
thunder	20–100 Hz
ultrasonic cleaner	45–50 Hz
dolphin	0.2–150 kHz
male speech	85–180 Hz
female speech	165–265 Hz
train whistle	307 Hz
car horn	405–500 Hz
police siren	635 Hz–912 Hz
musical note (C fifth octave)	523 Hz
soprano voice range	261–887 Hz
dog barking	400 Hz–2 kHz
bumblebee	10 Hz–1000 Hz
insects	2kHz–15 kHz
vacuum cleaner	4.2 kHz
grasshopper sounds	10 kHz
dog whistle	23–54 kHz

Note
Human beings can hear everything in this table except for the infamous dog whistle, which emits a sound that dogs can hear but humans cannot.

Sample rate

Look at the last item in Table 2.1, the dog whistle which is beyond human hearing. In other words, when creating the technology for digital sampling there was no need to be able to sample a dog whistle or a sound beyond what a human could hear. This leads us into a discussion about sampling rate.

The sample rate, in a nutshell, is the number of samples per second a piece of sound is recorded at. It is measured in Hertz (Hz) or Kilohertz (kHz). A sample rate refers to how many times per second a sound is recorded digitally or *sampled* in order to reproduce a digital sound. The best sample rate for compact disc (CD) quality audio has been determined to be 44.1 kHz (44,100, although higher rates are now used) and 48 kHz (48,000) for sound in the digital video world.

The term "sample rate" uses the same terminology that is used for frequency because measuring sample rate is measuring frequency. One is a measurement of the frequency of a sound wave, the other is how you reproduce sound to make sure everything possible for the human ear to hear can be reproduced and heard.

TECH TALK – Even though the human ear can only hear up to 20,000 Hz (20 kHz), the Nyquist Theorem states that the sampling rate must be double that in order to be perceived correctly. Hence the rates of 44,000 Hz (44.1 kHz) or 48,000 Hz (48 kHz) that we've grown accustomed to using when recording digital music and digital sound for video, respectively.

Amplitude

If someone picks a fight with you and starts yelling loudly you notice their *volume* right away. Volume and *amplitude* are pretty much interchangeable except that amplitude is the more technical term used in sound recording. It's basically the measurement of the wave from its base to its peak. The larger the wave, the more amplitude, or the louder the sound. Amplitude is the term that is used to measure (and manipulate) the level of sound as recorded with electronic devices. Like the term "signal to noise" ratio, amplitude is a term that coincides with electronic output devices (either speakers or headphones) and underscores the fact that the sounds we record in nature (or invent in a sound lab) must be turned into electronic signals by digitizing them so they can sound recognizable through speakers or headphones.

For our purposes, the relationship between amplitude and frequency is simple. So long as the amplitude of a sound that we don't want (that sound of background traffic) does *not* raise to a level that is too close to the amplitude of the actors talking, it's not a problem – despite frequencies in both sounds having commonalities. If a low rumble of a moving train is loud enough to compete with the dialogue – or too close in amplitude to the amplitude of the dialogue even though it's a completely different frequency – you have a problem with the dialogue or lack of *separation* from the background.

Bit depth

If you've studied cinematography, you will be versed in concepts such as reso-
lution and codecs. There's "1080 P" (progressive scan), "4 K" (approximately
4,000 pixels on the screen in high definition), "8 K," etc. These numbers refer to
the amount of information in the image, or its *resolution*. Bit depth is essentially
the resolution of a sound image. Common bit depths in usage are 16 and 24 bit.
The standard wisdom used to be that 16 bit was perfectly fine for all recording
applications since the output would generally not deliver any more information
then could be captured at 16 bit. But as data storage capabilities increased, so
did the tendency to use higher data sound files in recording, namely, 24 bit. The
24 bit sound file allows for greater dynamic range and more information to be
captured, so if you have the capacity to record at a higher bit depth, do so.
While 96 bit is available, it's probably overkill and will require more storage. As
I'll say over and over again in this book, make sure you test your equipment and
your storage capacity before embarking on a filmmaking project.

> TECH TALK – If you wish to go down a technical rabbit hole look up bit rate vs.
> bit depth. In short, bit depth refers to the measurement of recording and bit rate
> has more to do with an audio *output* measurement for playback. For obvious
> reasons, we as filmmakers are more concerned with what settings of bit depth we
> need on set.

Decibels

A decibel (dB) is a unit of measure of sound that can either be an absolute
measurement or a measurement of recording for levels. dB is the primary way we
measure the amplitude of sound in sound production for film and video, so let's
look at it in detail. dB can either measure absolute loudness or it can be a
measurement of *perceived* loudness from one level to the next – the latter is the
kind that is used on sound recording device meters.

Here are some absolute dB levels:

- average road traffic 70 dB
- diesel freight train 80 dB
- bulldozer 88 dB
- power mower 94 dB
- loud music in nightclub 98 dB
- ambulance siren from inside ambulance 100 dB
- leaf blower 115 dB.

These dB measurements are of *actual* loudness. But in the devices we use to
record and reproduce sound for film, the dBs we are reading off the meter have
more to do with what's known as *perceived* loudness. What does this mean?

Measuring the absolute loudness of a sound via an input signal on an audio recorder won't be as useful as the perceived loudness of the signal, especially considering what we need to happen in the device we're recording with.

What matters when we record are far as dBs are concerned is how loud incoming sounds are compared to other sounds – signal to noise ratio. The dBs level you are reading is useful to let you know you're getting as much signal into the machine as you can, and as much separation from the noise as possible.

The science and physics of what all this means is very complicated but this is what you need to know: in perceived dBs (the kind you read on your recorder) an increase of 10 dB is perceived to be approximately twice as loud as the *previous* sound. This means that a 20 dB gain would seem to be about four times as loud and a 40 dB gain would seem to be 16 times as loud. And just as the human eye can see a wide variance of light, the human ear has an incredible range.

Reference levels in recording devices/sound meters

Sound recording devices (including cameras) use reference level meters to let us know how much signal we're getting into the recording expressed in dBs. Today, in digital sound recorders, cameras, and postproduction platforms such as Logic Pro X, Pro Tools and Audition, the reference level meters we use are called *peak* meters. Peak meters are inventions of the digital age and for the most part work well. But, in either meter, the measurement of dBs has more to do with the measurement of one level of sound against another rather than a measurement of the actual loudness of the sound, hence the term "reference."

In other words, a power motor's *absolute loudness* might be 97 dB. But when you record the sound on your recording device it might read on the reference level meter at −10. What that is telling you is how much sound information is being recorded relative to the entire amount of signal that *can* be recorded. It's a reference to the amount of information that's being recorded onto the sound file *not* how low the sound actually is. If you are recording dialogue simultaneously and the dialogue is coming in at −8 because you have a lavalier on the actor and a good mixer, then you have two degrees of separation between the mower sound and the dialogue which is probably not ideal. What's more important than the true level of the actual decibels of the incoming sound is how much the dialogue is separated from the mower noise, or anything else in the sound field that is not dialogue. And this is expressed in dBs in the meter, or *perceived* loudness.

Analog VU meters

A VU (volume unit) meter is a leftover from analog days when sound was measured in voltage. Zero represents the target voltage a signal should be hitting while recording. It's not a measurement of the signal, but it allows users to aim the signal level at a target level.

In other words, in old school analog VU meters, zero is a target you want your sound to come in at without peaking. A limitation of an analog meter is that it

won't leave a digital marking so we can see average loudness, in the way that digital meters do. An advantage of analog meters is the meter's slower response to small but rapid amplitude fluctuations. The analog meter's slower response tends to ignore the fluctuations. The rate of fluctuation and the digital meter's sample rate can cause the average value to jump around a bit. 0 VU is often referred to as "0 dB." The VU meter was not designed to measure the signal, but to let users aim the signal level to a target level of 0 VU (sometimes labelled 100 percent).

Sound file types

These are some common sound file types:

- WAV (Waveform Audio File Format) – very common
- Broadcast WAV – common in professional set ups; same as WAV and contains *metadata* like time code, etc.

Digital meter

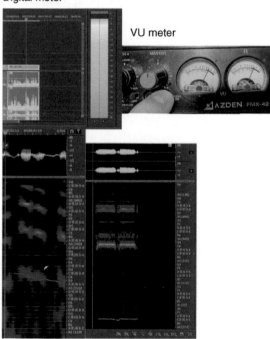

VU meter

A digital meter shown side by side a VU meter. In the digital, the yellow area is the "warning track" of the meter, considered the beginning of peaking, the sweet spot, and above zero in the red you'll start to "clip" or distort. You don't actually hit distortion until you reach the top. A good location mixer will try to keep the dialogue in or near the yellow without peaking as this provides good saturation of signal. Conversely, the VU meter shows 100 percent of signal at 0 (red) meaning the electrical input of the signal has reached "full" capacity. Some mixers still like the way VU meters respond (they are a little slower to move and some feel a little more accurate).

Jalopy car horn human voice

This side by side snapshot of two sounds compares the frequency spectrograph of an Old Jalopy car horn with a human voice. Notice how they share similar frequencies. Also notice that the frequency graph (to the right of each sound) can also be represented by notes on the musical scale – the higher frequencies represented by higher notes, the lower ones by lower notes. The darker the color of the sound the greater the amplitude or loudness of the sound.

Figure 2.1

- AIFF (Audio Interchange File Format) – a proprietary file developed by Apple for editing platforms.
- MP3 – an output format for music, generally considered too compressed to work with in the edit stage for film except maybe for background music.
- CAF (core audio format) – a container for storing audio, developed by Apple Inc. It is compatible with Mac OS × 10.4 and higher; Mac OS × 10.3 needs QuickTime 7 to be installed.

If you have sound files such as sound effects currently existing in CAF, you can convert them to WAV files.

Figure 2.1 shows a digital meter next to a VU meter, as well as a spectrograph of an Old Jalopy car horn side by side a spectograph of a human voice for comparison.

In a field that uses the language of physics to express some of its most complex concepts, I have outlined above the basics or core technical concepts you must understand to achieve quality sound production and postproduction.

3 Location sound recording
The basics

Before we get into the more technical terminology of location sound recording, I want to plant the most important idea in your brain, the key concept you must learn, the veritable only true tenet that really matters when you're doing location recording. I realize that to some this might be obvious, but there is a bigger point I'm leading to. Okay, drum roll please, here is the big earth-shattering truth about recording location sound: *the only thing you're doing when you record location sound is gathering assets for the final sound mix.*

That's right. That sound quality you grab on the set has to serve you in the final mix and you have to know how to get it right for that end, which means when you do get to the final mix you have usable location dialogue. Of course, editing is better served, and part of your entire gathering of location sound assets includes getting room tone (I'll show you a trick to get the best room tone possible), wild sound where needed. and on-set sound effects. Another reason why the untrained ear might deceive you that your sound is usable is if you've never gone through a complete mix where shot to shot, scene to scene the mixer is striving to EQ (equalize) the dialogue to make it sound like it's coming from the same character. The clearer the separate signal recorded on axis the better it is for this purpose.

You probably won't even understand what kinds of problems you'll encounter your first time around until you actually get to the sound mix stage. As with all filmmaking you have to shoot to edit. You have to shoot to your ends. The same goes with location and postproduction sound: record to sound edit and mix. But you have to train your ears.

This leads me to another aspect of gathering your sound assets starting with location sound. Dozens of times, I've seen a student recording a phone call and being proud that they made the phone ring on set and have dialog talking over it. This is a mistake because it's easier to reconstruct the phone sound. What you are supposed to be doing in the field is getting the cleanest dialogue. Period. Not dialogue and traffic, not dialogue and loud backgrounds, not dialogue and phone calls. Dialogue raw, not equalized, sometimes with a limiter, sometimes using a high pass filter to help push down loud, low frequency sounds like traffic and never EQ or compressed.

So there are a few things you have to think about when you're setting up to record sound for a final mix. You have to listen for signal to noise, you have to

listen with trained ears. So forget what sounds good to your ears out of the box. Here are some guidelines to getting good location sound – the 11 things you need to remember when you are recording location sound.

1. Dialogue recorded with minimal additional frequencies

When you record dialogue indoors and sound bounces off the walls, ceilings, and floors (commonly called "reflections"), the bounced sound provides added frequencies that discolor the pure sound of the voice – which is all we want to be recorded on location dialogue tracks. It's difficult to eliminate those additional frequencies or *colors* that are printed on the dialogue once they are burned into the recording.

This again underscores why location recording is so difficult. There are almost no real locations that are ideal for recording sound. Some may think that the inside of a car is a good place to record sound, but that's partially due to the fact that *playback* from a car stereo sounds great because car stereo systems are designed to interact with car interiors. And while the way a car interior is designed and insulated can help reduce outside noise when recording in a closed car, the interior of a car creates a large amount of *phasing* or *comb filtering* which means the sound will bounce off all the parallel glass in the small space and sound a little unnatural.

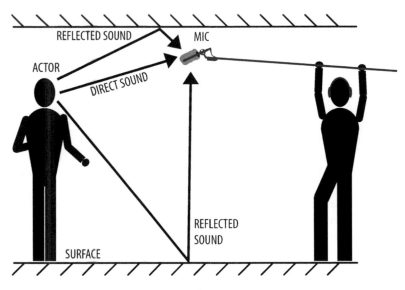

(REFLECTED SOUND) SENDS OUT OF PHASE
FREQUENCIES TO THE MICROPHONE TAINTING
THE PURE SOUND OF THE VOICE

Figure 3.1 Reflected sounds that get recorded along with the sound of the pure voice (making the overall production sound less than pristine).

TECH TALK – Figure 3.1 shows the phenomenon of combing or phasing where the desired sound, such as that of a human voice, will hit the microphone on axis but also bounce off the walls, floors, and ceilings causing different frequencies of the same voice to hit the microphone milliseconds off from the original sound and also be recorded, causing an undesired sound. It's hard to remove those additional frequencies once they print onto the sound recording.

2. Dialogue that isn't spoiled (i.e., "married to" other noises on set)

If your friend walks into your house with shoes that clonking on the wood floors as she talks, that is not a problem because your magnificent ear can pick out what she is saying. This does not hold true for location recording because that clonking will be *married* with the dialogue in the sound file and become a problem in postproduction. Anything that is heard with the dialogue, like footsteps, planes, fire engine sirens, etc., can interfere with the quality and effectiveness of the final mix. Your ear can pick out the line in the headphones when the sound happens simultaneously with the dialogue, but the devices in postproduction cannot do so as easily. And it doesn't take a lot of incidental set noise to ruin a good dialogue track.

TECH TALK – Learn to use judgment as a filmmaker as to whether or not location dialogue has been ruined by incidental set or environmental sounds and then to stop recording until the unwanted sound has stopped. For example, you're recording on a city street and a plane flies over head. The sound recordist might want to cut, but you as a director should know your tolerance for dealing with dialogue that has some sound issues like airplanes in it. It all depends on what kind of sounds are ruining the dialogue take and what kind of signal to noise ratio your dialogue versus the noise is when the take is recorded. It also depends on how lively or "realistic" you want your location sound to be. A general guideline is that if you can't make out the actor's speech then the noise has ruined the take and you need to record a clean one without the airplane noise, or, plan to replace the dialogue in postproduction with a process called ADR (Automated Dialogue Replacement). More on this later (see p. 171).

3. Always get great signal to noise ratio

For our purposes, signal to noise ratio simply means that the sound we want (signal = dialogue) has to be louder than *any* other sounds (noise = traffic, wind, crowds talking, etc.). Now the term "ratio" might sound like you'll need a calculator on the set but fear not – it just means you want enough separation of the level of the sound of the actors talking from anything else on set. This is

required so you can treat dialogue as a separate aural entity in the final mix. We call it a ratio, but you'll have to learn how to read your device's recording meter, see where the noise is coming in, see where the "signal" (dialogue) is coming in, and begin to develop a *feel* for whether or not it's enough.

4. Dialogue without microphone sounds from the boom operator

Boom microphones can make a lot of bad set sound all on their own. Let's face it, it's a live sensitive mike being moved around all over the place. Your boom operator will need good cabling (or a wireless connector) so the movements of booming itself will not create extra noise on dialogue tracks. Such noise is usually loud, disruptive, and hard to eliminate or treat.

5. Dialogue without clothes rustling from radio microphones (lavaliers)

Radio microphones (often referred to as lavaliers) are great but can create sounds if they get loose and move around under clothes. A big mistake independent filmmakers tend to make is to use the wrong kind of radio microphone (a broadcast one meant to be visible on an interviewee) on a narrative film set. The problem is you must hide the microphone in the actor's clothing and some broadcast radio microphones are *not* designed for that purpose. Also, if you're going to wire up actors you must know how to do it effectively and using appropriate etiquette.

6. Even "on-axis" sound when booming actors

On-axis sound means that the actor's dialogue hits the center of the capsule of the microphone as much as possible when they are speaking. It means the dialogue coming out of the actor's mouth is hitting in the microphone's pickup pattern optimally. It's achieved by pointing the microphone directly at the actor's mouth and *moving* the microphone with the actor when they move, *keeping* on axis throughout the scene via booming technique. What I tell students is your job when you're recording location dialogue is not just to record the sound, but sound of a very distinct quality. You're not recording a police deposition – in other words, it's not enough that you can *hear* the speech and make out what they are saying. You have to capture the full frequency of the human voice in order to transmit emotions to the audience. This is essential.

Figure 3.2 points, in a nutshell, to the main skill of a boom operator engaged in a little choreographed movement – this is the primary art of this technical position. It's inevitable that occasionally an actor will turn and say part of a line "off axis" causing the dialogue to hit the side of the microphone. Off-axis sound will have a different amplitude and frequency than sound that hits on axis. We'll discuss microphone pick up patterns and booming technique later, but

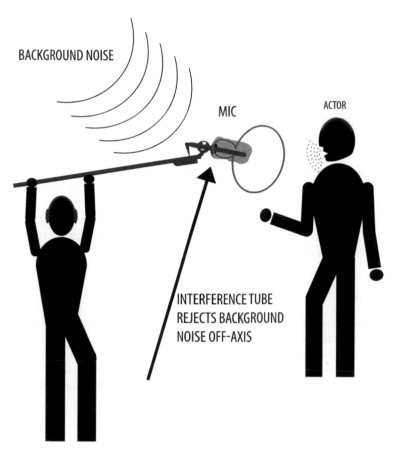

BACKGROUND NOISE

MIC

ACTOR

INTERFERENCE TUBE
REJECTS BACKGROUND
NOISE OFF-AXIS

Figure 3.2 Booming to capture the actor's voice on axis and simultaneously reject background noise.

your primary goal in booming is to try as much as possible to get the dialogue recorded evenly "on axis." It's also important that the microphone distance stays at a consistent distance from the actor's mouths to create a constant level as far as possible that matches the shot scale.

7. Sound that matches the "shot-scale"

Most of this is common sense; if you're booming a close-up, the microphone will be closer to the actors and the dialogue recorded will sound more "present" or, to put it simply, louder then it will in a wider shot. A medium shot will make the boom operator match perspective with the shot scale because the microphone will be further back. All this will result in dialogue that feels right to an audience and will make the final mix a little easier. However, it is also important

always to try to capture a close perspective whenever you are recording dialogue regardless of the shot scale; that is why it's good practice to deploy wireless lavalier microphones whenever you are shooting. It will give you a backup, the ability to change the perspectives in postproduction.

8. Clear easy to understand dialogue without actor muttering, or eating words

If you wrote the script you're shooting, you probably know every line of dialogue by heart. This might make you all the more capable of picking out dialogue even when an actor is muttering the lines incomprehensibly. I've seen excellent actors trained in speech "eat" words because they are engrossed in the emotions of the performance or trying to be too "realistic." Don't be afraid to tell actors to talk a little louder if you need more signal to noise ratio. By the way, if you're the sound crew, it's your job to call out unintelligible dialogue by talking to the director, never to actors directly. But, in case you really miss a line, there is....

9. Wild sound

Sometimes, it makes sense to get an actor (or a few actors) in a quiet place on the set and ask them to act some of the lines right into the microphone just as a backup for sound editing. These are called wild lines. Sometimes they will match, sometimes they won't. You can play back some of the synced takes for their reference if that will help. Doing this may save you from having to record ADR in postproduction

10. Capture good room tone with every camera set-up

Room tone is a term that describes background noise that is always present in every environment and that we tend to tune out. It can be traffic, air condition-ers, or the murmur of a crowd in a bar. Regardless of what type of room tone it is, the location tracks will pick it up, and you'll find, when you are dialogue editing, that you will need some *extra* room tone to fill in holes that have invari-ably been created due to the picture editing. So, having captured extra room tone is a precautionary element the sound editor will have at their disposal to fill in those holes, or to create *tone extensions*.

Running a few minutes of room tone for every camera set-up at your location is ideal. I'll tell you a trick to make it faster than doing room tone at the end of each scene. The last take of every set-up simply instruct everyone that once you're rolling sound, the director will wait 30 seconds to call "action" and no one should talk or move or cough, etc. This way, for each set-up you'll have 30 seconds of clean room tone that you will probably be grateful for when you do a dialogue edit. If you can't get clean room tone, one per set-up, get 30 seconds of clean room tone for every scene. You'll thank me in postproduction.

11. Preservation of natural Foley or PFX (production sound effects)

Reproduction of everyday sound effects that are added to films, videos, and other media in postproduction to enhance audio quality are named after sound-effects artist Jack Foley. This includes sounds that bodies make, such as clothes rustling, people walking, etc. You'll likely have to do some Foleys in postproduction, but when you record location sound, the boom microphone (and sometimes the radio microphones) will pick up a lot of great natural Foley, especially footsteps and clothes rustling.

But guess what, if the director talks over the production Foley, it's not usable. Where possible, try to preserve natural Foley or PFX. They are especially handy for low-budget filmmaking postproduction, but don't slow your shoot down for it. Getting clean usable dialogue is your main (and, in some ways, only) goal. But learn to develop an awareness of when you can keep the natural Foley usable. For independent filmmakers, it's always useful.

NOTE – While there shouldn't be much variance from sound crew to sound crew in terms of the quality and nature of the sound they record on a set, you should always view a location sound mixer and boom operator as active creative participants in the filmmaking process. This includes sharing the script, storyboards, shot lists, etc. with them. They should also be invited to location scouting trips, etc. They are sound recordists, not audio capturers.

4 Location recording microphone basics

Figure 4.1 shows a preamped microphone in my school's sound lab. It can record clean, unadulterated human speech (or signing). It's a high-end mic, "cardioid" microphone. Preamping a microphone brings it to a line level signal so it can be recorded. Why is this so much better than the situation you're likely to encounter on location? Because in this insulated quiet room you are able to record *only the sound of the human voice*. And that clean sound coming into your Digital Audio Workstation (DAW) of choice will have as much aural information as can possibly exist in a human voice so it can be manipulated and blended into a film soundtrack.

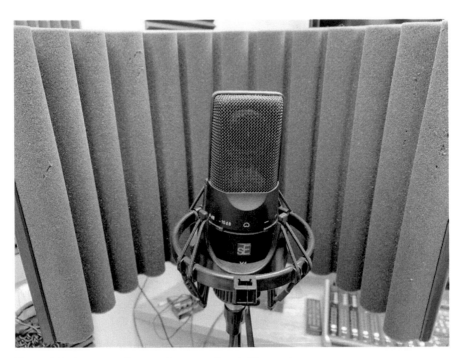

Figure 4.1 A preamped microphone in a booth-like environment.

But you usually won't have this kind of pristine environment to shoot in: you're on location. But, in some ways, you should strive to replicate this kind of recording environment with every word of location sound you record for your film. Because the closer you get to having only (or, realistically, *mostly*) the human voice and nothing else on your location tracks, the better the final sound you're going to have for your dialogue in your overall sound mix.

Of course, nothing on location is ever going to sound as good as the above set-up. I'm not showing it to make you hyperaware of what your location recording attempts might be lacking in, but to emphasize a point. Let me restate it as a question. What will be so much better with booth sound compared with the sound you'll get when you record location sound? There are three things that will be better in a booth recording than a live boom recording in an active real environment. They are:

1. perfect even levels recorded on axis
2. great signal to noise ratio
3. the full spectrum of unadulterated frequencies of human voices as dialogue without mixtures of frequencies via reflection off walls and ceilings – in other words, without *combing* or *phasing*.

These three characteristics of well-recorded booth dialogue are what you should be striving to emulate when you record location sound. But there is a missing aspect of recording sound in a booth versus recording location dialogue and it's this – there's no video or "picture" being recorded simultaneously. In other words, it's easy to record just sound, especially in a booth standing in front of a stationary microphone. You don't have to worry about what the video is doing, getting booms in the shot, etc. So, in essence, what makes location sound recording challenging is that you have to figure out how to get the microphone in the right place at the right time and also record the best clean signals possible. In an effort to support these goals, the filmmaker should *test* record and playback the results using their editing software, playing back the tests on computer speakers or testing "through to the end" – mimicking the same postproduction process they will ultimately go through when finishing the film.

Back to the three things mentioned above that distinguish booth recorded or perfect sound. What's interesting to note is that booth method of sound recording is consistent with some of the dialogue used in big budget Hollywood films, especially special effects driven epics. In these films, much of the dialogue is replaced in an Automated Dialogue Replacement (ADR) booth. The challenge sound mixers then have with the replacement dialogue recorded is that they must strive to make the dialogue not sound too "boothy" or too clean. I knew one prominent film rerecording mixer who thought digital recording on the set yielded dialogue that was "too clean" to start with, and the practice of recording it in a booth made it even cleaner.

So modern high-budget cinema has made our ears accustomed to unbelievably clean levels of dialogue – I would argue, a little too clean. I shot a scene from *Turn*

Back Night where we opted for using wireless lavalier microphones on the streets of New York because the shot was too wide to boom. So we had to do a few radio microphone only takes. While the resulting tracks will need to be carefully EQ'd to separate out the dialogue from the surrounding traffic, this method of recording location sound has a fresh and lively feeling to it, compared with the kind of "canned" and overly clean sound sometimes found in Hollywood films due to the frequent use of ADR when location tracks come in a little noisy.

FOSSIL RECORD – Woody Allen used to absolutely refuse to do any ADR with his actors because he felt that it would render a less then authentic performance. I believe he has since rescinded on this and does some ADR. But when I mixed a student film with Jack Higgins in the 1980s, Higgins, who had mixed *Annie Hall*, told me that in the scene where Annie and Alvy Singer discuss their relationship in a café on Sunset Boulevard there was loud traffic at different levels. Higgins directed the sound editor to cut "to the bone" (a technique we'll be exploring), and then he spent a week weaving traffic noise in and out. The whole picture took three weeks to mix, but that scene alone took a week to mix. This should give you an idea of how sometimes it's good to be prepared to do a little bit of ADR if necessary, and that even well-financed Hollywood films have location sound problems.

Microphone types and "pick-up" patterns

If you're a low-budget filmmaker, you might not have much choice in microphones. You might be stuck with a single shotgun mic for your shoots, like many of my students are, and I certainly have been stuck with this limitation at various times in my filmmaking career. But let's pull back a little bit and see what we can learn from a lot of the technical information and research methods out there and how it might apply to your shoot. I've spent significant time researching this and have found that it's a little simpler than it appears. Believe it or not, chances are that while as a low-budget filmmaker you might not have a wide range of microphones to use, you might have access to – and have to learn – how to work with maybe one or two.

Microphones are the lenses of sound recording? Yes and no

The choice of camera lens is a creative decision that a director makes to *change* perspective, while the right microphone is chosen more universally to *correct* the needs of a scene and is less about manipulating it the way a lens can manipulate an image. While there are times that you might wish to alter the incoming sound and make an unconventional mic choice, in general, the following rules apply:

• choose the *right* mike for a scene

- get good signal to noise ratio
- record dialogue on axis with even signal
- match the sound to the shot scale without disruptive set noises that interfere with intelligibility.

Location sound recordists might change microphones for various reasons, but the changes might be broader and more general – they might use one type of microphone for indoors (such as a short-tubed cardioid) and a supercardioid shotgun microphone for outdoor recording. They will also use radio microphones consistently; these tend to be omnidirectional because they are positioned on the same place on the actor throughout the shoot and benefit from the omnidirectional pickup pattern, recording the voice "falling on it" from above. In short, if you can have a shotgun or supercardioid pattern microphone for outdoors, a short tube cardioid or hypercardioid for indoors, and omnidirectional radio microphones you're set.

Overview of the different pickup patterns and their uses

The following is an overview of different pickup patterns and their uses:

- *Omnidirectional* – This records sound from omni or "all" directions. This is the most basic of all microphones and tends to be common in lavalier microphones because this pickup pattern is best suited for the scenario of being fixed on an actor's body, from where it must capture sound falling from the actor's mouth above. Its direction or placement can't be moved during a shot like a boom can move a shotgun microphone. Using lavaliers effectively involves three things: placing them on the right spot, hiding them, and keeping them from rustling due to rubbing on clothes. Sometimes lavaliers can be hypercardioid (see below) as well, but the ones I tested are omnidirectional.
- *Bidirectional* – This is not a common microphone on film sets as it records sound from the front and back of the tube. It can be used to record, say, two singers in a duet standing side by side. It can also be used to record, e.g., an interview, catching the speaker and the interviewer speaking *behind* the microphone. Because of this it might have some use in documentary filmmaking applications.
- *Cardioid* – This is a directional microphone where all of the sound comes in a circular heart shaped pattern (hence the term "cardioid"). It's ideal for booth or studio style recording. It can also be used for indoor dialogue because its design tends to be more forgiving when it comes to dealing with reflective sounds.
- *Hypercardioid* – This, too, is very directional and receives most of its incoming signal from the front of the tube, while it also receives a little bit from the back as well. It can also be used for indoor dialogue as it, too, is forgiving with regard to reflective sounds.

- *Supercardioid/shotgun* – This is also a variation of the cardioid, but it allows a for a little less back of microphone pickup. Because it's a shotgun microphone it is very directional, has a little room for pickup in the back, and will tend to "reject" off-axis sounds like traffic and other outdoor ambiences.
- *Lobar* – A shotgun microphone with an extremely narrow unidirectional pickup pattern has what's known as a "lobar" pickup pattern. This allows for a very narrow range of pickup at the front of the tube and very little on the back. It makes it extremely directional; it can be used for recording dialogue outside but it's very unforgiving.

For our independent filmmaking purposes, I'm going to eliminate all mics except the omnidirectional radio microphone, a supercardioid shotgun, and the cardioid short-tubed indoor microphone. With these three microphones you are pretty much covered in any situation. In *Turn Back Night* we used a supercardioid, omnidirectional radio microphones, and hypercardioids.

Let's zone in on the supercardioid shotgun, the cardioid indoor dialogue microphone and the omnidirectional radio microphone (lavalier). When we say "shotgun" microphone, we mean a pattern that is very directional and has a tight pickup at the front of the mic. It also uses an *interference* tube to reject or minimize any sound that comes at it "off axis" or at the sides. One key use of a shotgun microphone is to record location sound outdoors where you need to isolate the sound from the background noise generated by the environment. It's also used when you don't have to worry about reflection from walls, floors, or ceilings. In fact, supercardioid shotgun microphones are often *mistakenly used indoors*. I've done this myself when I was starting out as a filmmaker. If you have to use a shotgun microphone indoors there are ways of mitigating the problems this can cause – but you have to be very careful. Of course, if you're shooting indoors in a controlled environment like a sound stage, a shotgun microphone is fine, even ideal. But if you can afford all three microphones mentioned above for your low-budget shoot, having the variety will go a long way toward giving you excellent sound.

Now we're going to do some testing to demonstrate how these microphones work and to start to train your ear on how to use them. I also include information on using a shotgun indoors if you get stuck doing so.

When you first see the microphone pickup patterns shown in Figures 4.2 and 4.3 you might wonder, "How can knowing these patterns help me make my film?" The answer is, "It will, because what you're looking at is not as hard to understand as it seems." You can get amazing sound without even knowing that much about these patterns, just by *practicing with the microphone you're going to be using* and training your ear to listen to how they respond. Obviously, if you understand the principle behind the pickup patterns of various microphones you'll learn how to use them properly.

Figure 4.3 represents the pickup pattern of a radio microphone (lavalier) which tends to be omnidirectional. This is due to the fact that the microphone

is stuck in one position, below the actor's mouth, and must simply catch sound that *falls* on it from above. Also, due to the close proximity of the microphone to the actor's mouth, recording levels can be set to minimize surrounding noise.

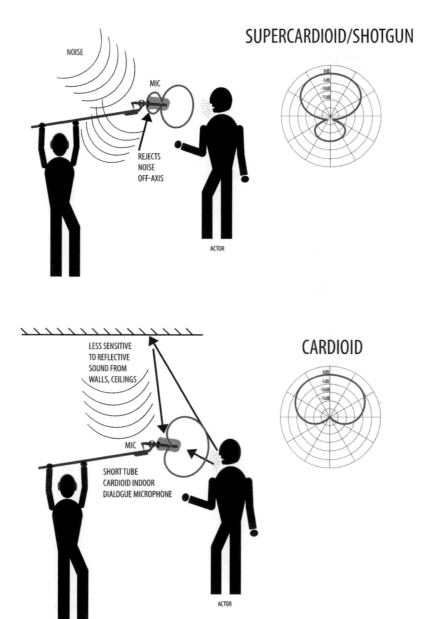

Figure 4.2 Reasons for using a supercardioid shotgun microphone outdoors and a short tubed cardioid indoors.

OMNIDIRECTIONAL

ACTOR

SOUND WAVES
FROM DIALOGUE

RADIO MICROPHONES ARE USUALLY
OMNIDIRECTIONAL AND CATCH SOUND
FALLING FROM ACTORS' MOUTHS. THEY
ALSO BOOST HIGHER FREQUENCIES
THAT MIGHT BE CUT OFF DUE TO THE
SOUND HAVING TO GO THROUGH
ACTORS' CLOTHING.

Figure 4.3 Lavalier microphones tend to be omnidirectional and capture sound from any direction.

TECH TALK – MICROPHONE FREQUENCY RESPONSE

Professional location microphones tend to have a *flat* frequency response, meaning they do little to color the sound that is recorded on axis. There are some radio microphones, like *Countryman*, which boost high frequencies because these mics are meant to be hidden in clothing, a method which cuts off high-end frequencies. If you're going to go all lavalier for a scene, the chances are you will have to add low-end frequencies in postproduction, which may or may not be doable. So know what you're getting into if you go all lavalier on a scene. If you're lucky enough to have a boom recording simultaneously with your lavaliers you can sometimes *combine* microphone recordings.

Now, let's talk about how these different microphones are used on location.

Location recording outdoors – Shotgun microphone

There are a couple of things you need to know about how to use a shotgun microphone. And the best way to understand these principles is to take your shotgun mike and test with it. You should test with it and practice with it because it's designed to be used with precision and skill.

It's relatively easy to make mistakes recording with a shotgun mike outdoors because it's easy to "miss the axis" and get the signal (sound you want) hitting the microphone "off axis" and getting a lot of noise "on axis." Because of the design of the shotgun microphone, your signal hitting it off axis will be colored. And given that we're starting with the premise that a good location sound should minimize altering frequencies, it's important to realize that booming incorrectly can do just that, by distorting the frequencies of the voice hitting the microphone off axis.

Sometimes with outdoor dialogue, and given shotgun mics' supercardioid pickup pattern, it's better to opt for *rejecting* noise a little bit and to position the boom so that you reject noise *and* lose some on axis (signal) dialogue. This technique might seem counterintuitive, but experiment and go into a noisy outdoor environment and position your boom pole slightly "off axis" of the actor talking; listen to see what you hear. Boom operators will sometimes record this way to "reject" noise rather than having the strongest signal to noise ratio.

For example, you're recording on a busy street and there's a lot of traffic sound. I'd rather see you position the boom to help reject the traffic noise and lose some "on axis" sound, rather than get more "on axis" sound but have more traffic present with a stronger noise level (less signal to noise). In other words, signal to noise ratio *trumps* direct levels of signal on axis. Microphone placement can be as much about where the microphone rejects noise as about where it picks up dialogue from. Shotgun and other directional mics will often pick up from the back, so look at the polar pattern and know where to place troublesome sources of noise in relation to the microphone. Figure 4.4 demonstrates the difference between recording dialogue on axis when background noise isn't interfering and how sometimes you might record dialogue slightly off axis as a trade-off to help minimize background noise.

In Hollywood complete unadulterated frequencies of the dialogue need to exist as an isolated piece of audio information, so the dialogue can literally be placed anywhere in the mix according to the filmmaker and rerecording mixer's preference. This is why action heavy or computer generated imagery (CGI) centred big budget Hollywood films record a portion of their dialogue in an ADR booth, so they can blend it into their intricate soundtracks seamlessly. Remember: recording dialogue during certain CGI/green screen action scenes might not yield the best signal given mic placement issues, noises generated by the production process itself, etc.

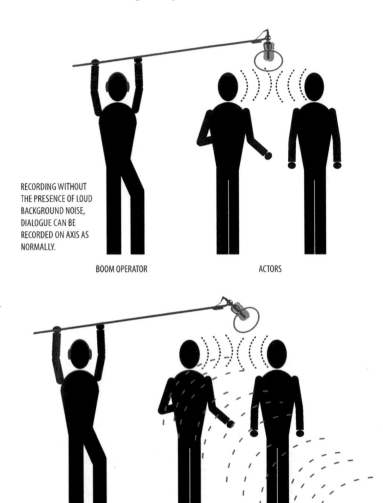

RECORDING WITHOUT THE PRESENCE OF LOUD BACKGROUND NOISE, DIALOGUE CAN BE RECORDED ON AXIS AS NORMALLY.

BOOM OPERATOR ACTORS

TRAFFIC NOISE

OCCASIONALLY THE BACKGROUND NOISE IS SUCH THAT IT MIGHT ACTUALLY BE BETTER TO RECORD DIALOGUE SLIGHTLY OFF-AXIS SO AS TO AVOID DIRECT CONTACT WITH THE BACKGROUND NOISE. THE BOOM OPERATOR SHOULD SEARCH FOR THE OPTIMAL MICROPHONE POSITION TO SEE IF IT'S WORTH GOING OFF AXIS A LITTLE BIT TO AVOID MORE BACKGROUND NOISE.

BOOM OPERATOR ACTORS

Figure 4.4 Recording outdoors with dialogue on axis and (below) slightly off axis to avoid direct traffic noise.

Hollywood does ADR often and does it well. A good professional film actor has to be skilled in "looping" or ADR acting. But ultimately, sound recorded on location is the best quality in terms of matching the performance conveyed in the picture. That's why even in big Marvel films most of the controlled live

action scenes use production sound, although the action scenes are finally finished with dialogue recorded using ADR.

That booth recorded ADR dialogue Hollywood resorts to, when needed, contains deep, rich sound frequencies that can stand up to all the other sound effects that the sound designers will layer into the film. It's also easier for the emotions of actors to transmit on the soundtrack with more frequency information in booth-recorded ADR rather than dialogue recorded on set – the latter might be comprised due to some of the special effects production needs that might hinder microphone placement, etc. For some of the quality you lose regarding the natural performance of the actor that is created on set, you gain as well, because of the quality of the sound generated in the controlled environment of the booth. However, creating good ADR is difficult unless you get good "reference audio."

Reference sound

Reference sound is the location sound you record on set for the purposes of using it for ADR and Foley. In other words, if an actor needs to replace dialogue they will listen to the dialogue recorded on the set and use it as a guideline to record ADR in a booth. The same applies with Foley; sometimes Foley artists can use the Foley recorded on set as a guide to recreate Foley in a studio.

The better the quality of the reference sound you capture on set, the easier it is for actors to do the ADR and Foley. It's better to have separate sound recorded rather than trying to do ADR using camera sound where the dialogue is buried in the background noise of the location. The reason is that if you have a location dialogue track that includes a blend of direct voice and voice bounce off the floor, there is by definition less reference information for the actors to work with. Don't get me wrong – the sound information available from camera tracks is workable, but it's not as good as clean sound from a boom and/or radio microphones. So, even if you are positive you're going to ADR a scene, record sound exactly how you would if you weren't going to ADR, where possible.

5 Configurations of location recording set-ups

GEARHEAD ALERT – Disclaimer!

It's impossible for me not to mention specific gear in this book, even though by the time you read this some of the gear might be obsolete or you might be using different gear. That said, remember, it's never about the gear or software – it's how you use them and it's about understanding the principles of filmmaking that led to these devices being conceived of as tools built in a certain way to accommodate those principles. These devices and software platforms' sole purpose is to facilitate production of film via location sound recording principles that are unchanged regardless of what you use. It's about learning universal principles of filmmaking *via* specific devices and software – they are there to serve the universal principles only. Devices and software will change; principles of sound in filmmaking won't.

So, for location recording there are a few primary devices involved:

1. the device that gets the sound into the device that records the sound – this could be a camera microphone or a Røde NTG2, or a wireless radio microphone like a Sony UW PD 11s
2. an external recorder or the device that records the sound – such as a Zoom H4n, an iPhone, a camera like a C100 or any DSLR (digital single lens reflex)
3. headphones (and a splitter or multichannel headphone amp) so the sound crew can monitor sound as well as the director while filming – this is imperative
4. cables
5. optional: an intermediate device like an analog mixer (e.g., Azden FMX 42a).

There is other gear involved like boom poles, windscreens, etc., but right now I'm concerned with the foundational devices and methods that actually record the sound onto a file for editing.

Different location sound recording configurations

This section describes different sound recording configurations you might use when shooting your film.

1. *Auto level/manual level camera microphone.* This set-up allows you to capture usable ambience, sometimes a little PFX (production sound effects), and good reference sound. But to achieve any usable location dialogue via an onboard camera microphone, it had better be a good onboard camera microphone. If you are shooting in close quarters such as a bathroom and your actors speak loudly you might get away with some usable dialogue, but run tests. In general, don't count on onboard camera sound, use a shotgun instead *mounted* onto the camera. The advantage of this set-up is that no sound crew is required. The disadvantage is inferior sound unless you're close to the actor, and even then it's not that good. If you're shooting a line and you want to replace it later with Automated Dialogue Replacement (ADR) it could work. Manual level with this configuration is the same thing except you can control the levels.

TECH TALK – Auto vs. manual leveling

"Auto level" sets recording levels based on an average of *all* sound coming into the microphone. It automatically adjusts to whatever sound it's hearing but doesn't try and differentiate dialogue from background noise. It's for reference recording, that is, recording sound as a reference for ADR and for synchronization. Auto leveling is identical to "auto exposure" when shooting video. An interesting experiment is to test shoot in your desired location using an onboard camera microphone and auto leveling to see if you can glean information about location sound. You might learn a lot about ambient noise, responsiveness of your environment with regard to sound, and the quality and limitations of your actors' speaking voices in that location.

2. *External microphone recording directly into camera using camera's preamps.* Location recording microphones tend to be *condenser* microphones; this means they need phantom power to work, which makes them very sensitive and hence ideal for recording location dialogue. But they need to be powered. Powering can come from batteries in the microphone, the actual recorders, portable mixers, or preamps that some cameras themselves have.

 This is a better way of recording location sound and usually means you'll be using manual leveling – you can adjust the gain up and down depending on the needs of the scene. You won't, however, be able to finesse these levels much; this method is often used in documentary interviews where the level of the interviewee speaking will stay constant so you can set it and forget it.

The advantage of this method – and anytime you record sound onto the camera – is that you have instant synchronization between sound and picture and won't have to sync it up in postproduction. The disadvantage is that the boom is "tethered" to the camera, usually via a cable, and it can be cumbersome. And, as I mentioned, it's hard to adjust levels which is crucial in narrative filmmaking. Also, you're relying on the camera's preamps to power the microphone, which is an added drain on the camera battery, and camera preamps tend not to sound as good as stand-alone sound mixing devices and recorders.

A variation is that you record with the external microphone on one channel of the stereo and the camera microphone on the other side, which will give you a different aural take on ambient noise.

3. *External preamp (DSLR) mixer attached to camera with external mic(s) recording directly into the camera.* This is mostly a set-up for a single person crew, maybe for documentary, interviews, or ENG (electronic news gathering).

4. *External mixer with a boom controlled by sound recordist connected to the camera via unity gain (see below) so the sound mixer records and monitors the levels.*

5. *Connecting an external mixer to a camera to control levels is a great way to "run and gun" set-up, especially if you have a separate sound recordist to control levels.* (This configuration using unity gain is explained below.)

GEARHEAD ALERT – A breakaway cable is used often in ENG but it can work well for narrative filmmaking too. The cable facilitates the connection of an external mixer directly into a camera's external line return (XLR) inputs and can also connect a "send" to feed the camera sound postproduction record into the mixer for monitoring. It can send time code that can be recorded separately onto an external recorder. The advantage lies in is name – it gives you the ability to disconnect or "breakaway" with only one special cable to connect/reconnect. It's like a "docking station" for your cabling connections when you are connecting an external mixer to a camera. This is very helpful when a filmmaker wants to go fast and be untethered, the ultimate "run and gun" filmmaking style.

Unity gain to connect a mixer to a camera

The trick in setting up an external mixer to record levels on your camera is to deploy a technique called "unity gain." Unity gain means inputs on your connected devices start at 0, so they aren't adding or subtracting amplitude from an incoming signal. The term is also used when establishing the balance between pieces of audio equipment so as to have an external mixer control and monitor location sound recording onto a camera without having to touch the dials on the camera once they are set.

The idea is that input of the mixer should equal output to the camera in regard to level, in a way that makes it easy for you to monitor. When sound goes into a device at one level and comes out of that device at the same level, it is

said to be at unity gain. Unity gain makes sure that no piece of gear in the chain has a greater influence on the overall signal that is recorded than any other.

The first step in establishing unity gain is to connect the XLR output of the mixer into the input of the camera. If your camera doesn't have XLR output, you can still do this, but you want a balanced input for best results. The next thing you do is zero out everything including your mixer. Your mixer will need to have a 1 kHz (1,000 Hz) tone generator. This will be the reference to set up the camera with. On the Azden mixer, it comes in around –6. Your mixer might come in higher or lower or the same, but you must learn the specs of your specific mixer and where it puts the 1 kHz tone (it's usually at unity: 0).

Since the Azden is an analog mixer, I move the master output so the meters hover around zero. I press the tone generator button and the mixer sends the tone through the camera. In short, analog VU (volume unit) meters are different in that, unlike digital meters, there is some flexibility in the red. They aren't peak meters, and you have to get used to using them.

The trick is, you'll want to leave some digital headroom above because while in analog clipping isn't the end of the world, in digital sound it can be. So the first question you have to ask yourself is this: What do I want "zero" on the camera to be? The standard answer is sometimes touted to be –12, or you'll hear people say "zero is –12." What they actually mean is that beyond zero you can get distortion. So we tend to think of a number *lower than* zero as the place we want to keep below so we'll have plenty of headroom. Headroom simply means there is breathing space in the levels, that if sound suddenly gets louder it has somewhere to go without distorting.

I have typically set unity to be around –8. The reason for this is at this level I can ride the gain (or adjust the levels) in accordance with how soft or loud the actors are speaking without fear of peaking if they suddenly get very loud. Starting at –8 there's room for error. I can ride the gain hot without peaking. One reason I choose so much headroom is because VU meters don't respond as quickly (and are more user friendly), so I have to factor this in when feeding and reading an analog Azden signal to the digital C100 meters through unity gain. There's also a great workaround to understanding your gear: *shoot your meters and play back the results in your digital editing workstation for comparison.*

If you're not 100 percent sure whether what your meters are showing will translate into the meters on your editing system after you've *calibrated* your mixer into camera set-up, my solution is to "shoot your meters." What I mean by this is connect your camera to an external monitor, set it up so the meters are displayed, and film your meters in action. Then, when you load up this test into your editing application, you'll have a real-time demonstration of how the camera metering system translates to an editing application (see Figure 5.1).

This will help you understand how unity gain between connecting a mixer to the camera works. You can shoot your meters using an iPhone or a DSLR. You can use an external monitor and shoot right at the screen then play it back and decode how your meters work.

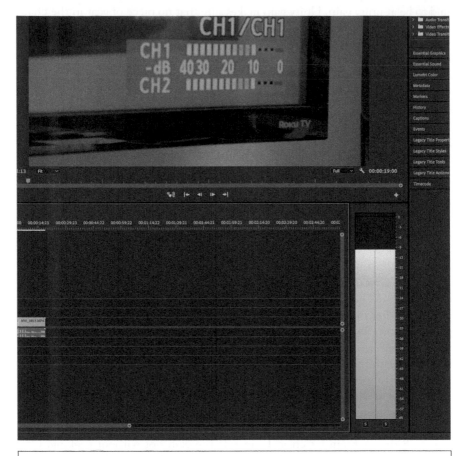

Typically, camera sound recording monitoring features can be a little hard to read. So if you're going to be relying on your camera for your main sound recording device and plan on setting up an external mixer using unity gain, do a little testing and "shoot your meters." In other words, connect your mixer into your camera and start filming with sound. Then, play back the clip in your editing application and you can see how the sound levels on the camera's sound monitoring screen, when shooting, translates into the levels of an editing application

Figure 5.1 Shoot your camera meter and play back through your editing application.

I tested with my C100 using an external mixer to preamp the microphones and get the sound into the camera, thus turning the camera into a "sound recorder." I used the Azden mixer and its preamps, bypassing the sound processing of the C100 preamps. The Azden adds a little noise, but it gives analog warmth to the digital recording, not to mention the capability to control the mix without touching the camera.

The "warmth" the analog Azden mixer adds is subtle but, again, this shows that it's not a bad exercise to start training your ears to hearing such differences

in how various devices record sound. But, more importantly than just adding a little bit of warmth, is the fact that it gives you control over mixing the sound without ever having to go back and touch the inputs on the camera. In fact, the C100 cuts off control via the camera input dials when you select "EXT INPUT." Many professional video cameras work this way. If yours doesn't, you'll need to dial up the unity gain you're seeking using the camera's input dials and then tape them shut so they won't change. (When taping dials and nobs on devices, be careful: doing this can gunk them up and make them stick or not work properly!)

What my test initially yielded for me was that it's observationally hard to know exactly what I'm getting with the C100 meters because the actual metering space on many camera flip screen monitors is small and looks very compressed to the eye – there's not much capacity to finetune it as the screen is small and hard to read.

Camera meters are designed for *passive recording* while we need to be riding levels *actively* to get usable dialogue. As pictured in Figure 5.2, the VU meter of the Azden reads around 0 which I then interpret as –10 on the C100 meter (remember, I set digital zero on the camera's meter to be –9 for headroom). But when I look at this on the monitor I shot it on and upload it to Premiere Pro (or any editing workstation of your choice) the meter is telling me that this is interpreted as –11. In other words, I have a little more room to pump up the headroom. I did so by adding a little more gain out of the Azden, which took my meters on the C100 up to what looks like –6 and gave me around –8 with some room to spare, a good level for recording.

Variation of configuration with one or two radio microphones

This configuration is when you opt for radio microphones directly into the camera. It's similar to booming into a camera but it's equally hard to set and adjust levels. You get more than one microphone recording but a cameraman has to control levels while shooting.

Auto onboard microphone from an iPhone (or any video phone), iPad, computer etc.

To use the microphone on a smart phone or iPad, computer, etc., the same rules apply as when using a camera microphone; you have to get it close to the actor's mouth and usually you are stuck with using automatic leveling. Nothing beats it for run and gun – we caught all the behind the scenes footage for *Turn Back Night* with an iPhone. But don't expect broadcast quality from an onboard phone microphone. A variation of this configuration is to shoot with a video phone using an *external* boom or radio microphone. For documentary you might get away with recording sound on the phone; for narrative filmmaking, you'll want an external recorder.

1

For those who wish to record sound on the camera with the video, there is a professional way to do so via an external mixer. You set up both devices to be connected via "unity gain" which means that whatever you're reading on the mixer matches what you're reading on the camera. I give myself a little extra headroom in the camera because it's a digital recording device and I want to avoid peaking and distortion at all costs.

2

1. The mixer has a button which generates a "1 kHz" tone that comes out of the device's outputs. Then you use your master dial to set 0 on the mixer as "unity" for your reference point.
2. This signal is then outputted to the camera you wish to record your sound on, and you then set 0 on the camera. You can set 0 on the camera to be whatever you want it to be, but it should be close to actual 0. In my case, I make 0 to be around −6 which gives me ample headroom. Once you've done this, you can set and forget the levels on your camera. On my C100 I bring the inputs halfway up to 5, which is close to what my master out of the mixer is.

Figure 5.2 How to set up unity gain between an external mixer and a camera.

Double system

Double system is when you use an external recorder to record sound separate from the picture, and it will all be synchronized later with video through an editing application. You can get good sound from low-cost external recorders but in some cases the preamps aren't great. The advantage of double system is

that the sound recordist isn't tethered to the camera. On independent films, the boom operator often also "mixes," but it's two jobs rolled in one.

TECH TALK – *Tangerine* is a great film shot on an iPhone 7 but the sound was recorded on a separate device using high quality microphones, a double system shoot.

 When possible, shoot double system because it affords greater control of recording levels.

Here are a few double system set-ups:

- *Boom into an external recorder.* You can either use just a boom or a boom and radio microphones or just radio microphones into an external recorder. If you only have stereo on your recorder and are forced to mix a boom and, say, two radio microphones, you can keep the boom on the left side and the two radio microphones mixed together on the right side.
- *Boom and radio microphones into an external recorder.* Mixing multiple radio microphones to a single track means that if there's a problem with one radio microphone (noise, clothes rustling) it will ruin the other one – but presumably you'll have a clean boom to cover yourself. This is all the more reason to choose a recorder with more than two isolated channels or tracks to capture each radio microphone on its own in addition to a boom.
- *Just radio microphones into an external recorder.* Using radio microphones into an external recorder is a great way to go if you're running and gunning and with wide shots where you can't get a boom near the actors. If there are only two actors and each has their radio microphone you can send them left and right so you'll have separation of the different channels. The camera can then capture great ambience.

6 Train your ears ... learn your gear

Test your devices all the way through to your final intended output

Watching sound mixer Chris Esterguard on my *Turn Back Night* set was enlightening because he wasn't trusting his ears or his equipment; he was using both at once with a specific mindset: maximizing signal to noise ratio *without* peaking and maintaining the best levels for every set-up and take. But his skill comes from experience and understanding how to use recording devices correctly.

In this technical chapter we'll delve into some ways to test gear and learn aspects of what Digital Audio Workstations (DAWs) can do. This needs to be done in a way that will help our ears to improve. Knowing how to listen to sound on a set is not intuitive, and the steps I want to show you will help train your ears as to what quality of sound is needed to record properly on location in order to get through a final mix with great results.

> TECH TALK – A cinematographer told me that before making a film he test shot as much as he could and reviewed the results all the way through to the *end of the production and postproduction process*. In terms of sound, this would today translate to recording sound and test listening to it on a computer, an iPad, a home theater, or in some sort of larger retail theatrical environment if one is available.

These tests are very preliminary and basic, designed for you to customize them and apply them to your own location recording scenarios and gear packages. I'm going to help you:

1. Get the most out of your gear, learn to record great sound, and satisfy your location sound goals. To do this, I want you to experiment, drive your meters and see how they respond, especially after you bring your location recording tests back to your DAW and analyze the results.
2. Test the sound conditions of your various locations, how reflective the interiors are, what ambient noise is present, how ambient noise interacts with the environments and actor voices, etc.
3. Learn more about what location sound recording is supposed to achieve by getting a glimpse into high-end postproduction sound technology and

processes. This can help you foster an appreciation of why it's important to achieve a certain quality of sound recording on location and what good location sound is – which isn't intuitive.

To begin the test experiment, I want you to take whatever gear you have, and test drive the meters; test the "noise floor" of the equipment and the device's frequency response rate, and how it responds to pushing record levels to the top levels of the meters. The noise floor means that all recording equipment generates a little bit of "machine noise" that is usually inaudible once sound is recorded, but if nothing is recorded you'll hear it. Frequency response rate is simply how much information in respect of frequency your equipment can record.

You're not necessarily going to record near peak, but you certainly need to understand the responsiveness of various kinds of gear. A Zoom H4N recorder is going to have a different kind of response than a digital single lens reflex camera (DSLR) in terms of recording sound, as will a $7000 Sound Devices recorder.

This is not to say these tests will cause you to stop using the gear you have, but it might help to train your ear and filmmaker brain to understand what sound quality the gear is capable of and how to prepare for shoots given your limitations. Remember it's about the filmmaker, not the gear.

These are the basic pieces of gear I'm going to test for now:

1. an Azden mixer with analog style volume unit (VU) meters
2. a C100 mark II camera
3. a Røde NTG2 microphone
4. a Røde NT1A booth mic connected to a Scarlett 2i2 external sound card.[1]

Creating a ground recording for comparison

I'm going to record a line of dialogue in the cleanest environment as a baseline ground. I'm going to use a Sennheiser cardioid microphone in a treated room, then a Røde NTG2 for recording into the location sound devices. These few basic tests should give you an idea of how to test anything before you shoot.

Basic tests

Sample #1 – Baseline recording directly into computer

Booth microphone condenser mic, cardiod NT1
Recorded into Logic Pro X at unity gain
Input from the Scarlett (see GEARHEAD ALERT box below) was about 50 percent up (5) on the dial.

Mic levels were at yellow red, where we want them.

To start with I'm going to record a single line of dialogue in a treated room: "Testing one two one two. Testing one two one two. I can't think of anything else to say except testing one two."

GEARHEAD ALERT –The clip I recorded was right into a computer via a Focusrite Scarlett 2i2, an external sound card that is very reasonably priced. An external sound card is indispensable to anyone planning to do sound postproduction work. The sound capture quality of an external sound card is superior to plugging directly into a computer and you'll get more accurate playback through good speakers.

Play sample #1
www.michaeltierno.com/link-1-1

My voice is captured with a tiny bit of machine noise. It's clean, there's no reflection of the room and the sound is rich in information, containing a wealth of human voice frequencies that can transmit emotions. Remember, the more frequency information available via dialogue tracks, the more emotion an actor conveys. It's that simple. The actress in *Turn Back Night*, Holly Anne Williams, has a wonderful voice and I'm glad I had a good sound crew recording it in all its rich splendor. I'm dialogue driven, so the quality of an actor's voice is as important to me as any other element.

I'm now going to take the sound I captured and run it through RMS (Root Mean Square) Normalization. First, I'll give a quick primer on general normalization which will lead into RMS Normalization. Normalization is a useful concept to understand and can come in handy during the postproduction workflow.

Normalization

Normalization is the application of a constant amount of gain to a sound recording, bringing amplitude of the signal to a *target level*. Because an equal amount of gain is applied to the entire recording, the signal-to-noise ratio and dynamics are unchanged. Usually, this is done by setting a ceiling, say −6 or −3, so that the signal can't go over those peaks when raised up to prevent overall peaking. Normalization is a useful tool at various stages of production and postproduction. It can be deployed to temporarily raise amplitude of production sound for editing without peaking, or it can be used at the end of the postproduction process when you are outputting final distribution assets to help raise a mix to the right levels for different distribution venues such as streaming, broadcast, and theatrical.

That said, it's important to remember that if you bring signal up, you'll bring noise up as well, and this is partly what we're interested in analyzing when using such processes to test our sound, gear, and recording environments. In other words, I am going to utilize advanced normalization to test and learn about gear,

recording environments, and how this all feeds into your preproduction and postproduction processes. By delving into these technical experiments you'll learn to appreciate the "smart/dumb" aspects of recording devices and train your ear's sensitivity as to how they handle sound. Also, these tests will help you get under the hood of your equipment. To do this, I'm going to use something called *RMS Normalization*.

RMS Normalization

RMS Normalization involves processing a sound file and analyzing all peak values; this is then used to create an *average* peak reference which acts as the anchor for the RMS normalizing value. In summary, RMS is an average peak not *overall* peak. It is used for mastering sound levels for distribution, but it can provide interesting windows into our own gear and how it behaves in various scenarios and environments, especially how much we can push the meters, etc.

Using RMS as a process to test devices can be useful even if it's just a learning exercise to train your ears. It can help reveal limitations of gear including what "machine noise" is present in recording equipment, how devices deal with signal-to-noise ratios and what to watch out for when recording human speech (dialogue) in various environments and scenarios. RMS Normalization helps in applying a process that will help neutralize the differences between the various devices while emphasizing their individual strengths and weaknesses.

To run RMS Normalization tests, my DAW Adobe Audition accesses it through Match Loudness.

SOFTWARE/GEAR AGNOSTIC – Sometimes I use terms and/or images from specific software like my current DAW (Adobe Audition CC 2019). That said, all of the principles and tests discussed in this book are available on any professional DAW such as Pro Tools.

The goal here isn't to train you to be a sound engineer; it's to make you think about how your machines generate sound and how to get under the hood of making them work the best for you.

Sample #2 – Booth test after RMS normalization

MATCH TO: PEAK –18

Play sample #2
www.michaeltierno.com/link-2

Using RMS Normalization, your DAW is going to scan the sound file for multiple peaks and use an average of all the peaks to bring up sound file so its volume is raised evenly. This affects machine noise, not to mention how much you can push the meters when you record. You can experiment with target loudness between −24 and −18 but make sure you don't generate any distortion or peaking. If you listen to sample #2, you'll notice that it's still a pretty clean signal and little to no noise has been accentuated by processing it using RMS Normalization. You can also tell that the noise level indicated by the flatline is very small, in fact, negligible. This is good sound and what we want to achieve when are booming; great signal-to-noise ratio and clean, unadulterated frequencies of the human voice.

On this first baseline clip there is a little bit of noise in the room (air conditioning) that hovered around −42 but nothing to worry about; I have a lot of signal-to-noise ratio but this RMS Normalization test showed that creating clean, usable dialogue tracks is not going to be a problem.

Sample #3 – Røde NTG2 plugged directly into a C100 mark II using the C100's preamps

Play sample #3
www.michaeltierno.com/link-3

My next test is putting the NTG2 microphone directly into the Canon C100 mark II. I used the preamps on the camera to power the condenser microphone and took the signal and processed it using RMS Normalization through my DAW Adobe Audition with a target peak of −18. Remember, RMS Normalization is an elaborate way of raising the amplitude using all peaks within the file, averaging them, and bringing up the file in a uniform way.

I raised the input level so that the voice was hitting around −9 which meant about 50 percent input on the C100's dial. For our baseline location sound recording in *Turn Back Night*, we used a quality shotgun microphone into a professional camera like a C100 mark II which, when properly deployed, can yield broadcast quality results but will work better with an external mixer. Of course, if you have a single person sound crew where one person booms and mixes it's hard to get as good a sound as you would with a two-person crew, but a single person sound crew must understand that they need to watch levels while booming. Or, at least, they should be aware of their levels at all times.

Sample #4 – Røde NTG2 plugged directly into camera after RMS normalization target − 18

Play sample #4
www.michaeltierno.com/link-4

I notice right away that while this is fairly clean (except for some air conditioning noise), the preamps are not capable of producing as bright a sound as the Focusrite Scarlett and computer in Logic Pro X were able to produce. This is not, however, a cause for alarm and if you need to shoot with a microphone like the NTG2 into a camera using its preamps there will be limitations but you can still get good sound. But rather than using your camera's preamps, the next thing you can try is to bypass those preamps and use an external mixer when recording directly into a camera.

Sample #5 – External Azden mixer used to preamp microphone and record onto a camera

Play sample #5
www.michaeltierno.com/link-4-1

This test shows an NTG2 microphone into an Azden mixer with phantom power from the Azden's preamps. I took the XLR out of this into the C100 (at line level). I controlled levels to about –9 by turning the sound coming from the Azden up about two-thirds on the dial. As mentioned earlier, this is one of my favorite run and gun methods of recording sound.

On the C100 mark II (our specimen camera) it's relatively simple to set up, as it probably is on most video cameras. DSLRs can be mixed via small, camera-mountable preamp mixer/recorders such as a Tascam DR-60D mkII 4-Input/4-Track Multi-Track Field Recorder. But to have a stand-alone mixer that a sound recordist can control without having his hands on the camera, you'll need a basic professional level camera.

Again, you might want to test out different variations of these levels along the chain and see what kind of gain staging works best with your configuration. Running your results through an RMS Normalization process will help you hear what is going on.

Summary of testing using analysis tools

This short chapter is just a brief introduction to testing gear and recorded dialogue. It's designed to expose you to some analytic tools available on all DAWs to help you test your sound recording devices and make decisions about how best to use them. Take some of your equipment and go into the field with actors, record some dialogue, bring it back into your DAW and run RMS Normalization tests. Test how far you can record near the peak levels, especially before and after you run normalization tests.

Figure 6.1 provides snapshots of the wave forms of various tests before and after RMS Normalization. While it's hard to tell anything by just looking at a static waveform, I'm including these here for a reason. You should learn to study sounds and waveforms of your tests and ask yourself:

1. What levels did I record at and what happened when I processed the sound via RMS Normalization –18. Did the machine noise raise significantly?
2. Which preamps in my chain of devices sound the best?
3. What is the difference between my supercardioid microphone and my indoor dialogue microphone (short-tube cardioid or hypercardioid) in terms of how it handles ambient noise, room reflections, etc.?
4. How much can I push the levels of my devices and, if I'm creating unity gain between a mixer and a camera to record sound onto, what is the precise best level of input to output?

Before RMS Normalization After RMS Normalization

When doing RMS normalization tests to learn more about your gear, it's important to see what RMS normalization does to your overall noise floor (the thin line in between the signal).

Recording with a Røde NTG2 directly into a Canon C100 camera *before* RMS Normalization.

Recording with a Røde NTG2 directly into a Canon C100 camera *after* RMS Normalization (target -18).

Doing this test of recording directly into the camera and listening to the results without RMS Normalization and then after RMS Normalization gives me a better understanding of the quality of the sound of the recording device (the camera in this case), and the noise floor of the camera/microphone combination. This kind of testing will help train your ears.

Figure 6.1 Gear recording tests using RMS Normalization.

Recording some test dialogue in the field is the best way to understand your gear's capabilities and shortfalls. Taking the sounds you record, using RMS Normalization in a DAW and then listening carefully to the results is a good way to process everything equally and do a side-by-side comparison. By doing such a technical analysis you'll hear things better regarding your devices, but you'll also understand what level a good, healthy signal should record at.

Note

1. Many sound recordists might prefer a short tubed hypercardioid microphone for indoors. I found the Røde NT5S to be a very reasonably priced cardioid and it sounded great for indoor dialogue, so I went with it.

7 Location sound recording

Preparing for the shoot

Preproduction for sound

In a low-budget film you might be stuck with a single prosumer microphone like a Røde NTG2. That's fine, it's a good universal shotgun microphone that can reject off-axis noise and be put into service for indoor dialogue. It's a condenser microphone which means it needs to be preamped, a feature which makes its sound pickup capabilities stronger. We know that not all preamps are equal; the Azden mixer's preamps are better than the C100's, the C100's are better than the Zoom's, the R44's are better than the Zoom's and the C100's but perhaps not as good as the Azden. You won't know until you test everything.

It's very important that you use the *best* preamps available on your device chain as you might have the option to choose to use either the ones on your camera, your recording device, or your mixer. You won't know until you test them all and you might be surprised at the results.

> TECH TALK – IMPEDENCE MISMATCH
>
> If you try to bring your microphone to line level and turn on the preamps on a mixer *and* on the camera you'll be overloading the signal or *overmodulating*. In essence, you are doubling the preamp process and it will generate sound that is distorted. Only use preamps from one part of the chain and turn off all the other ones. Also, be careful because preamps can drain battery power. Test everything to find out what is the optimal use or preamps in terms of power efficiency and sound quality. And don't leave preamps in the "on" position if there is no microphone plugged in. It can still drain power.

The NTG2 microphone uses a supercardioid pickup pattern which means sound is supposed to enter at the very top of the capsule, hence "shotgun." But reading about pickup patterns isn't going to help you very much if you don't grab the microphone and recording devices and practice! Don't just go by yourself; take a fellow filmmaker, a friend, your significant other, actors, or anyone who will talk and have them speak in your desired locations and see

if you can get a feeling for how the supercardioid shotgun pattern micro-phone records sound *and* rejects noise when you use it right. Practice doing this in all your potential locations; record some of the tests and run them through RMS Normalization for extra analysis and to develop ear sensitivity to how your devices respond to recording scenarios.

The next thing you're going to need is a good boom pole and a few XLR (external line return) cables. Or, if you can afford it, a wireless boom micro-phone connector. We used one on *Turn Back Night* and we never had to worry about boom cables or a utility person to help the sound crew. There are many kinds of boom poles; I prefer the ones where the cabling runs through to the bottom and you just connect the XLR in. These devices, which are good enough to connect flawlessly from boom pool to mixer, aren't cheap but great if you can afford to buy or rent one.

You'll need a couple of other accessories: first, a blimp kit for wind. The physics of a blimp is simple and fascinating. The simplest way of explaining it is that the microphone floats in a fabric-lined plastic casing. This causes any wind to hit the casing first and it is deflected *away* from the microphone, so minimizing the damage it might do to your recording by adding wind noise. You'll also need a dead cat – a fuzzy fur that fits over the microphone and a blimp, a cylinder that covers the microphone. Both absorb the wind; the blimp is a little more aggressive in blocking the wind, while the dead cat is easier to throw on. You can even combine them but make sure you test every-thing so you're not caught off guard.

Then you'll need a device to record onto, like a Zoom H4N PRO, a Roland R44, or you can record directly into the camera. Digital single lens reflex cameras (DSLRs) usually need a converter (or preamp) to convert the XLR from the microphone cable to the mini-pin jack that these cameras provide. This is not ideal, but remember, test everything so you know what you're getting into and understand the limitations of your gear.

So now you have your basic package. You'll need recording media, usually SD (secure digital) cards. Some recorders record directly to their own hard drives as well. Regardless of how your recorder works you must....

Learn the file structure of your recorder

Digital files are small in comparison to how big and cumbersome analog tapes used to be. We have so much power at our fingertips now. But devices can be tricky to use because there are so many different functions that it can be hard to learn where everything is. So, here are some basic guidelines for maximizing your digital recording device:

1. Always set date and time stamp correctly, to the second if you can. This is the first line of defense for being organized and keeping basic "time code." I've seen many students who have not time/date stamped their media and lost it because of this.

2. Format your card on the machine you record on. This sounds obvious but I've seen students who have not done this and it can cause problems in postproduction. If you pop an SD into a Zoom recorder that was formatted on a Canon T7i it might work – but it might not. That's asking for trouble. Use one kind of formatting per card. In fact, segregate your cards for the various devices you use them for and keep them dedicated to their respective devices.

3. When your battery light starts to blink and it's near the end of the charge finish the take you are shooting and then immediately change the batteries. Don't try and squeeze out a few more takes before lunch before changing the batteries. I have watched my professional sound guys; they changed batteries soon after they received power alerts. Some digital recorders will let you record with weak batteries, and then when it's time to finish off the file and close it out, if there's no juice left the file may not close properly and you could lose access to the media of the last take. And if you're recording all your takes in a single strand you can lose the whole file. It's happened to me. No matter what you think about how your recorder responds to battery warnings, as a rule *the take you are on when the low battery light flashes will be the last one until you change batteries.*

FOSSIL RECORD – Old analog recorders like Nagras worked differently than today's digital recorders. If it was running and on "record," you knew you were recording at 24 fps (frames per second) because sound printed automatically onto tape as it recorded. But if its batteries were weak and the Nagra couldn't sustain perfect sync speed, it would stop. In retrospect, it now seems somewhat primitive but it was state of the art back then and very reliable.

4. Be careful about using the recorder preamps. Take, for example, those available on the Zoom H4N or the Roland R44. The R44 has good battery life if its only job is to record and *not* power condenser microphones. If you power the boom off the R44's preamps this drains the battery life faster. But if you try and power up a boom *and* a few radio microphones you'll kill the batteries quickly. In general, if you can have something other than your recorder providing preamp power – like a mixer or a mini preamp (provided it's a better sounding preamp then your recorder) – you'll be doing yourself and your production a big favor.

File structure of digital recorders/preproduction/scene numbering

I came away from my *Turn Back Night* shoot with new knowledge, not only of the importance of labeling everything, but of the industry standard of labeling shots. The sound department usually make sure everyone is using proper shot

and file-naming conventions, and there's no reason why you shouldn't engage in these standard practices yourself. We'll take a look at the file structure of a Zoom H4N (see SOFTWARE/GEAR AGNOSTIC box below). By understanding this specific set-up, you'll be able to extrapolate this information and technique and apply it to *any* digital recorder.

SOFTWARE/GEAR AGNOSTIC – There are dozens of affordable recording devices on the market and they all work in pretty much the same way. It doesn't matter about the specifics of what I use because the principles of any cheap recording device will transfer to any other one. So view my software gear specifics as "case studies" that then need to be applied to whatever gear package/software you find yourself using.

The Zoom H4N Pro can give you a lot of different configurations to record in, such as mono into stereo and left/right separate channel recording. It can record four channels by pulling two from the onboard mics and using the mini-pin use to access channels three and four (but not with balanced inputs).

But when the files are transferred to a computer, you'll see the file structure can either make separate folders containing various files or one folder with a long file containing *all* the sound clips. This variance depends on whether you start or stop the recorder completely or just pause between takes. When they see how the files are structured, most people scratch their heads and eventually find their sound. But why not use the file structure in the way it was intended. Any digital recorder is going to have its unique file structure and it behoves you and your production team to learn yours and use it correctly. The Zoom H4N has a very unique file structure that you need to familiarize yourself with if you're going to use it, as you would with any recorder. Whatever recording device you decide to go with, you should learn it and master it.

Preproduction creation of file structure

Okay, so this is going to seem insanely fussy and a lot of work up front when all you want to do is shoot your movie. While it's great to have the passion and energy to shoot, you'll need to get the shoot through to the finish, and finishing a film is mainly about editing – being organized on the set contributes greatly to organization in the editing room.

So, as part of your preproduction you'll need a few things:

1. A lined shooting script with shots labeled correctly.
2. A shot list (more aptly named a "set-up" list: when I write a lined script, I'm writing out my set-ups. I don't know how many shots each set-up will turn into. So it's more apt to call your shot list your "set-up" list).
3. A shooting schedule.

These preproduction and production methods are the basic tools for being organized that everyone, including whoever is doing sound, should deploy. It takes a little bit more time to label things on the set, but it is so worth it when you get into postproduction. Figure 7.1 (top) shows the default file structure of a Zoom H4N, and the same files manipulated to match the naming conventions of professional film shoots (bottom).

Industry standard lined script/file structure

There is a standard way of making a lined script and calling shots ("set-ups") that everybody in the industry uses. The first set up is named *after* the scene number. Every subsequent take is take 2, 3, 4. In other words if you're shooting the first setup of scene 8 it's scene 8 take 1. Then scene 8 take 2, scene 8 take 3, and so on. The next set up moves to letters – scene 8A take 1, 2, 3, etc. Your preproduction lined script should reflect this file structure.

The first shot of the numbered scene is named after the scene number. For example, in the scene in Figure 7.2 (scene 3), the first set up is scene 3 take 1.

File names customized easily via the menu to match shot names

Here are two examples of folders generated by a Zoom H4N Pro, a typical affordable digital recorder. The top section represents "the wrong way" to label your sound. The bottom section is the "correct way." In other words, the recorder (and any digital recorder) can be set up to have different folders corresponding to different scenes before you get to the set or while the scene is being set up. Then, each individual file can be named after different shots to correspond to the shooting that day. The key is to get this in place at the start; you'll be more organized in editing and it will help keep you from losing sound files.

Figure 7.1 Default file structure of a Zoom H4N recorder.

Then all subsequent takes will be named scene 3 take 2, scene 3 take 3, so on. The next setup is 3A take 1, scene 3A take 2, etc.

In a lot of low-budget shoot without a lot of crew to keep you organized it often falls to the sound mixer to do basic organization and provide the slate, the lettering system, and maintain the correct labeling of your files. This can translate into good organizational practices throughout the entire postproduction process. As the filmmaker on a low-budget shoot you can help set up a filing system to follow this structure, but it starts with the way the shooting/lined

Figure 7.2 Lined script with correct shot number and lettering system.

Table 7.1 A professional location sound report

190714_REPORT
SOUND REPORT

Date:	7/14/19
File type (CF):	B-WAV Poly
File type (SD):	B-WAV Poly
Sample rate:	48kHz
Frame rate:	23.98
Bit depth:	24-bit
Tone level:	0 dBu

File name	Scene	Take	Length	Start TC	Track 1	Track 2	Track 3	Track 4	Track 5	Track 6	Notes
3T02.WAV	3	2	0:01:06	12:05:28:00	MixL	MixR	Boom				
3T01.WAV	3	1	0:01:45	12:01:49:00	MixL	MixR	Boom	Lisa 600	Clay		
3T03.WAV	3	3	0:01:43	12:07:11:00	MixL	MixR	Boom				
3T04.WAV	3	4	0:01:52	12:11:25:00	MixL	MixR	Boom				
3T05.WAV	3	5	0:01:37	12:15:08:00	MixL	MixR	Boom				No lavs

script is broken down. If you keep this in mind when you're creating your final shooting script it will help you all the way through to editing.

It is the procedure to follow when you plan and call shots, slate a shot on set, and name your sound files. This practice should be maintained regardless of what digital recorder you're using or how small your sound crew is. If you're recording sound single system right onto the camera, you can still slate this way and then rename the files later for postproduction efficiency.

So now that you have your filing structure set up, I want to show you a sound report from my sound crew. It's obviously one that is generated by a higher end sound recording device, but at least you can see what kind of information is captured on location and possibly use this insight to create the kind of records for sound you might need on your location.

Basic information contained in the report

A typical sound report will contain the following information:

- **Date:** Always date everything. The day also flashes on the slate when it's closed as a further organizational element. Get out of the habit of not setting dates and times on recording machines – it's unprofessional and you will regret it later.
- **File type (CF) B-WAV poly:** This is the CF (compact flash) card that records the data onto a B-WAV file. A B-Wav is a Broadcast Wav file that has embedded metadata in it, most importantly time code information that you will use to sync.
- **File type (SD) B-WAV poly:** This is the same as the cf. card. A possible workflow would be to keep the cf. card on board and then use the SD card to save and/or back up.
- **Sample rate:** 48 kHz (see "FOSSIL RECORD – 48 kHz" box below).
- **Tone level:** 0dbu. In a digital audio system, 0dBFS refers to the maximum signal level possible, also known as the clipping point. Therefore, dBFS values are always less than or equal to zero. −10 dBFS corresponds to a signal that is 10 dB (decibels) lower than the clipping point of the system.

FOSSIL RECORD – 48 kHz (kilohertz)

While the industry standard for sound for film and TV is 48 kHz, for music it is 44.1 kHz. The film/TV spec was changed specifically so that they would have their own standard distinct from music. There are a few minor technical reasons why 48 kHz might be a little better, but nothing that is that pronounced. If you use effects or music recorded in 44.1 kHz, make sure you convert it to 48 kHz *before* you deliver it to your editor or before you set up to edit.

- **Frame rate:** 23.98. Industry standard frame rate for narrative film is "24P," which is what cinema has always been shot in with analog film. This became

the standard 23.98P (23.976) which has been synonymous with 24P (basically the same thing in terms of how it matches the look of film). But when we first started shooting video, it ran at 30fps. So, translating it involved an elaborate "pull down" conversion – hence, the odd numbers. Actual 24P is now used too. Make sure you (or your sound person) and the cinematographer are in sync about this in terms of your video and sound capture frame rates. They must be exactly the same, and this is usually set by the camera department. As a low-budget filmmaker, make sure the cinematography and sound departments talk to each other and are in sync.

FOSSIL RECORD – I stated in Chapter 1 that when films were shot in analog and sound was recorded onto a little ¼ magnetic tape via a Nagra the tape had to be "resolved" to 24 P before it could be edited. This means it had to be *converted* to 24fps so it would match the film when editing. This process is now automatic, but make sure you "resolve" what frame rate you're using *before* you shoot and that everybody – namely, the camera and sound crew – is in sync. You don't have to worry about resolving sound to picture but you do have to get it right up front to avoid postproduction problems.

• **Bit depth:** 24bit. This refers to how much information the sound file you're recording contains, the sort of "resolution" of the sound. Sound files for location recording can either be 16bit or 24bit, or even higher. For our purposes, either one works; 24bit is more information and higher quality but requires a little more storage. It's a good idea to have this and all the other frame rate information written on the slate as a reference. There have been a few times when editing when I said to myself, "Am I sure these frame rates match what was intended?" Checking the slate reassured me that they did.

Mixer's notes

The sound crew should be provided with the "sides" (the pages of the script that are being shot) for the day and the camera set-up list (or shot list as it's wrongly called). This way, they will be able to begin to structure their files and labeling strategy based on this basic information about what is to happen on the set.

On the day's sides they'll see which characters are in the scene, which are speaking, and what the conversation is going to be like. This will tell them who to "mic up" or connect radio microphones to.

Remember, in their overall channel mix, the sound crew will try to keep the same characters on the same tracks. They should also keep the internal *mixdown* of all the sounds onto stereo tracks one and two, and the boom and isolated radio microphones (individual character mics) on the same tracks as well. It's a basic strategy and might provide for more information than you have time to make on your set, but it's great organization if you're doing more than just a single boom recording on location.

Here's a summary of your channel structure when recording:

1. If you have a mix down of all your channels into a stereo mix, make these the first two channels on your mix.
2. Keep the boom in the same channel at all times.
3. Keep the radio microphones on the same channels.
4. Try to keep the same character radio microphones on the same channel, at least for scene and day, and ideally throughout the shoot.

Taking this care in how you set up the sound recording will go a long way in organization that will save you time in the edit. If your sound recordist has the chance to not only label things but to make a note or two when something goes wrong, that is ideal. Again, all this is doable even on no-to-low-budget sets. So we're sticking to our Røde NTG2 microphone, we have our cables, dead cats, blimps, and extra batteries. What's next on the list?

Set treatments

Remember the booth sound we created – the baseline sample sound quality we're always chasing with location sound. Set treatments are designed to get you closer to this ideal recording condition. And this will only happen if you plan for it in preproduction. This includes scoping out your locations and preparing to have materials on hand that can help make the environments you're recording in sound better.

In independent film, we tend to shoot in real spaces because they are usually free. But along with real spaces comes hard surfaces like floors, walls, and ceilings, which make voice sounds bounce around and add additional frequencies that get recorded with the pure voice sound, so diminishing the overall quality of your recordings. Remember, the purer the sound of the human voice you capture on set, the more information there is to work with in the final mix and the more emotion can be conveyed. Figure 7.3 shows basic set treatments using sound blankets to dampen reflections.

Set treatments created to counter the sound reflection effect can be deployed by simply dropping a sound blanket on the floor to curb reflections, or there can be a more elaborate treatment of the space, such as hanging a sound blanket off C-Stands to create soft reflection barriers to help encapsulate the sound. It's similar to the way recording studios put up gobos around, say, an instrumentalist to help isolate them.

We didn't use any set treatments in my film *Turn Back Night*; I suspect we might have been moving a little too fast to slow down and try to alter the environments. However, we did use some basic measures to create the booth-like experience that caused the cast and crew to suffer. Despite the fact that we were filming in the middle of July during a heat wave we:

- shut the windows
- turned off the refrigerator

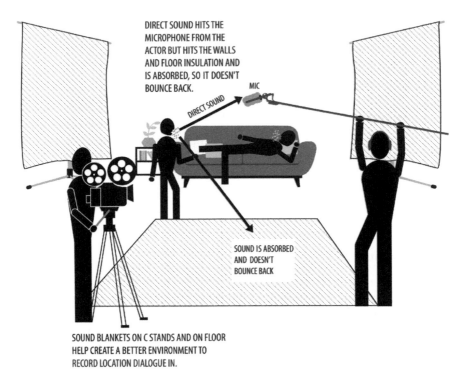

DIRECT SOUND HITS THE MICROPHONE FROM THE ACTOR BUT HITS THE WALLS AND FLOOR INSULATION AND IS ABSORBED, SO IT DOESN'T BOUNCE BACK.

MIC

DIRECT SOUND

SOUND IS ABSORBED AND DOESN'T BOUNCE BACK

SOUND BLANKETS ON C STANDS AND ON FLOOR HELP CREATE A BETTER ENVIRONMENT TO RECORD LOCATION DIALOGUE IN.

Figure 7.3 Set treatments for indoor location recording.

- shut the air conditioning when we rolled (though we always turned it on between takes).

All of this created a challenging environment in terms of human comfort. At times, we were pretty sweaty! But this extra attention to set treatment worked: we got great usable sound.

Another key set "treatment" was that our lead actress wore pads on her boots on the wooden floor because, when she walked, the clonking on the floor occasional covered a line of dialogue and could have potentially ruined it.

Thankfully, the apartment we shot in for most of *Turn Back Night's* interior scenes was a small space with rugs, soft furniture, and curtains, so there wasn't a lot of reverberation caused by the environment. (Reverberation is bad because it creates echo, and once echo prints on sound it's hard to get rid of it, although that's not as true as it used to be – yes, there are plug-ins for removing echo.) So we didn't do any treatments, no massive sound blankets were draped on C-Stands, and we still got quality sound. But, as I said, we had a very small room and a lot of furniture and carpeting to absorb reflections; your location could be very different.

8 Booming and mixing techniques

Booming positions and movements – Rehearsals are where it happens

It's been said that the boom operator must be the most perceptive crew member on the set. A director and cinematographer can alter how a scene plays, or may be blocked in order to satisfy some coverage or compositional needs. But a boom operator has to be reactive – watch passively, and adjust to the action they see. It's good practice to know the pages, know who is talking when, and then learn where the action is going *before* you start to boom. That way, you'll be able to have the microphone in the right place at the right time.

Booming, when done correctly, is a little bit like watching a conductor. The boom operator has to have the microphone in place a split second *before* an actor delivers a line. They can't be moving the boom to catch a line after it starts. This will result in uneven levels, recording off-axis dialogue, etc. As a boom operator, you should watch an actor's shoulders – they move before the feet and this will let you know that someone is going to move before they do. Figure 8.1 shows the positions often used that will cover you in most booming situations.

Taping is useful, to mark the floor so that people stand in the same place every time, so positions don't change between takes. It helps with placing mics. If the shot is static, taping the edges of the shot can help the boom swinger keep the mic out of shot.

Moving the microphone during rehearsals to find the optimal sound

Remember, when you are recording location sound you're not just trying to passively capture dialogue that is easy to understand, like a police confession. You're trying to maximize signal-to-noise ratio, get on-axis dialogue, and record as much of the full frequencies of the human voice as possible.

To achieve this the boom operator should move the boom around and try to find the best booming strategy to get the strongest signal-to-noise ratio of the dialogue recorded and get the sound on axis. The boom operator should practice

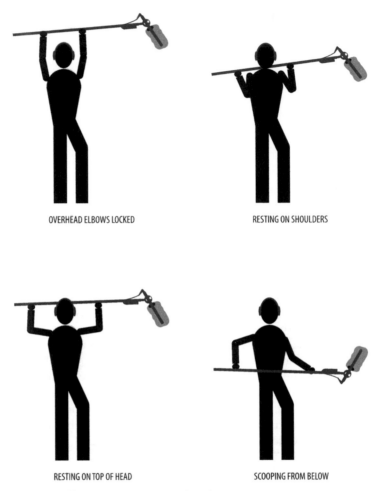

OVERHEAD ELBOWS LOCKED RESTING ON SHOULDERS

RESTING ON TOP OF HEAD SCOOPING FROM BELOW

Figure 8.1 Key booming positions for a boom operator.

searching for the best sound during rehearsals but remember – it's not just what sounds good to your ears, it's sound that is at a strong level with good signal-to-noise ratio that stays relatively even throughout the shot. This includes any traveling the shot entails, so the boom has to follow the actors. Figure 8.2 demonstrates how a boom operator will look for how to record the actor's voice with the strongest signal on axis.

Hold the roll or not?

A professional sound crew will want to "hold the roll" every time there's extraneous noise including planes, traffic, etc. that might interfere with a clean dialogue track. If you're inexperienced, these pros can be a little

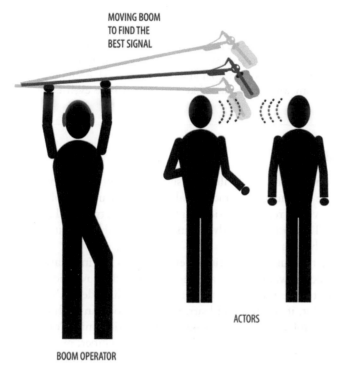

MOVING BOOM
TO FIND THE
BEST SIGNAL

ACTORS

BOOM OPERATOR

Figure 8.2 Finding the strongest signal.

intimidating and forceful. They are trying to protect your soundtrack and their reputation. You need to understand what kinds of problems they are trying to avoid and be prepared, on the set, to say "yes" or "no" to their request to hold the roll.

For example, there were some takes when my sound crew was holding for a helicopter to pass. I asked if it was "blowing" the sound and they said it wasn't but it was still very present, close to the dialogue on the levels but not killing it. We shot anyway. I have to live with a helicopter sound in my shot and fix it in postproduction.

But I didn't want to slow down the production, and this is a judgment call. When you override the mixer and allow extraneous sounds to be recorded on the dialogue track, those sounds are there forever in postproduction and might even force you to cut around the take. I recommend you come up with hand signals; tell the sound recordist to give you a cut (such as a neck slash) if the noise is ruining the dialogue, so you can quickly decide if you still want to roll the take and do Automated Dialogue Replacement (ADR) later. These proto-cols are very important to understand when working with professional sound recordists and should be communicated to anyone you might be trying to bring up to speed to do sound on your film.

TECH TALK – You'll need to practice booming dialogue with friends or actors and move the microphone around, get it on axis, and listen through the headphones to recognize the difference between good location dialogue recording and that which is not good. When you think of recording location dialogue, ask yourself if you're getting great separation from any noise, and good, even on-axis dialogue. Once you learn what this sounds like your ears will be even more of an assistance.

Levels to record at

I have touched on recording levels already (see p. 17), but it's important so I'll review some of the information. Traditionally, you'll hear filmmakers remark that the optimal level to record location dialogue at is between –12 and –6 or between –18 and –12, but this is partly because of acceptable *output standards* of levels of dialogue which is –12.

Minus 12 in digital sound is sometimes referred to as "0" in location recording because you don't want to go above –12 and risk overmodulating or "peaking" – going to the top of the red of the recording device's meter and getting distortion. But, if you test and learn your gear you can push even closer to the peaking and probably get better sound. My location mixer often pushed the meters above –12, sometimes near –6 or –5. But remember, my mixer was a professional and he knows his equipment and how to maximize the levels without peaking and distorting.

Again, this is all the more reason why you need to test with your own gear and make sure you understand how it tends to record. Normal speech that rises to yelling makes it hard to "ride the gain." But using a limiter introduces processing to the sound file and we usually want to minimize any processing on the location tracks and save all or most of the processing until the final mix. Location tracks work best when they are brought in raw, clean, and completely unadulterated.

Riding the gain

To start with, your goal in recording levels for dialogue is simple. If you're just doing mixing and don't have to worry about booming you can keep both hands on the gain controls and try to push the meters are far as you can without distorting. Of course, you should recognize that some low-talk dialogue will be lower on the meters, but try to bring any dialogue above –20. It's all about matching the perspective of the shot and the performance to the recording. And, of course, signal-to-noise ratio.

If your system can stand a little red or some reddish yellow in the reference meters (and they probably can), then record at this level. But make sure you've tested beforehand (see p. 40) so you understand your devices. While "riding the gain" is an oversimplification of location recording technique, it's a good place to start.

However, it's important to avoid big conspicuous "ups and downs" when recording dialogue. Constant, even recordings that allow for loud bursts or quiets are preferred. If an actor's range is wide and goes from very low to loud you might want to ride the gain down a little as it hits the peak. But, be careful to do this with finesse – too much fluctuating within a single take, or even within a single sentence or word, will be noticeable and require more processing in postproduction.

If actors start speaking very low you might want to ride it up a little. You'll need to practice and develop a feel for this technique. It's also important to note that when actors are talking low, you might want to pump the gain up to get good levels and good signal-to-noise, but the levels don't have to be as high as normal conversation or loud talking would be. You can always ask the directors if the actors could talk a little louder if their dialogue is being buried in background noise.

TECH TALK – Figure 8.3 shows a single person sound crew trying to set the levels or the right "gain" before recording dialogue. A note about the word "gain." It's an aptly named term that means you are "adding to" a signal or the signal is gaining. It's not "volume" which is a passive raising of sound that's already been fixed. We raise the volume on our car stereo. Raising gain means adding to the level that you want it to be at. So, the best way to get great sound is to start with leveling knobs at unity (0) gain and see how much signal you can pump by good mixing technique. Then add gain to make up for what booming can't do. This is why a good preamp for a condenser microphone is important because preamps greatly contribute to your ability to add gain.

Filters

Limiter

If you have a scene with a big dynamic range, that is, there will be wide variances in the amount of amplitude of your actors' voices, you might have to keep the levels mixed down lower than is optimal to avoid peaking when they get loud. Or you can deploy a limiter.

A limiter is simply a device that can aid in this goal. It sets a ceiling for how high a signal can go. Say you set your limiter at –3. Any loud voice coming in that went over –3, say an actor screaming, would not go over that mark even though there was plenty of signal to push beyond that level into the red. Sounds great, right? So why not have a limiter on during dialogue recording at all times? The reason is that a limiter is *processing* the sound and, as I've said already, the less processed the sound you bring in from location recording the better.

Here's my rule about using a limiter – I only use it if the sound would be *unusable* without it. Limiters can do weird things to sound; as they kick in, they

BOOM OPERATOR USING
ONE HAND TO BOOM
TEMPORARILY AS THEY
ADJUST THE MIXER
HANGING ON THEIR
SHOULDER OR IF THE
LEVELING REQUIRES
RIDING THE GAIN. THE
BOOM OPERATOR/MIXER
CAN BOOM WITH ONE
HAND AND MIX WITH
THE OTHER.

NOTE: If you're stuck doing two jobs
(booming and mixing) then you'll
have to juggle between watching
the levels and getting good
microphone placement. Sometimes,
I've seen boom/mixers use one hand
to set the gain levels in rehearsal
then return to two hands when the
scene starts shooting. It's not as
good as having a two-person sound
crew but it's the best compromise.

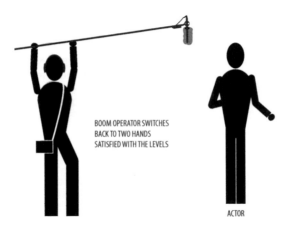

BOOM OPERATOR SWITCHES
BACK TO TWO HANDS
SATISFIED WITH THE LEVELS

ACTOR

Figure 8.3 Single person sound crew setting the the right "gain."

can sometimes start sounding "crunchy," or slightly distorted, depending on the mixer/recorder. Using a limiter is doing on-set processing: you are changing the sound before you even get to postproduction. A lot also depends on how much limiting you need to do.

Low cut/hi pass filter

These filters are available on most recorders, cameras, and mixers. Low cut and hi pass pretty much accomplish the same thing in different ways. The low cut cuts off frequencies below a certain mark, around 60 Hz (hertz) for location recording (remember, the human voice comes in around 85 Hz), so there's no risk of shaving off parts of the voice.

But beware, this technique is processing sound *before* you go into postproduction so the same rule applies as for limiters – only use it if you can't get good sound *without* using it. (Low-cut filters in postproduction might use a wider frequency range but for location recording don't go above around 60 Hz.) For the record, some microphones have low-cut switches on them, as do some recorders which have hard switches or switches accessible via the menus.

Here are some considerations if you are thinking of using the two main filters – a limiter and a low-cut filter:

1. Is the low frequency you're seeking to cut off something like a refrigerator hum or traffic sounds that get in the way of the best possible signal-to-noise ratio? If so, will cutting lower frequencies allow you to achieve better levels of dialogue?
2. Is the limiter needed? Are there unpredictable peaks in the scene (like an improvised fight) that can't be ridden up and down, or easily adjusted on the spot by a good mixer? Or is it one or two peaks you can time, or can you even bring the whole level lower and normalize it all up later? Remember, in digital sound you have leeway and even coming in at –25 can be usable if there's separation from the noise and it's a clean recording (although it's not a desirable level, except for low speech and whispers).

With regard to shooting in noisy environments and needing more signal-to-noise from your actor's speech, there's something else you can do. It's something I've learned the hard way: ask the actors to speak up!

Working with actors – Speak up!

If you're not achieving good signal-to-noise ratio in a scene it's okay to ask the actors for another take and to speak louder. Otherwise, you could be forced to do ADR.

In *Turn Back Night* street sequences, we used lavaliers only because we couldn't get the boom anywhere in the wide frame. And it worked fine except traffic is picked up fairly loudly in the track. Now, we all want to achieve "naturalism" in an actor's performance, especially when it comes to dialogue. Yet we'll also tell actors to contort to block a scene, walk unnaturally to hit marks, or turn their faces and look in odd directions because it looks good on camera. But tell them to speak louder for recording purposes? Blasphemy! You're ruining the naturalistic performance! At least some directors think of it this way.

Here's my take: if the signal of the dialogue is registering low, there's nothing wrong with trying a take or two and telling your actors to speak louder. Having my actors speak a little louder in some of the street scenes gave me more room or *separation* in the tracks to work with. And, depending on the scene, you can often find ways to motivate the actors to deliver lines with more energy without changing the naturalism of the performance or the scene dynamics in terms of

character interaction. In many of my slightly problematic shots, I requested they talk louder because it was mostly during wider angles where actors can play a little bit bigger. And it worked.

TECH TALK – THE PROXIMITY EFFECT

It's great to get the boom microphone on axis, i.e., close to the actor's mouth. But, if you get it too close you run the risk of creating what's known as "the proximity effect." This means that the low frequencies of the voice will be accentuated unnaturally. Think of when you're listening to talk radio hosts and they have that great full bass sound. That's the proximity effect. If for some reason your boom has to be very close to an actor's mouth, you can try using a low-cut filter to counter this phenomenon. Again, it might be better to cut the low-end frequency when recording on location due to the proximity effect; this might afford you the ability to get more signal-to-noise rather than having all the low end, which will impede you recording with the best levels.

Mixing down on set

Again, location mixing can simply mean controlling the gain and levels even if you're only recording sound with a single shotgun microphone into a camera. Or it can be more like the term sounds, *mixing* the boom and separate microphones into a stereo mix to create a composite sound track the picture editor can use to cut the film. Now, whether you can achieve this level of sophisticated location mixing depends on your budget and and how much attention you can give to this technique. But there's a cheap way to get a stereo mix on your set by pushing the equipment to mimic higher-end recording devices.

Recording channels

Years ago, when everybody screamed for The Beatles as their records spun endlessly on turntables, these legendary vinyl artifacts began as "mono recordings." A mono recording means the sound is processed down and lives in a single channel, which translates into how the sound comes out of the speakers – namely, from one direction, no matter how many speakers are connected. Cinema used mono sound right up until 1940 when *Fantasia* was made with stereo sound, including left, right, and center channels.

TECH TALK – Even though in stereo we say there is a left, right, and center channel, it only really requires two separate sides of the same recording. Left and right are the opposite sides represented by a left and right speaker, and the center is approximated according to how sound is panned in between left and right.

Eventually stereo sound became the norm in cinema, and sound in theaters developed to include 5.1, 7.1, or 9.1 or Dolby Atmos etc. sound with multichannel speakers in the walls and ceilings.

In location recording, it's best to record a single boom that captures all the main characters speaking and then individual isolated tracks that record the characters individually, all on separate channels. Ideally, you will record a discrete signal for each microphone in its own channel container, but they will show up on one track container. The best example is when your camera records stereo left and right, two separate channels, but they will come up together on the timeline when you import the mix. When we record, say, ten channels on set we're recording ten mono channels discretely *and* mixdown to stereo left and right.

The Hollywood way to record multichannel recordings is with a professional multichannel recorder such as a Sound Devices 688: you record the boom for the whole scene and the characters have lavaliers all on separate tracks. Then you have a mixdown of everything on stereo (or a mono-mix track) for picture editing purposes. The dialogue edit will be where microphones are selected and/or combined. The cheap way of doing it, if you don't have a recorder that can mix isolated tracks into a separate stereo mix, is to take the output of whatever you are recording on and record it onto another recorder or the stereo input of the camera. (I'm not sure why you'd want to do this, but you can if you want to.) Regardless of how many microphones you have for your location recording, the most important gain to be controlling throughout the shoot is the gain of the boom microphone. This will be your primary source of location sound.

A seasoned Hollywood mixer will dial sound from the booms and lavaliers in and out of the master stereo mix so the editor will have a robust complete soundtrack for dailies, picture cutting, and work-in-progress screenings. Usually, during the sound postproduction phase, a dialogue editor will rebuild for the final mix using the boom and isos (isolated lavalier tracks). But a set mixer has to be monitoring all the levels, the boom, and the lavaliers at all times and trying to composite it all into a stereo mix for the entire editing process.

We've covered a lot in previous chapters about levels, including signal-to-noise ratio and why getting sound on axis is so important. But bear in mind that it's *not* intuitive and easy to hear through headphones if your sound is recording in an optimal way, especially when you're starting out.

Complete checklist of gear for a low-budget shoot

In Chapter 5, I discussed the main machines you need to record with, including microphones, recorders, mixers, etc. Here is a comprehensive list of items you should try to have for any low-budget shoot:

1. Sound recorder for double system (or camera with good sound recording capabilities).

2. Shotgun supercardioid microphone (and, if you can afford it, a spare).
3. Indoor microphone, such as a short tube hypercardioid (if you can afford it).
4. 2–3 omnidirectional lavalier microphone sets.
5. Boom pole with cabling running through it.
6. Wireless connector for boom pole (if you can afford it).
7. Handle for handheld, planting.
8. XLR (external line return) cables, short and long.
9. Wind blimp (a contraption that blocks the wind from hitting the microphone).
10. Dead cat (another form of protection against the wind; it's less heavy and sometimes used *inside* the blimp as a double layer of wind insolation).
11. Plenty of batteries – enough to change every piece of gear 3–4 times (I tend to avoid rechargeable batteries for sound gear because they are not as reliable).
12. Headphones for the boom operator and sound mixer (if they are two different people); have a split so the director can listen in.

TECH TALK – Always wear headphones when recording sound. This applies both to the boom operator and the mixer. You can't trust your naked ear – you need to hear what the machines are recording, but learning to decipher what this sound through the headphones really means takes practice.

13. Gaffer tape for making tape triangles for radio microphones, taping up sound blankets, etc.
14. Slate and plenty of dry erase markers and a cloth. Slate every shot – every single shot – since it will be important not only for your picture edit but also for key sound information.

GEARHEAD ALERT – SMART SLATES

If you can afford it, buy or rent a smart slate – they are great and relatively easy to use. Smart slate prices have come down a lot in price, from thousands to hundreds of dollars. I'll discuss them in more detail in the section on time code (see Chapter 9).

15. Band-aids for the radio microphones – to adhere them to your actors if your gaffer tape triangles don't work.
16. Flashlight with extra batteries.
17. Pads for shoes/heels.
18. SD (secure digital) cards (or whatever recording medium you're using).
19. Something to copy and back up files from your cards such as a computer (you might want to get into the habit of backing up sound files during the day in case a card fails).

20. Good sound bag for your sound equipment and good organizing practice. You should have a bag that is only for sound gear – or even a few, if necessary. You should also have a method for coiling cables, and for how the bag gets packed. Anyone who is shooting sound should follow the procedures for wrapping cable, breaking down, and storing equipment. It should be a ritualistic routine.

There are other pieces of gear relevant to location shooting, but these will be discussed below (see p. 71); they aren't always available for low-budget shoots and there's some related technology which must be discussed in conjunction with them.

File backup strategy and archive

Now that I've shown you how to set up a lined script correctly to industry standards and how to label all your sound clips as you make them you're going to do so, right? Don't get lazy. A little laziness on set means a lot of work later. With regard to sound cards and sound files in general, my rule is *not* to erase them during a production. *But* (and this is a very big but) copy the data from them at the end of the day, every day. Don't relax and think the sound is on the card, let's keep shooting tomorrow. Because you never know what's going to happen:

- **Assume that all drives will fail.** You have to make the assumption that any – and all – hard drives will fail. So never relax; copy the data from the card, and then try and make another three backups, or at least another two.
- **Make sure you have a backup off site.** This simply means don't keep all your original data cards *and* your backup in the same place. What if there's a theft, or a fire? Or a meteor hits it? You get the picture. Make a few copies of your sound and give one to your mother or a friend or neighbor. Put one somewhere else offsite.

Phasing issues with multiple boom and lavalier microphones

If you record an actor talking with a boom that is two feet overhead and you are also recording them with a lavalier taped to their chest six inches away you might encounter microphone "phasing" when you try and combine the sound from the two microphones. Phasing in this case involves the sound hitting the microphones at different times, perhaps only by milliseconds, but enough so that they aren't perfectly in sync when lined up.

First of all, why combine the two microphone tracks? Maybe there were some slight aspects of the sound the boom missed, or you get a more complete frequency spectrum from both microphones. But lining up two microphone records is done in postproduction so why worry about it on set? There is another aspect of phasing when using multiple microphones.

There is another kind of microphone phasing that is caused when you are using multiple lavaliers. Say you have a lavalier on each of two characters having a conversation. You have to watch and make sure that there is little to none of the other actor's voice bleeding into the other channel; it will be out of phase due to the fact that it's a millisecond off, and can affect the sound if you try and combine the microphones. When you monitor try to make sure you get only the character you a connecting the lavalier to, and nothing else.

That's a wrap (proper care of cables and gear)

There are two main aspects of learning to manage your sound gear. First, you should have a routine way of breaking down and packing your gear the same way, in a manner so you will know where everything is. This will lessen the chances of breaking things. I suggest using the same bag for sound, putting certain parts and accessories in the same compartments, and also training whoever might be doing sound how to do so.

Storing gear with batteries

If you store gear for a short period, say a few weeks, it's okay to leave the batteries in. Things that require batteries for sound include:

- shotgun microphones (an internal battery in a microphone can replace the need to have to power it via a preamp on a camera, mixer, or sound recording device)
- a mixer
- a sound recorder
- a microphone preamp for a DSLR (digital single lens reflex) camera
- lavalier microphones
- wireless connectors for boom poles.

All of these devices can require batteries. If you plan on storing them for longer than a few weeks it's a good idea to take the batteries out while the devices are in storage. First of all, you minimize the risk of storing the device in the "on" position (it happens). Also, batteries stored in devices can sometimes corrode and gunk up the battery compartment.

Wrapping cables

Cable wrapping requires practice. The best method I like to use is called the "over–under technique." Cable is like hair – it has a natural curl and the over–under wrapping technique will help you to work with its natural curve. My recommendation is to find a good YouTube video on how to wrap cable because it will make your overall gear issues less cumbersome and preserve the life of your cables.

9 More asset gathering when location sound recording

Or what you need to come away with (hint – it's not just great sounding dialogue)

Now we come to everybody's favorite topic, time code. Not. But sync (or synchronous sound) is one of the things I see a lot of students and low-budget filmmakers screw up. And it's impossible to talk about synchronization of sound and picture without talking about time code.

Actually, that's not absolutely true: you can shoot with traditional clapsticks and sync up in perfect sync afterwards without using time code on the set. I've done it. But there's a problem with shooting without any sort of time code reference – you won't have an overarching point of reference so you know if your footage goes out of sync. The best thing you can do in this circumstance is to create time code *after* you've synced up manually which I'll explain in a little while (see p. 97).

FOSSIL RECORD – Back in the analog days, "crystal sync" meant there was a tiny crystal in the camera that locked the analog recorder so they both ran at 24 frames per second (fps). But that just got you a picture and a soundtrack running at the same speed. Then, in order to ensure you could *stay* in sync after an editor synced up your resolved sound and picture, the only way to have an ongoing reference was to line up both "work print" and "synced soundtrack" and printed series of numbers on both tracks. This way if you got lost you'd have a reference. Pretty primitive but it worked.

We're in the digital age now and have a lot of ways of ensuring we get in sync and *stay* in sync. So let's start with the basics of the operation, getting in sync in the first place.

Time code is probably an underutilized technique of low-budget filmmaking but it doesn't have to be. Even if you don't have a sound recording system powerful enough to use time code, you can learn from how the pros do it and also generate a form of time code after the fact to *stay* in sync. Nothing is more amateurish than a shot that is conspicuously out of sync with its soundtrack, or *rubber sync* as we call it.

First, what is sync?

Synchronized picture and sound means two things. First, that the picture and sound both run at exactly the same *frame rate*. A common one for film is 23.976 fps (23.98), now 24 fps. 24 P is the frame rate of motion pictures and has been since the advent of sync sound. But it used to be that in order to match picture and sound, the sound tapes had to be *converted* to 24 fps. Then, it set up the next phase, which is making sure the exact moments on the sound take are lined up with the picture. This used to be done manually using a clapstick. If you don't have your picture and time frames per second locked, you could be in trouble.

Tentacle sync

Tentacle sync is a powerful form of time code. Tentacle boxes work with any camera or audio recorder that has an audio-in jack. They are add-on devices that have come down in price over the years.

 These devices can record time code to an available audio track on devices such as lower cost recorders or H4ns. In postproduction, time code signal recorded on the soundtrack can be used to sync up to any other device with the same time code information. Tentacle sync boxes work equally well with professional devices that natively support time code. The best way to use these little boxes is to make sure every camera or audio recorder on set has their own tentacle sync box. Using wireless (Bluetooth) signals, every tentacle sync box in the connective chain stays in sync with one another and then keeps the devices they are connected to, namely the camera and recorder, in sync. They even work with cell phones and iPads, and can provide an easy way for a script supervisor to use their phone as a time code display to make sure their notes match the time code of all the other devices on set. A device will be connected to the camera and sound recorder and it will make sure both are running (and printing) the same time code into a dedicated time code (or audio) track. This makes syncing up dailies totally automated. If you have a separate box put it on your equipment list.

Jam sync or "hot sticks" with a smart slate

In *Turn Back Night* we used jam sync. "Jamming sync" refers to using a cable (or wireless device) to sync one device on set to another. It's a less automated but still reliable sync method that requires some manual syncing between picture and sound in postproduction. One device (it can be the camera, recorder, or a stand-alone time code device) serves as a master clock, with all other recorders, cameras, and time code slates being synced to this master device. A time code slate, when clapped in view of all cameras and with all audio recorders rolling, gives a visual indication of at what specific frame of the time code the sticks clapped together. If time code feels off when syncing in postproduction, the waveform spike of the sticks hitting each other can be manually lined up with the frame of video where the sticks meet.

Jam sync is pretty simple. And while you can't completely automate the syncing, at least you have a scientific reference. It's crucial that your frame rates all match. If you are going to jam slate, make sure the slate is jammed often during the day and test it to ensure it is working. Also, don't forgo using the clapper because if something goes wrong you always have the clap.

Traditional slate

Let's assume you're going old school. You have a traditional slate and use it like in the old days – the sticks hit the clapboard and you mark your sound track and video and sync up everything this way and all is fine. When you sync you need to make sure you know exactly when the slate has slapped together (the blurring has stopped) and ensure there is a full clap and not a bleed of the sound coming in a microframe before on your sound track. Hold the slate with one hand and slap down with the other, holding the slate still, so it's easier to determine the precise moment of contact for the editor.

Hand clap

If you forget to clap the slate, you can always resort to hand claps. They work provided you understand you only have an *aural* reference to what shot it is. (If you hand clap do it this way: turn one hand up towards the sky and hold it, and then bring the other one down on it.) To sync this way in postproduction will pretty much follow the rules of the traditional clap; it's the same thing, but a tiny bit harder to decipher when the hands hit.

All editing applications can automate the syncing process once you've made marks on the sound file *and* the video clip. Find out the specifics of how your editor works.

If you are using the old school ways of syncing with traditional clappers (or hand clappers), you can still go into your files and create time code references to lock up your files. The following more electronic syncing methods discuss how to use aspects of them to turn traditional clapped synced files into real time code connected sound and video clips.

Clap twice (you'll thank me later) – A great test to make sure everything is working

So, you have your DSLR (digital single lens reflex) camera and your Zoom recorder and your clapstick for tomorrow's shoot. Here's something I suggest you try. Roll sound and camera and slate with the clapstick and then let the camera run indefinitely as long as it can, say 12 minutes. At the end of this ridiculously long take, slate again. Then, line up everything on the timeline, lock in the first slate sync mark, and see if the second take at five minutes into the take is in sync as well. If it is, you know that you don't have any of the dreaded *drift*. Chances are you are in sync.

Planning to rely on camera sound/automated programs

As a sound person (or filmmaker overseeing sound) you're already a big part of the sync process, so now is a good time to talk about the reliance of camera sound for sync using programs like Pluralize. Pluralize is a program that only applies to double system sound. Here's how it works: it looks at the wave form of your camera sound and the wave form of your second system sound and it matches them up. I did it once on a web series and it worked fine. There are some issues to be aware of, however. First of all, if you're going to take this route, get *amazing* camera sound. Connect a microphone to the camera, a good shotgun, and make sure you're recording with strong levels. One issue with some of these automated syncing programs is that if the camera is too far away from the actor (about 25 feet away) the sync might not be true because the distance can change the sync. Also, most professional editing platforms like Final Cut Pro X, Avid, and Premiere Pro have a waveform syncing function. For *Turn Back Night* we used jam slate and it worked great.

Room tone proper

How many different ways are there to grab room tone? First of all, let's clarify what is meant by room tone. Basically, in sound terms, room tone is "silence." It is sound going on in the background that you don't really hear until it suddenly drops out and there is missing tone in the dialogue track. It can be the hum of traffic, appliances, wind, or a combination of these. It's a consistent sound that is part of the atmosphere that your brain tunes out. Stop what you're doing and listen. There is room tone.

On a set, you have to record room tone to fill in holes when you're editing, and then you just have to take out some piece of the soundtrack. You can't just drop the tone or the audience will notice. When we get into dialogue editing we'll talk a lot about room tone.

So you know you need room tone, but when and how do you get it? You need it for every scene change/location change. And if a takes a long time to shoot – say eight hours – and the traffic out the window has changed you need it twice, because drastic changes in traffic noise are noticeable. So how do you record it? It's simple. The last thing you record after a scene is complete is when the sound person calls "room tone" and all action ceases. You must freeze for 30 seconds. If anyone moves or coughs it ruins it. You need to record "silence" – just the background sound *and nothing else.* You may be wondering about the microphone position; given that the microphone has been in a lot of different places, how will the tone match? Also, what level do you set it at? Do you now record it full with the tone up around –6 or keep it similar to where it was, bouncing around –40. The short answer is: if it's meant to fill in holes in the dialogue track, record it at the same level it was during the dialogue. If you are building an entire scene from scratch in respect of sound or are going to Automated Dialogue Replacement (ADR) later you can record it hotter.

Room tone guerilla

Ron Kalish was a great sound editor from New York who used to tell me that he didn't like using canned room tone; the best room tone could always be found within the actual production sound. Why? Right, you guessed it, because the microphone was always in the same place as it was when it recorded the original tone that is missing. But, if you've done any dialogue editing you know you can't always find enough tone to fill in the holes. And I'm not a big fan of splicing pieces of tone together because it always sounds funny. So here is another approach to capturing room tone: on the first and last take of every set-up, tell your cast and crew to hold for 30 seconds after you yell "action." This will give you flawless room tone, and if you do it at least once at the beginning of every new set-up you will have an encyclopedia of great room tone custom designed for each particular set-up. Remember, whenever you change the microphone position you get a different sound, different levels of room tone, etc. If you think about it, on any given day you might have 10–20 set-ups so that would account for about an extra five to ten minutes. Back this up with traditional room tone after every scene and you'll thank me when you are dialogue editing.

Get wild … sound that is

Wild sound is sound that is recorded without picture, hence the term "wild." If there is a line of dialogue you just can't get clean for whatever reason, record it in a quite space. Or even record it in the same noisy environment, but get the microphone closer so the sound will be better. It's an underutilized tool of production sound. Do a few different takes and the chances are you will get it right. You'd be surprised how often you're able to cut it if you need to.

Go natural – Natural Foley or PFX (production sound effects)

Foley is an art in itself and to get it right takes a lot of skilled artists. We'll review Foley later (Chapter 18) but, in short, it's any sound that is synchronous that isn't dialogue. That includes walking, punches, clothes rustling, forks hitting a dinner plate, chewing, etc. I want to encourage you to be mindful of recording natural Foley when recording location dialogue. Sometimes the boom (and, in some cases, the lavaliers) is positioned to record usable Foley. The challenge with this natural Foley, or "nat sound" as it's sometimes called, is that the boom operator isn't trying to get the Foley sounds clean; their only goal is to get the dialogue right. But, in the process, they pick up natural Foley – boots on concrete, getting up or sitting down on chairs and sofas, etc. When I shoot, I try to preserve as much of this as possible. I don't restrict myself if I need to talk over nat sound but if you can come in with a lot of natural sound done via the location track your life is easier. At least you'll have a good reference track.

TECH TALK – M&E WORK FOR DELIVERY TO FOREIGN MARKETS

Production sound effects (PFX) are used more than you'd imagine, especially in independent film. When a film is prepared for foreign distribution the only thing that has to be replaced is the dialogue track or "stem" as it's called. A stem is a composite mixdown of all the dialogue into a single strand. There are three primary strands including music (the M) and effects (the E). The dialogue has to be replaced by the foreign language of the country the film is sold into. But guess what – in doing so, a good deal of PFXs that made the scene realistic are sometimes also stripped away. So a sound effects editor must replace these.

Wild Foley

If you have time on your shoot (and who does?) you can grab some wild Foley for specific sounds. For example, if there's a scene where there's some body contact, such as a fight or kissing, and the boom didn't quite get it right. You can do one or two sound-only takes and get that sound in the can and save yourself the trouble in postproduction.

10 Location sound recording in practice

Specimen film – *Turn Back Night*

Turn Back Night features a lot of different common location and postproduction scenarios that a low-budget filmmaker might encounter (but not every possible one). We shot on location in an apartment, on noisy streets, in a park, in a car, in a parking lot, on a green screen stage, and on a roof deck. We encountered helicopters, screaming kids, tons of traffic, planes, hecklers yelling to bust up the shot, etc.

The following screengrabs are from actual edit and sound editing/mixing sessions of my feature film *Turn Back Night*.

Specimen #1 – Over a noisy highway

Holly Anne Williams, who plays Jane in *Turn Back Night*, was miked with a radio microphone. We boomed, but the level of ambient noise made it hard to use. So, in postproduction, I went with the radio microphones. I was able to direct Holly to give her performance energy (that direction worked for the scene) and because of her vocal projection we got a little better signal-to-noise ratio.

This is noise is pushing around −14, trouble from the get-go. As a filmmaker who's been through a lot of final sound mixes, I know I'll be using the radio microphone for this scene because the boom is too weak. But even the radio microphone is dodgy.

When Jane speaks, the levels pushed up to around −11. Not great signal to noise ratio, but it's usable. Remember, there are all kinds of ways of processing the sound to make it even more usable, like pushing the energy of the traffic noise down a little providing its frequency doesn't interfere with the actor voice. But without separation of signal to noise, it's hard to have enough control of the dialogue in the final mix to really do anything to sweeten it up.

Figure 10.1 Specimen #1 – Over a noisy highway.

Specimen #2 – Natural Foley or PFX (production sound effects)

On low-budget film location sets, always try to get PFX. We were able to get decent signal on Jane's footsteps. The spike of signal from them versus the noise is significant enough to be usable in a mix. In Hollywood, they replace footsteps.

While the overall signal level of Holly's footsteps is low, against the ambient noise it's high enough that I can use them as PFX and not have to Foley them. It can also serve as a great reference track if you wish to build Foley for the footsteps after the fact. Bear in mind, the –30 is probably close to what Foley footsteps might be mixed down to anyway.

Noise –36

Footsteps –30

Figure 10.2 Specimen #2 – Natural Foley or PFX (production sound effects).

Specimen #3 – Inside a car

Microphone strategy for inside a car is pretty simple because there are so many places to hide microphones, and the actor is always going to be close to one. Also, a car is a relatively well insulated environment – but be aware of phasing issues (sound bouncing off windows). For this scene, we placed a plant microphone near the stick shift, a radio microphone in the visor, and kept Holly miked with her body radio. These multifaceted microphone strategies will provide rich voice signal if we decide to use the plant mic or even combine the mics, depending on what sounds best. Turns out the plant mic is great.

Figure 10.3 Specimen #3 – Inside a car.

mix	mix	plant	Jane	visor
L	R	mike	radio	radio
			mike	mike

Specimen #4 – Two actors/noisy exterior

This is pretty much the same as the scenario with one actor. There's a noisy background so the boom is far away and relatively useless (Audio 7 in Figure 10.4). The two radio microphones are doing just fine, carrying the scene and giving us enough separation to be usable. Again, another case of always being prepared to wire up each speaking actor because it gives you the greatest flexibility.

Boom radio mikes

The boom is weak but the radio microphones save us on this noisy exterior.

Figure 10.4 Specimen #4 – Two actors/noisy exterior.

Specimen #5 – Outside good balance between boom and lavaliers

This is a sample of a street scene where the boom is close enough to be usable on Natalie (it's her shot). But because Joe is also wired up we might opt to use his radio microphone, which is closer to the actor's mouth and picking up less background noise, for his dialogue. The boom operator did a good job of keeping the traffic sounds off axis so the boom would be usable. The boom operator moved the microphone until he found the right compromise between getting the most signal of actor's voices and minimizing background noise. This is part of the craft of boom operating.

Noise only

Signal

Figure 10.5 Specimen #5 – Outside good balance between boom and laviers.

Specimen #6 – Another example of how radio microphones are able to carry a scene when the boom can get nowhere near

Noise only

Signal

Radio microphone

The radio microphone in the scene is enough to make the recoding location usable.

Figure 10.6 Specimen #6 – Another example of how radio microphones are able to carry a scene when the boom can get nowhere near.

Specimen #7 – Radio microphones when there is wind noise

The boom was able to get close enough, and we used a combination of the radio and boom microphones – both are pretty strong and while the radios have plenty of kick, the boom rounds out the voice frequencies. Also, there was quite a bit of wind, and we used a blimp (described in Chapter 7) which helped us get clean sound. Always have a blimp if you're outdoors.

Figure 10.7 Specimen #7 – Radio microphones when there is wind noise.

Specimen #8 – Indoor dialogue (and indoor microphones)

Most of the indoor dialogue for done inside an apartment. We shut windows and closed the air conditioner (in both rooms). I was shocked that the mixer insisted on turning off the bedroom air conditioner as well, even though we were filming in the adjacent room. We also turned off the refrigerator. I got most of my sound from boom and for Mia, the actress with her back to the camera, I used the radio microphone.

Figure 10.8 Specimen #8 - Indoor dialogue (and indoor microphones).

Green screen sound recording

Recording sound on a green screen stage is easy because as long as the microphone doesn't cross the plane of the actors it can be removed. Hence, another reason to shoot in a green screen stage if you have scenes that need it.

We got the microphone very close to the actors. It was eventually completely removed in the final compositing of special visual effects.

Figure 10.9 Green screen sound recording.

11 Sound postproduction
An introduction to sound editing

Let's begin by talking about sound editing as a deliberate, distinct process in film postproduction, separate from picture editing, and how it should be treated as a process in itself like preproduction. I see a lot of students who leave no time for sound postproduction, and then they screen their films in a theatre on final thesis screening night – that is literally the first time they hear sound mistakes on big theater speakers, which are often pretty unforgiving.

Time allotment for sound postproduction

A good rule of thumb is to allow 1 week of sound editing for every ten minutes of film. So, for example, a 90-minute film would benefit from nine weeks of sound postproduction. Of course, you might not have the time or luxury to give it that much time. In the professional film world, one example I heard about is that a dialogue editor working on a narrative film with a mid- to high-level budget is expected to spend one hour for each minute of screen time. On television or lower budget productions, you may be looking at a lot less than that. On indie-level films (90 minutes), a dialogue editor could spend 10–20 days editing dialogue, 1–4 weeks on design and effects, two weeks on pre-dubbing, and a week on re-recording mixing. This can vary greatly depending on the budget of the film. On larger budget films, dialogue editors may have up to six weeks to edit the dialogue. Television can be much faster.

These are standard turnarounds for well-funded productions but if you are a filmmaker stuck with doing everything yourself, you might need even more time. But take heart: there are ways of handling sound in your picture cut that will make a lot of the sound postproduction easier.

Picture lock and when you start playing with effects and music

In the old analog days, the postproduction workflow usually required that you "lock picture" before you seriously started doing sound editing. The reason was that all film sound ran on magnetic film stock that was expensive to make and if you kept cutting this stock, it weakened. This was part of the "film is shot on

expensive film stock that needs to be developed so we'd better know what we're doing" analog mindset, something that has been lost in the new digital age.

> FOSSIL RECORD – Now, we can make a new copy of our assembly every morning and try different things. But in the analog days there was one copy of the workprint film (at least in the independent world). It dictated the workflow.

In the digital age, an advantage is that a lot of sound effect editing (and scoring for that matter) can begin *before* the picture is locked. It's not hard to experiment, slide things around, make duplicates of your timeline. That said, I think it's good, in your workflow, to assume that you are building toward a date in time when you will lock picture. You'll need to lock picture when you spot sound effects – in other words, sync specific sounds in sync to the picture. You'll eventually have to sync up your finished score. So sound editing can begin *during* the picture cutting phase, but it's best to keep this to a minimum and to do so in a way that will facilitate your DAW (Digital Audio Workstation) sound edit.

> FOSSIL RECORD – In the old analog days, after a picture was cut, you'd have a monstrosity called a "work print" that would be taped together and unstable. To make a print that could be utilized for sound editing a "slop print" would be made – a cheap black and white print of your film that looked good enough so you could do all the sound editing and mixing. I like to replicate this process by formally making an export of my locked film at the end of picture editing, so I won't be tempted to change picture cuts.
>
> Final Cut Pro Studio (a program made by Apple) had a great workaround this old-school workflow by coming up with something called "roundtripping." In this system, you'd do picture editing in Final Cut Pro then export to do sound editing in Sound Track Pro. You could then go back with those cuts intact and do more picture editing, and then back to Sound Track Pro etc. You get the picture. But this disappeared when Apple completely changed the paradigm of its editing suite. The editor (and sound editor) Walter Murch said of Sound Track Pro (including his assessment of the above feature) that it was a game changer in how we do the whole sound postproduction workflow. But unfortunately it disappeared.

The different jobs in sound postproduction

If you're doing sound postproduction yourself you'll have, to some extent, to do all of the jobs outlined below. If you're hiring any of these positions, knowing the job yourself can only help you communicate. But don't fret because many of these jobs are done by the same person, especially as you go down the ladder in terms of overall budget. For example, on smaller films the same person might do music supervision, composing, arranging, and music editing. And, as I've said,

you can be doing a lot of this as you go along. While the examples of what occurs in all the roles are very short, they will be enough for you to extrapolate from when it's time to apply them to your own filmmaking.

Postproduction supervisor

This involves overseeing the entire postproduction process, including all the editing, sound editing, and mixing, and working with special effects departments. The role usually only exists in bigger budget films. The postproduction supervisor on big films doesn't do any of the actual postproduction work – they just coordinate, hire, etc.

Sound postproduction supervisor (supervising sound editor)

This role is the same as above, but focuses specifically on sound postproduction and reports to the overall postproduction supervisor.

Sound effects editor

A sound effects editor is the person who creates and edits sound effects. An example is those famous laser hits in *Star Wars* (which were created by tapping on taut bridge cables and recording them).

Sound effects recordist

This can be the same person as the sound effects editor or it may be a separate recordist who specializes in recording effects.

Foley artist

A distant cousin of actors, a Foley artist is the person who watches a synchronized picture and creates sound that matches. Named after the father of the art (Jack Foley), Foley is when you replace sounds that are synchronous with the picture (usually, though not always, this involves a human being). It's a special craft to be able to cut Foley.

Foley editor

The Foley editor is the person who cues and edits the Foley. He or she decides what sounds need to be recorded and creates markers in the recording session, to let the recordist and artist know what they need to record during the Foley session. After the recording is done, the editor then edits the Foley into perfect sync with the picture (most Foley artists are good at nailing the sync of the sound they are creating to a picture, but sometimes sounds have to be knocked into sync a few frames).

Foley recordist

This is a specialist who records Foley during the Foley session. Sometimes a record-ist in sound postproduction will cover multiple kinds of sound recording, including Automated Dialogue Replacement (ADR) recording, re-recording mixing, etc.

ADR recordist

This is a specialist in recording ADR, which involves what's known as "comping." Comping is when a piece of sound is looped and takes are recorded repeatedly with a recurring beep that will be the same over and over again so the actor can get into a rhythm. So the comping is the beep track to help the actor to create a rhythm that will ultimately assist them in the ADR process. After all the ADR has been recorded, the ADR editor will splice together the best takes from pieces.

ADR editor

An ADR editor is used when a producer wishes to get better sound quality in their dialogue and re-records it in a booth using the location dialogue as refer-ence. This is also commonly referred to as "looping."

ADR loop group actors ("walla")

When you see a scene of a crowded restaurant or bar with patrons happily chatter-ing away, they are not actually talking. They are *pretending* to talk but not making any sound. Later, the conversation will be created by a loop group. A loop group is a bunch of actors who come together to record talking to be used for background chatter. If it's a SAG (Screen Actors Guild) production, they'll go with SAG actors. Sometimes, they will be supervised by an ADR editor. When they come together to record, they are told what kind of "crowd" they are, whether it's a noisy bar or an upscale restaurant. Of course, you can used canned loop groups but big shows with a lot of money make everything customized.

There are some actors who specialize in this kind of acting. I even met one walla artist who told me she made a living doing this, a good living. For big budget Hollywood films original walla works; for us in independent filmmaking, canned will do. But if you have a bunch of friends who don't mind hanging around talking and being recorded, go for it. Make sure you get a good clean signal and enough talking so you don't have to repeat anything, which could be noticeable.

Dialogue editor

A dialogue editor is responsible for editing the location dialogue soundtracks and delivering them either in a "pre-dubbed" phase or raw and unprocessed for the re-recording mixer to finish. Pre-dubbed dialogue means that it's been equal-ized, leveled out, compressed, etc.

Dialogue pre-dubber

Usually a sound re-recordist (mixer) professional will assist the dialogue editor in creating a pre-dub.

Re-recording mixer

This is the master mixer who takes all the raw (and sometimes pre-dubbed) stems and mixes them down to a final master mix. In big films, there is sometimes a master re-recording mixing team. For low- budget filmmakers, it can be a sound designer or, you guessed it, you.

Music supervisor

A music supervisor is responsible for selecting pre-recorded (or commissioned) music and placing it in the timeline, and also securing rights for the music. A rule of thumb: don't use music you don't have rights to and can't afford. Try not to fall in love with music you probably can't afford. It's very hard to get over losing music you've been editing to for a while, trust me.

Composer

The person who scores the film, writes original music, and often records it electronically and delivers finished music stems that can be dropped into a timeline. Some sound mixers prefer to have the raw tracks delivered with the finished score in case the mixer wants to rework the tracks to fit the overall mix. It's not a bad idea to view music as a sound mix element, hence the reason we're dealing with it here even though it's a completely separate art. That's right, you might have to figure out how to create music yourself.

Music arranger/orchestrator

If a composer just writes the music but doesn't do the orchestrations, a professional orchestrator will them allocate that music to instruments.

Music editor

This is a specialist who cuts music and has to understand musical cadence to cut it right.

Finally ... actors

That's right, your actors are part of the sound process because their voices will become the center of the entire sound mix, namely, via the dialogue track. In *Turn Back Night*, I had a fabulous situation where my lead actress's voice cut

through noise like a bell. My lead actor's voice was deeper, and in scenes that included traffic and city noise his levels needed a little boost in the postproduction mix. Be aware of this very salient point: different clusters of actors all have different tones, frequencies, and tendencies in their speech. Think about these all going into production and it might alert you to problems that may arise due to differing levels of recording between various actors on set.

12 Sound postproduction that starts at the picture edit stage

Before we get to the sound postproduction phase, where you move your film onto your Digital Audio Workstation (DAW) of choice to do sound, there has to be a picture cut. And in the picture cut phase a lot happens that can affect what happens in the sound edit. If the picture edit is done correctly it can make the sound editor's job easier.

Copy sound files

The picture edit phase is the first time the sound files get introduced into your project as .WAV files or B-WAV (Broadcast Wave) files. Sound files normally come in as they are, and don't need to be altered or changed or transcoded. This is due to the fact that sound files tend to be a lot smaller than picture files.

> TECH TALK – Today, the files from some cameras are so enormous that most of us can only afford to edit in *proxy* files, smaller versions of the original camera files that are used for editing. In sound, there is no equivalent; you edit with what was recorded unless the sound recordist recorded in 96 bit, which, while generating larger files, probably won't blow up your media storage strategy.

Setting up a sequence

Once your camera reels are transcoded and your basic bins are organized you will need to set up your synchronization process; here is where you can make some decisions. The syncing process is where soundtracks and channels can be determined and how you do this can influence how easy it is to set up a sound edit in your DAW of choice.

> TECH TALK – While not wishing to belabor the obvious, in your master bins (which should be labeled with scene numbers), store all your sound elements including location dialogue tracks, room tone, wild sound, wild Foley, and any voice-over that might be recorded on the set. *Turn Back Night* has a lot of voice-over and phone conversations and we were able to grab it all during downtime.

Importing your picture and files into your editing application

The first phase of the process is to set up your project. You import video clips and your sound files. When you import these assets you can make some up-front decisions right away. If your sound files are named correctly they can be the basis of your naming structure.

There are some decisions you will have to make up front. After you have imported your clips and audio you are ready to set up your sequence. You can use whatever structure you want, and this is more of an editing than a sound editing task, but it's my suggestion that you use the sound file names as the way to build your entire file structure. But to set up your sequence your editing application is going to ask you how you want your timeline structure in terms of sound.

Most editing applications work pretty much the same way except for Final Cut Pro X which is a somewhat different program. That said, the same basic parameters of your edit (and future sound edit) should be addressed at this early stage. These include the following:

Audio settings

Sample rate: 48,000 kHz (kilohertz) (samples) per second. Again, this is industry standard and there is no reason why any recording equipment you used should not be able to record at 48 kHz. Remember, this number was created to be explicitly different from 44.1 kHz created for CD recording. Both were chosen to be at least double the frequency that humans can hear (22 kHz).

Default sequence

Total video tracks: three to start with (this depends on your needs).
Total audio tracks: eight (again, that depends on how many you're bringing in; remember that in addition to your multitrack second system recording, you also have at least two, sometimes four, camera tracks).

Master track type – Stereo

Your master track is your master *playback* track. This means it's what every other track is going to be summing down to and represents your *final mix output*. The universal default is left/right stereo although it doesn't have to be. I talk below (see p. 94) about the different kinds of soundtracks that are used at the edit (and DAW) stage.

But for us ordinary humans, left/right stereo should suffice for now because, simply put, it relates to having two ears and is the most representative of human hearing. It is also how we have been listening to music, as well as a lot of film content, for the last 50 years. Now, what left and right mean here is two *channels* of audio that come together to be stereo. There are a lot of

differences between stereo and mono, but the main point is that mono is just a single *channel* of sound and there is no geometric space that your ear can perceive. Stereo means that you have two sides you can place or move sounds to and from.

The tendency with stereo is to place dialogue in the center (an imaginary location/position *between* left and right) and place everything else equally around the left and right channels. There are little pans you can do – if, say, someone calls from the left side of the screen you can place pan them left. But, in general, stereo film mixes tend not to work the aural field too much. That is the domain of surround sound mixing.

So your main output track is going to play in left and right stereo. This again is pretty much default. You can change it to mono which means single channel, 5.1, six channels for surround sound, mono (single channel), or multichannel – so you have separate channels that can play out as individual channels if you have the equipment to do so.

What you do to the master track does not affect your output in anyway, it's simply a monitoring track. It's the last track that your sound passes through before it comes out to your speakers. But your master track is what your ultimate output will be, therefore it's best to keep it at unity. And, in general, unless your editing application suggests something different, you're best off setting your master channel output to stereo and leaving it at that.

TECH TALK – Your master output will *not* send over to the DAW because it's the *sum* of all your tracks that is outputting to your speakers and what would be a master file.

Individual track types

Next, you need to set up your individual tracks. Most editing applications have the same or similar kinds of options and you need to select the number of tracks, and what each track container will hold. There are a number of choices.

Standard

This means the editing application can take any kind of track; it's usually the default for an editing set up. "5.1" means the track can hold a 5.1 sound file (six tracks in all), but you probably won't have any reason to put a surround file into a single track. 5.1 usually happens at the *re-recording* or mixing stage. Sometimes an audio file comes in with a six channel surround and you'll want to preserve that matrix. For example, effects may come in already split into a six channel surround so you'll want to keep them all on the same channel.

Adaptive

This can hold any kind of track including stereo, mono, and 5.1. It is also a flexible track that can hold multichannel tracks that come in from certain cameras that can record multichannels.

> TECH TALK – Remember, within your editing application a "track" is a container that can hold one channel or multiple channels.

Mono

A single mono channel. Often, complex sound mixes are built with many mono channels.

Stereo submix

A submix is a track that will have other tracks funneled to it, usually of the same kind, to form what is known as a stem. This can be the basis of setting up your project, which will eventually transfer over to your DAW with submixes intact. It's not a bad idea to begin to build your submix stems in your picture edit application, although it's not necessary. A savvy editor might build her/his project from the start with a few standard tracks for dialogue and then a submix stereo to channel all the dialogue tracks into. The same goes with the other two stems (effects and music).

5.1 submix

This is the same concept as the stereo submix, except you are anticipating that you're going to be building a 5.1 surround sound final output so your submix stems should also be in 5.1.

5.1 adaptive submix

If you're using adaptive tracks to hold multichannel tracks from certain cameras and video recorders (the Atomos series, for example) you're going to want your stems to be in the same format as those tracks. In my 40 years of filmmaking and film education I've never seen 5.1 adaptive submix used, but I'm sure someone out there has.

Mono submix

This is the same as adaptive submix; but you'd use a mono submix track for mono tracks.

I've probably left some out, such as 7.1, 9.1, and all their various tracks. But, if you're thinking this is overkill and too much information you are mostly right, except for this: you can set up your picture edit with stems, submixes that will make your picture editing easier and feed directly into your DAW sound editing phase.

Setting up your tracks for easy editing, DAW sound editing, and final stems in the picture editing stage

Your editing application should ask, for each track, if there is any specific pan you want. Usually, there's no reason to change the pan at this stage. Again, this control is a very finely tuned specification that you shouldn't have to worry about. I would leave it at zero; the output assignments are determined by the kind of track you select. Choose the number of audio tracks you want but remember, most editing applications will actually require RAM (random access memory) if you set up a lot of sound tracks, even if they aren't being used.

TECH TALK – Most editing applications will require you to set up a specific number of tracks for your edit. If you set up too few and then try to add them later, you might have to keep rendering.

Figure 12.1 provides an example of how a typical editing application will prompt you to make choices about what kinds of sound tracks you wish to use in your project, where they will be outputted to, and where they will be panned to. Normally, you don't have to touch panning and you can leave it at the default. Select how many tracks you think you'll be using for a preliminary edit based on the number of dialogue tracks you're bringing in, and maybe leave some room to move things around by opting for a few additional sound tracks.

This is the set-up window of soundtracks in a typical editing application. Like all digital editing applications, the one we're using here (Premiere Pro) has very advanced sound postproduction capabilities, and these capabilities start with the sound options afforded to us in how the edit is set up. You can even finish sound postproduction in your editing application, although DAWs are dedicated to sound postproduction so they tend to offer more flexibility and variety in how you can finish and manipulate sound than picture applications.

When you set up your picture editing sequence, you can also set up each clip to route its various channels to any channel structure you want. My advice is to leave it at stereo because camera sound will usually be in stereo and this will accommodate that tendency. Usually the defaults will suffice. But it's good to know the capabilities editing applications have in terms of sound, and also to understand that you can set up a lot of your DAW-based sound edit and mix at the picture editing stage in the picture editing application.

Figure 12.1 An editing application prompting users to set up basic track parameters before editing.

That syncing feeling

There are many ways to sync dailies, depending on what kind of syncing method was used in the location recording.

FOSSIL RECORD – I use the term "dailies" when talking about clips that are synced up and ready to be screened. It comes from an old Hollywood production expression where after a day's shoot the editors would sync up the day's scenes and then they would be screened, hence the term "dailies." In teaching I still find the term useful.

Clapstick sync

Clapstick sync is old school and has been around since sync sound started. A clapstick is simply a device by which you can have a reference of a distinctive sound hitting and a picture to match.

For about 60 years, this was the way it was done. The editor would then find the spike in sound on the "mag stock" (magnetic recording tape) and match it to the place where the sticks hit. That's it. There is pertinent information that should be filled out on the clapstick including frame rate, date, scene, and take number. Roll, of course, refers to old film stock camera rolls, but it could refer to SD (secure digital) cards or hard drives, etc.

Make sure you understand exactly where the slap actually happens; remember, sound waves come in subframes and a tiny tail of a second file can start before it claps. It's too late to talk about tests now – you're in postproduction with real stuff – but do some tests with your gear until you feel comfortable that you are able to fully read a clapstick. Also, a good boom operator might try to make sure s/he gets the boom to record the slate and then reposition for the shot.

Syncing with time code – Jam slate or "hot sticks"

In postproduction, the jam slate has time code that was fed by the recording device (in this case, the Sound Device 688). To reiterate, the sound recorder sounds out a signal to the digital slate and "jams" it or forces its time code on it. Then the slate shows the time code, so when you shoot it, you'll have a reference. Figure 12.2 demonstrates how you'll find corresponding time code on the sound track and the matching time code on the picture track, and then *change* the picture time code to be identical to the sound track.

TECH TIP – Poor man's sync assurance: once you have connected time code from your sound files to your video clips you can *export* clones of your clips with the sound connected so the metadata connecting them will be burned in the same way camera sound is connected to a video clip. Nothing beats this syncing guarantee.

Time code from jam slate

Pick any point in the sound file and match the time code to the slate in the video. You can insert marks at said points and sync them. Do whatever procedure your editing application requires to merge the files.

Change picture time code to match sound time code/jam slate

In your editor, find the clip and freeze on any frame. Change that frame to the time code showing. Then follow the procedure to continue syncing and merging the files based on time code. I find this the safest method; it will give you peace of mind when moving to a DAW for final sound postproduction.

Do this with all your clips then put the same clips on timelines with their corresponding sound clips and batch sync at the same time.

Figure 12.2 Syncing by finding corresponding time code on sound track to match slate time code then changing underlying picture time code.

Wave form sync

All editing applications provide wave form sync. This means they use the sound from the camera and match it to the sound files from your second system sound. I find this method works best if you put the clips on a timeline and the corresponding sound underneath each clip and then sync them up. There is also third-party software like Pluraleyes which does the same thing. Automated wave form sync can occur *before* the picture cut or *after* the picture cut if you cut with camera sound. It's recommended that you use it before you cut the picture because you never know what your second system sound is going to be like.

TECH TALK – If you plan on using wave form sync make sure you get excellent camera sound. Also, bear in mind that there are some rare instances when the camera might be far enough away from the actors that the sync can be milliseconds off (25 feet minimum, to be exact).

The way you choose to sync your sound and video clips will be determined on your location shooting. But make sure you end up with sound and video files that are connected permanently at the metadata level so you can edit without worrying.

TECH TALK – On high-end Hollywood films it's customary for clips to retain their original clip-based time code all the way down to the re-recording phase, so the postproduction process has a guarantee reference that everything is where it's supposed to be and in case any sound has to be replaced at the last minute.

Match frame sync

If you cut your picture with camera sound you can then do selects of the shots you used, sync up those clips, and match frame and replace them on the timeline. What match frame does is to take the master clip and if you sync that up and replace it on the timeline it will replace it in sync in the second system sound. It's probably not a recommended way to depend on, and match frame has a lot of other uses. But if for some reason you find you cut with camera audio you can use this method.

So, sync is complete, and much like a chef takes out a dish fully cooked from the oven seconds after we see it going in, let's go right into an edited scene, scene 73, in the next chapter.

13 Sound editing and mixing in your editing application

Some of you might wish to learn how to sound edit and mix *without* leaving your picture editing application. That is the purpose of this chapter. Bear in mind that anything you do to your soundtracks in the picture edit can be removed if you decide to move the project to a Digital Audio Workstation (DAW) for sound editing and mixing.

To demonstrate finishing sound postproduction while not leaving your editing application, I'm going to use a quick cut I made of part of scene 73 in *Turn Back Night* where Jane is seduced by Lisa 600.

The process is outlined below:

1. *Set up submixes as stems for dialogue, effects, and music.* In your editor find the "audio editing" view and work within this view.
2. *Select microphones.* To select microphones I need to make sure of which micis where. So my boom is on 3, Lisa 600 is on 4, and Jane is on 6. To make things easier I refer to the location sound notes provided by my mixer which show me precisely what is on each track (see Table 13.1).
 My ears (and the meters) told me there was nothing much to see here – the boom worked. I selected the boom and moved the radio microphones below, making sure to keep them in sync in case I needed them. I then toggled the sync lock so they stayed in sync on the timeline (even though there's a relation between the sound and video clips).

TECH TALK – Many professional sound designers and mixers never delete *anything*. They will move sound they are not using to the bottom of the timeline, making sure it stays in sync, disabling it, or muting it. I think it's a good practice.

3. *Normalize the sound.* We talked about normalization earlier (see Chapter 6) when we were testing the noise floor and responsiveness of various recorders and microphones. To reiterate, normalization is a way of raising the amplitude of your sound but setting a limit so it doesn't peak and

Table 13.1 Location sound report provides vital track information including the location of the mix, the boom, and the isolated microphones

File name	Scene	Take	Length	Start time code	Track 1	Track 2	Track 3	Track 4	Track 5	Track 6	Track 7	Notes
73T02.WAV	73	2	0:03:31	12:11:49:00	MixL	MixR	Boom	Lisa 600	Clay	Jane	Radio Voice	
73T03.WAV	73	3	0:03:13	12:17:42:00	MixL	MixR	Boom	Lisa 600	Clay	Jane	Radio Voice	

distort. Basic normalization is something you can do at the picture editing stage in a virtually non-destructive way to make your picture editing easier.

There are a few options on my editing application (Premiere Pro) but there are equivalent options on any editing application:

- **Set gain to**: this raises the overall gain monitoring to a certain level, but unless you have a very specific reason to change it leave it at 0.0.
- **Adjust gain by**: this raises the gain by a fixed amount of dBs (decibels) that you select regardless of whether that will cause peaking and distortion.
- **Normal maximum peak to**: this will raise the peak in a clip to a maximum dB level and raise everything else by the same amount. In other words, if the maximum peak is –10 and you raise it to –6 that's 4 dBs in total and *all* the sound will be raised by 4 dBs.
- **Normalize all peaks to**: the same as above except it applies to multiple clips on a timeline.

I normalized all peaks to –6. As expected, this pumped up the volume but also pumped up some noise in the room for Holly's close up. It sounded to me like the air conditioner was left on (the notes don't reveal that but it's a good opportunity to try some noise reduction). After I have normalized, I "scrub" the play head over the track and make sure the levels are fairly even.

TECH TALK – When normalizing the sound, it's very important that any sort of amplitude adjustment is done *non-destructively*, that is, it's only temporarily added onto to the sound file as *metadata* and leaves the raw sound intact. Some DAWs that interact with picture editors (such as Avid/Pro Tools or Premiere Pro/Audition) can alter sound on the timeline, and if you don't know what you're doing you can wind up delivering altered sound so that the sound postproduction workflow is hampered.

4. *Split dialogue tracks based on shots.* I split them into A/B based basic shots. I've moved all of Holly's clips to one track and created a basic A/B split by putting Jenna's on another track so like dialogue recordings are on the same track. I first tried to reduce noise on Holly's track before I even did tone extensions, fades, dissolves, etc. Once like shots, in regard to sound, were on the same track I could denoise track base.

TECH TIP – AUDIO CLIPS VERSUS AUDIO TRACKS

Now is a good time to introduce you to an important concept in sound postpro-duction clip effects versus track effects. It's going to come in play often, but here is the gist of it. A track is a container that holds sound. It can hold multiple clips and even multiple channels. It's good to have this freedom to process and control entire tracks because there might be something generic you want to do to a whole track. For example, say you have a dialogue scene where there is a noisy generator going through the whole scene. You pretty much know you want to EQ (equalize) it out of the whole scene even though there are many different clips with different levels of the generator, given the different positions of the microphone. You can then *globally* process sound throughout the track instead of having to process it out of each individual clip. This saves processing power. You might ask, "What if the different levels of generator sound require different levels of process?" Well, there's a way to do that at the track level.

5. *Do a little noise reduction.* I used the denoise selection in the track and used about 20 percent of it on Holly's track and 40 percent on Jenna's. If you have a sound team doing your final mix, it is best to leave noise reduction to professionals. If you are going to be finishing the sound yourself, you're going to have to learn how to do basic noise reduction, unless you get extremely lucky and have production tracks that don't require any.
6. *Create fades and dissolves with keyframes.* Keyframing is a creative way to do customized fades and crossfades and dissolves within your editing applica-tion. Keyframing allows you to plot on the actual sound file how you want the fades and dissolves to be constructed.
7. *Add some room tone back in.* I added some air conditioner from my sound effects library.
8. *EQ the dialogue.* I EQ'd the dialogue using a parametric equalizer. I did it based on tracks (the A/B splits) and removed some low end on both tracks. Then, using a sweep of the parameters in ranges that are associated with voices (85 Hz to 225 Hz), I found some annoying sounds in the recording and ducked them down. I used separate EQ's on each track and was then able to tweak the output gain on each of them so they matched in volume.
9. *Added music from sound effects library.* I chose an electronic piece of music with a pulse so it would help cover the scene.

I've just scratched the surface of what can be done inside a typical editing application. They all have powerful sound postproduction capabilities, albeit not as easy to use as a DAW when posting sound.

Auto sound design in picture editing apps

Another way to do sound postproduction without leaving your picture editing platform is to use new automation tools that have become available in all

Most picture editing applications have sound editing views including clip mixer or track mixer. The difference between clip and track processing is more significant in a DAW version of sound postproduction but, in summary, you can treat the sound of every clip individually, or you can treat tracks as a whole, or both at the same time. You might have a very specific noise reduction problem that is on a single clip *or* you might have noise on a whole track, so you process the entire track at the same time.

Keyframes allow for customized cross fades of A/B dialogue tracks. Note there are many different variations of keyframes that most editing applications will have. I've never had to use more than a linear one or a Bezier for a more nuanced curve. What's also interesting to note is that you can copy keyframe information from a motion effects app like Aftereffects and copy keyframes into a sound edit timeline to match certain points of change in the visual effect and audio effect.

Figure 13.1 Sound editing in picture editing applications.

editing applications and DAWs. They can be very useful, especially just to do quick fixes to facilitate picture editing.

In my editing application, Premiere Pro, the panel to access these tools is called "Essential Sound." There is a similar panel in Audition. These sound design automation panels can do everything including auto level, noise reduction, EQ, compression, etc. I don't really use these features myself because I feel I can get better results by manually working the sound. That said, as with many of these tools, they can help you gain insight into your soundtracks and perhaps understand how to approach fixing them when you do decide to work them manually. Of course, you can start with the automated sound design tools and tweak them, or use a combination of automation and manual sound design.

Figure 13.2 shows different examples of how you can set up advanced sound postproduction functions in the picture editing phase, as well as a sample of a picture editing application's automated sound processing capabilities.

TECH TALK – Automated sound design features in editing applications and DAWS often use RMS Normalization to match loudness levels to a certain average peak level. So you should learn to apply RMS Normalization yourself, because it affords you greater flexibility over your sound tracks.

Routing of tracks into "submixes" means like tracks (dialogue, FXs, music) can be grouped in the picture editing stage. This is helpful if you either finish sound postproduction in a picture editing application or wish to move to a DAW and retain whatever track/submix structure you created.

Many editing applications and DAWS offer automated sound design platforms that utilize RMS Normalization and elaborate algorithms to provide you with an easy way to fix sound. But most sound designers and sound mixers prefer to work more manually. Check your editing application and/or DAW to see what automated sound tools exist.

This is an example of using clip EQ to process a problem in an individual sound clip. As you can see it's pretty sophisticated.

Figure 13.2 Most picture editing applications offer advanced sound postproduction functions that can be set up/or applied in the picture editing phase.

14 Organizing your picture cut for export to your DAW

When you organize your picture cut to move it to a Digital Audio Workstation (DAW) for a sound edit and final mix, remember that you need to have your picture locked first. A locked picture simply means you aren't going to change the timeline. The cuts and the length will stay the same.

Then you'll need to collect all your location assets first, including any wild sound, wild Foley, and room tone you might need for the scene. Keep them in the same scene folder.

Now, I'm going to make a simple transfer over to my sound DAW. In this case, I'm using Adobe Audition, but you can use any professional sound DAW you feel comfortable with. Adobe Audition is a very powerful film sound postproduction application with some limitations but nothing that you can't work around. Perhaps its biggest limitation is that it doesn't "comp" when it records Automated Dialogue Replacement (ADR) so you can loop and do automated repeated takes.

For now we're going to export over to our DAW, but it will take some preparation. (We will be doing some sound editing and mixing within our editing platform just so you can see what that is like, but for now let's set this up.) So, in order to move our project over to our DAW I'm going to need some reliable sync references. I'm doing this assuming you'll create matching time code between picture and sound. It's advisable to do whatever you can to create matching time code for your sound postproduction process. You can easily do this even if you had no time code reference for your location recording. Sync using your clapsticks or your camera audio/wave form and then go in and manually change the starting time code.

First of all, you'll need to create your *countdown leader*. When you do this you want to make sure the technical parameters are set correctly; in this case the sample rate should be 48 kHz and the frame rate is 23.976 (23.98) which functions as 24 P (progressive scan). If these two parameters are off, you can run into trouble later. My DAW Premiere reads what the technical parameters are in the timeline and *mimics* this so it's automated.

Figure 14.1 shows a universal countdown leader and the frame that shows the 2 pop, the sync reference.

Drag the universal counting leader into timeline by *inserting* it and rippling everything else down in sync. Test the leader and know how it works, especially the 2 pop. This is why: you'll drive yourself crazy if you're relying on a 2 pop and notice this weird little quirk, namely, that the first hint of a sound is when the

Your picture editing application should supply universal counting leader. If it doesn't there are places where you can get it cheaply or free. When you use it, make sure it matches the frame rate of your picture editing. Also picture frames are exact. Sound frames can be subdivided more finely and a wave can have its head and tails extending beyond a clean frame cut. And remember, sometimes when you're reconnecting your final mix to your picture from your DAW mix a 2 pop heads and tails might be the only reference you have.

TECH TALK – The universal countdown leader, or "2 Pop" as it's called, is for the beep to fully sound when the frame is on the 2. However, a tiny tail of the beep begins before the 2 frame plays. This drove me crazy when I was submitting a film for distribution, but I came to learn about how sound can bleed in and out of frames enough to detect it. The same applies with understanding when a clap happens.

The 2 pop, when it hits, will be distinct and loud.

Figure 14.1 A word about universal counting leader.

frame reads "3." That is similar to hearing a tiny bit of sound of a clapstick hitting *before* the actual sync slap. Therefore, I will also move the play head to where I hear the full "beep" which will be when it's right on the 2 pop, which is the next frame. So I don't get thrown by hearing a tiny microsecond bleed when the play head is on the 3 – I know the full beep is what corresponds to the 2 frame. So remember this for when you're resyncing everything back into your editing application and using the 2 pop because it can drive you crazy (it has me). The 2 BEEP is a full sound that spikes the meters.

So the countdown leader is in place. The next set up phase is to set the time code. This is a two-step process so it's important to get it right. First of all, when prepping a film for sound edit always use some sort of continuous strand video or adjustment layer or transparent video on top of your edited timeline. All digital editing applications will have such a feature. This will create a continuous time code over the whole length of the film. After this is done, drop time code onto the continuous layer and the time code should appear.

After this I drill down on the adjustment layer with the continuous time code in case I need to modify the STARTING TIME CODE. Change the opening time code to 00:59:52:00. This will set you up so the 2 pop will last six seconds to 00:59:58:00. This is industry standard. With the academy leader that comes with my workstation Premiere I have to cut it so the first frame is PICTURE START. Figure 14.2 shows how to set up a time code in a picture editing application, and how some picture editing applications can automatically export to a DAW internally.

Once this process is done, you're ready to make your scratch print for sound editing – or, as I like to call it, our *slop print*.

TECH TIP – It's smart practice to export a stand-alone movie for your scratch print and *not* rely on using dynamic link or any other interlink that might connect your DAW to your editing platform. The reason is that if you export a stand-alone movie you know that it exists as a stand-alone movie and can play as such.

Make sure you copy the beep from the 2 pop onto every single track of your dialogue. Then take the exact same universal counting leader and drop to the *end* of the film, just as you did at the beginning of the film, and copy the 2 pop on each subsequent track. Now that the scratch print is ready, we can set up the sound edit session.

There are a couple of ways of getting your information over to your DAW. You can use whatever dynamic link is available between your editing application and your DAW. Avid and Pro Tools have such capabilities, as does Premiere Pro/Adobe Audition. Regardless of the software you are using, if you are sending your project over internally *within* the software it should ask you about some very important parameters:

Add continuous video on top of your picture cut to allow you to build a "timeline" time code. Some editing applications call it "transparent video" or "adjustment layer." Your time code will default to 00:00:00:00 in "One Hour Time Code." Find your PICTURE START frame and adjust this to 00:59:52:00.

My editing application (Premiere Pro) gives me the ability to send directly to Adobe Audition internally. You might have a similar structure with Pro Tools/Avid or DaVinci. Make sure you choose not to transfer clip and/or track effects and that you have adequate handles (at least 1 second, maybe 2). Handles give you room to extend the heads and tails of a clip on a timeline to allow for fades, cross fades, and dissolves. Pan and volume information is checked because you want to send it over. It tends to be non-destructible but make sure of the nuances of your editing program and how it send over to a DAW.

These are new sound files cloned from the picture timeline for a 90 second scene. Notice two sets of files .wav and pkf files. The wave is the audio; you can drop it into iTunes and play it. The pkf is specific to my DAW so the timeline can read the sound files like a render file for timeline purposes. A DAW will need rendering files so it can "play the sound," so to speak. This is all you need to know about the file structure and you should learn how it works for your DAW of choice – but plan to be organized upfront.

Figure 14.2 Importing a project into a DAW.

1. Audio handles. This is a function that determines how many frames or seconds you want to come on the sound clips above and beyond what is on the timeline. In other words, moving to your DAW might cut you off from the original underlying scratch media and it wants to know how much you need to build you're A/B checkerboard sound editing. I usually choose 1 second/24 frames.
2. The path or where you'd like this all to go. For file management efficiency, it's best to create a separate folder for your sound assets (including slop print) to go to.
3. If you editing platform sends to your DAW internally it will ask you whether or not you wish to send a video. I always say "no" because I'd rather create an external movie and reimport it later.
4. Audio clip effects/audio track effects. You can choose to either not send your clip/track effects or to send them. In general, I like to start over in my DAW and say "no" because I fear saying "yes" might cause the process to *print* effects onto the clips and tracks which I don't want.
5. Pan and volume information. You can say "yes" provided it's easy to manipulate in the DAW. It's a good place to start.

TECH TIP – Don't forgo having a start beep at both the heads and tails of your entire film on the timeline. There's nothing more disheartening than to think your sync is drifting when you match back a DAW output to picture. If your start beep *and* your end beep are in sync, it's plain and simple. While there are more sophisticated ways of maintaining sync using time code, filmmakers on a budget might not have such luxuries. Of course, you could *encode* your DAW's underlying time code to match the timeline's time code in the editing application as well.

File organization is key with sound editing

We've discussed file organization on the recording side of the equation. Staying organized on the *postproduction* side of the sound equation is even more important, and can be a bigger challenge.

Sound editing has its own particular nuances concerning file management, and they can really cause confusion if you're not cautious. It's important to understand how your DAW works and how the connection between your editing application and DAW interchange (if they have interchange capabilities at all).

We'll be exploring how to bypass the interchange and use a more universal industry-standard process called OMF (open media format) later (see pp. 112–118). But just as you have an excellent file structuring system for your picture edit (you do right?), you need to have an even better organizational system for sound editing. This is because, guess what – when you move your picture edit to a DAWs, be it via an interchange process internally within the

software platforms, a straight file export, or an OMF transfer, these all generate a lot of new sound files. Remember, sound has multiple clips and tracks and each clip will generate a new sound file.

The file structure system with most DAW transfers is the editing application and it will strike brand new copies of *all the sound files* and put them in a separate folder. If you don't designate that folder to send to someplace specific, it will default to the place where the picture edit file is.

Now, onto the interface of the DAW. In my case, Premiere sends audio tracks over that are already on a timeline but without a video because I selected *not* to send the video. I selected this because I don't want to trust the engine of Audition to have to generate my video.

Set up your project window so you have access to your media and you can find your sound easily as well as any other sound assets you might have already collected.

The next phase you'll do with your DAW is to get the movie into the timeline. You'll need to create a video track and a stereo audio track to drop it in. While it might be tempting to just drag the movie into your timeline from your desktop (or wherever it is you exported it) don't. Change your starting time code to industry standard 00:59:52:00, usually starting on the "picture start frame" as shown in Figure 14.3.

TECH TIP – Always have a formal way of keeping your project organized, especially when it comes to moving an edit to a DAW to work on sound. Don't just drag things into the timeline from anywhere because you'll eventually lose things. Bring the sound clips you want to use in your project folder and *import* them from the project folder. This is a principle that is standard for digital editing (picture and sound), because sound tends to generate more files than picture editing.

TECH TALK – The start of your countdown leader should be 00:59:52:00 with the countdown leading to a beep at 00:59:58:00 and then the first frame of picture at 01:00:00:00. At first this seems counterintuitive but actually it's comforting to look at a time code and say we're in the first hour of the picture, at so and so minute, frame, etc.

OMF versus AAF

So you've found out how your editing workstation internally links to its own DAW as is the case with Avid/Pro Tools, Davinci, Final Cut Pro X, and Premiere Pro/Audition, etc. This kind of dynamic link has its advantages in that it's obviously the easiest way to get sound and picture into a DAW. That said, I'd like to introduce you to a way of sending your sound edit to a DAW that is *not* connected to your picture editing application by using industry standard

Reset starting time code to match the burn in (and underlying time code of clip): 00:59:52:00. You'll also need to make sure that the frame rate matches the frame rate of your project. I shot in 23.976 so it checks out here.

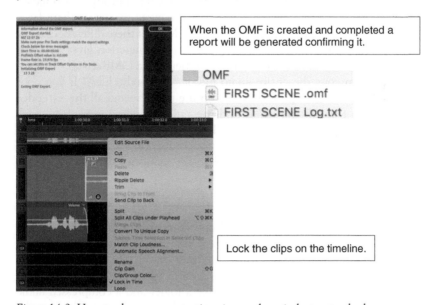

When the OMF is created and completed a report will be generated confirming it.

Lock the clips on the timeline.

Figure 14.3 How to change your starting time code to industry standard.

protocols, OMF (open media format) and AAF (advanced authoring format). We'll look at both techniques and discuss the advantages and disadvantages of each.

OMF (open media format)

First, we'll look at OMF. It's been around a long time and some sound editors and mixers I've worked with prefer it. Your editing workstation will have an export for it, and it should bring up a dialogue box, typical in all edit platforms, with the following information:

- OMF title
- sample rate: 48,000
- bits per sample: 16
- files: embed audio
- format: wave
- render: trim audio files
- handle frames: 24
- include pan.

The sample rate, 48 kHz, will transfer over from the project (but check it anyway). The bit rate defaults to 16 bits but if you recorded location sound at 24 bits you could select 24. Since bigger data storage is much more affordable, why not? Your editing application might ask you to either "embed audio" or "separate audio." I always choose to embed audio because this will give me the metadata links to the actual project. In other words, sound files will be already connected on your timeline. If you choose "separate audio" you'll have to reconnect them later. This is not a big deal; it's just for your information. Most of these differences come down to organizational preferences. The separate audio function gives you easy access to the sound files *without* needing to open them in an OMF set-up.

Finally, you can copy the entire audio file or "trim audio files." If you copy the entire audio file you will pull the audio on the timeline and all the extended audio on the clip through the heads and the tails, including everything each clip is connected to in the scratch media. This can be helpful if, like me, you're going to pull a lot of your room tone from the production tracks. If you choose, as I did here, to *trim* the audio you need to set frame handles – my editing application defaults to 24 frames (1 second).

However, just to be safe you might want to increase it tenfold, to 240 frames (10 seconds) to give you plenty of room. This will come in handy, especially when creating overlaps for dialogue in A/B checkerboard configurations. Include pans, which will include all the left/right panning moves you might have made, again all easily removable in the DAW timeline. At the end, you get a report called an OMF Export Information report as seen in Figure 14.3.

Wherever you send the OMF, it will make a folder and a compressed audio folder that contains all your audio and data to make sure it lays out in a similar

way to your timeline. Your DAW will know how to unzip it if it can read OMF files, and most of them can.

TECH TALK – OMF is a great way to get a video project with multiple dialogue tracks *into* a DAW because by default it will split all stereo tracks into separate tracks, which is a great way to set up. Sometimes, stereo camera soundtracks come in paired and OMF splits them.

Now *copy the movie* that we used in the previous set-up *into your OMF folder.* Remember the golden rule: *don't take anything into a timeline unless it comes out of the project folder.*

I created a video track in my DAW and added a stereo audio track to hold the sound from the exported movie as a reference. Notice how the beep lines up right away visually. The next thing you need to do is "lock" them in time and go in and reset the starting time code to 00:59:52:00 to match the time code of the film and the burned-in counter. Now you're ready to sound edit.

TECH TALK – LOCK YOUR TRACKS IMMEDIATELY!

Every DAW has its own way to lock your sync. You must figure it out and deploy it right away. There is no other simple method unless you want to go through the trouble of exporting *all your location dialogue tracks* with time code and reimporting them.

While all of these technical gyrations might seem a bit difficult to try to get through a simple (or complex) sound edit, they are industry standard practice. But there is a more important point about setting up this way: you can communicate with other artists using time code (such as composers, etc.), and you can facilitate your ADR, Foley recording, and editing sessions as well as your sound creation. Time code will also help you if you're going to try to create music yourself.

TECH TALK – ONE HOUR TIME CODE

Your time code officially starts 8 seconds before the first frame of picture, which will read 01:00:00:00. This might seem confusing at first, but it comes from the old analog days and relates to film reels, etc. The "01" means the first hour of the film. So 01:10:15:13 means you're in the first hour of the film, 10 minutes, 15 seconds, and 13 frames in. To me, it's much easier to look at this and know where I am in the film, and it will become intuitive to you as well.

AAF (advanced authoring format)

AAF works in almost exactly the same way as OMF but carries more metadata such as file names it will carry over, more effects, and more time code information, which can be priceless. Most editing applications and DAWs will work with either.

Now, it's time to do a little warm up sound editing just to get the sound editing ball rolling. First of all, I implore you to *keep your reference scratch mix and camera sound present* throughout the entire edit and mix process. Professional sound designers are often in the habit of keeping everything on the timeline and just muting what they don't want. I strongly suggest you do the same. A real sound designer's timeline will have many tracks, half of which are muted at any given point. But that doesn't matter – all that matters is what clips are in play at any given moment.

Just to be sure, I ensure that the 2 pop on the dialogue tracks match with the scratch reference track. An easy way to do this is to open up your mixer and drag the play head over the beep and make sure all the spikes are equally up.

For this little scene of getting the ball rolling, I'm going to do a few things. First, I'm going to mute everything I don't need and then do a simple sound edit. I specifically want to use sound as a character in the film, so I'm going to start with the opening image of the windows flashing on and off. I choose this as the opening image for the film because it immediately evokes a sense that something is wrong, and with all the lights and movement I know that sound can play an important role in connecting the interior and the exterior.

On the clip I've muted everything except tracks 9 and 11, because this represents a stereo left and right that came in. From looking at the wave files it looks to me like as though the boom will be the most usable track in my dialogue edit.

I know from my sound report that what I have here is a MixL, a MixR, and a boom – basically a three-way redundancy. So I can choose any file, but I'll stick with the boom.

Next, I open up my sound effects in the media browser. All DAWs give you the ability to sample your sound effects right through the browser. Make sure, though, that your project has access to whatever sound effects folder you want to access. Mine is Adobe Sound Fxs and a few other things. Keep your sound effects in one master folder that you can easily point towards. I also notice that within my

Table 14.1 Location sound report for reference when selecting microphone

1T01.WAV	1	1	0:00:54	12:40:09:00	MixL	MixR	Boom
1T02.WAV	1	2	0:01:05	12:42:26:00	MixL	MixR	Boom
1T03.WAV	1	3	0:01:11	12:45:56:00	MixL	MixR	Boom
1CT01.WAV	1C	1	0:00:26	12:55:34:00	MixL	MixR	Boom
1AT01.WAV	1A	1	0:01:07	12:48:42:00	MixL	MixR	Boom

DAW, the cursor is moving in fractions of frames rather than whole frames. Again, this is due to the fact that sound editing involves minute tweaks where you might need to get at the subframe level. Find out how your DAW is set.

So, the first thing I note is the rhythm of the lights blinking on and off in the hotel windows. I test to see if the blinking is hitting on frames but it's not, so I'm going to settle for a quick sound edit. I settle for *Technology AM Radio Station Change* in Adobe Science Fiction effects. It's not a perfect effect but it will do.

As is standard practice for sound effects editing, when I'm planning on changing perspectives (exterior to interior in this case) I create a duplicate track of the effect right underneath. This will introduce you to the concept of checker boarding.

FOSSIL RECORD – I still use checkerboarding when I sound edit. I understand that not all sound editors do so. Checkerboarding is a concept left over from analog days when sound would have to be set up to pass through in a linear fashion. You would split A and B tracks (checkerboard) so that you'd be able to set up the mixing board to have tracks that were most like each other going through and could manipulate them. However, given the ease with which we can manipulate digital tracks, some don't believe it is necessary to split tracks. I still do.

Notice the overlapping link of the dialogue clip in Figure 14.4. This is where the fraction of frames comes in because sometimes I want the transition to be so quick and smooth you don't *hear* it; rather you *feel* it. But this is a general place to start in terms of thinking about overlaps. If it's a simple transition of the same

Figure 14.4 When checkerboarding dialogue tracks and creating transitions each transition must be handled individually.

sound effect from the outside to the inside, you want to have *minimal even overlap on each side of the cut*. Also, I make the simplest little hook of the fade out so it's almost a mirror of one another. So now I've set up a simple perspective split using a cheapo canned effect. I want to go inside the head of the character, Lisa 600, a cyborg, and she is hearing all the things going on in the rooms inside her head.

So, by using sound I can communicate that there is something out of the ordinary about her. I also slowed down the clip of the agent approaching and this created slow motion sound which, again, I was able to manipulate a little bit. I split the traffic ambience so I can duck out the higher frequencies on the inside. When Lisa 600 grabs the agent's wrist I used electricity sound and bone crunch. I left the natural Foley of him hitting the bed for now, but will probably replace it as it's a prop bed air mattress and doesn't sound right. Now go through the paces of setting up this basic little scene just so you can feel your way around creating an OMF or an AAF and using sound effects to finish the project.

15 Basic sound design project structure

Using the same OMF (open media format) project as in Chapter 14, I'm going to walk you through a generic sound design and mix project file, and discuss various items that you can use to build your sound design as you go along. This will be a quick overview – topics such as dialogue editing, Foley, music, etc, will be explored further in later chapters.

The specimen scene from *Turn Back Night* I'm going to use is when Clay is about to propose to his girlfriend, Felice, and she breaks up with him. It's full of traffic and crazy variances in ambience sounds, so let's prep it, export the movie, export an OMF, and open it in our Digital Audio Workstation (DAW) of choice. To reiterate the sequence to get your movie into a DAW with an OMF (or AAF, advanced authoring format), you need to follow these steps:

1. Drop universal counting leader at the beginning and the end.
2. Cut it at "Picture Start." This will set up the counting leader at 00:59:52:00 and in the 6 seconds until "2" it will be at 00:59:58:00.
3. Duplicate the sound for all the tracks. Take note of how many camera tracks there are (in this case the Atomos generates four).
4. Drop transparent video and connect the entire scene.
5. Drop a time code window onto the transparent video.
6. Change the starting time code on the transparent video.
7. Change the starting time code on the timeline to match.
8. Save everything.
9. Create a folder called "OMF scene #14".
10. Export with "Match Sequence Settings." Note: DAWs are not going to take every single CODEC (compression decompression algorithm) you can feed them; you'll have to find out if your DAW can use the CODEC you shot in or which one you should export to.
11. Send the movie to the OMF folder.
12. OMF using all the settings I showed you (see p. 107) into the OMF folder.
13. Open your DAW (in this case Audition) and open the OMF.
14. Highlight everything in the timeline and "lock it."
15. Save the project, pointing everything into the OMF folder for the scene.

And I'm going to add a few extra steps:

16. Hold off on importing the movie just yet.
17. Highlight the entire timeline and lock your tracks.
18. Copy and paste your tracks onto the clipboard.
19. Open a template for film mixing in stereo. In Audition it is called "Film Sequence Stereo."
20. Paste the contents of the clipboard (the raw sound tracks only) onto the timeline.
21. Create a video track.
22. Create a stereo track.
23. Drop the movie into the timeline and make sure it's in sync, head and tails (you should always do this).
24. Make sure everything is in sync by checking head and tail sync. (My movie picture beep was off by a few frames; I had dropped it in wrong. I corrected it.)
25. Change the start time code to 00:59:52:00.
26. Command "A" the entire timeline and lock it again. This will ensure the picture locks in place as well.

Before we start the sound editing process, I want to point out the structure of this wonderful template (which I'm sure you have or can easily build). Figure 15.1 shows a basic sound design/mix template that can be built upon for any size film sound postproduction job.

All DAWs will have similar film sound editing and mix templates, but if yours doesn't you can create one. The structure shown in Figure 15.1 is useful in enabling you to stay organized. Using a mix template helps you to be already organized when you start your sound design.

When you drop your tracks into a timeline of a mix template make sure they don't come with processing already on them. Certain film templates in DAWs will open with some processing plugged into the tracks in the "On" position. For example, in my DAW Audition the "Film Sequence Stereo Template" comes with "Speech Volume Leveler" applied to all the dialogue tracks. Speech Volume Leveler is available on all DAWs and editing applications in some form or another. It uses RMS Normalization to let you normalize dialogue tracks. It's like auto exposure in cinematography. As explained in Chapter 6, because RMS in an averaging of all peaks it has a tendency to do all kinds of crazy things to background noise – therefore, I forgo RMS Normalization (Speech Volume Limiter) for dialogue tracks and opt to make adjustments to amplitude manually. So, I first clean up the onboard process to make sure it's not in play during my sound edit.

The first thing I'm going to do is drop the camera tracks that come in as tracks 1–4 all the way to the bottom of the timeline, out of the way (but still in sync). If I don't have four empty tracks I'll create them below everything else. Those camera tracks came over from the editor that were recorded onto my Atomos recorder. I'm pretty fastidious when I'm sound editing and prefer to

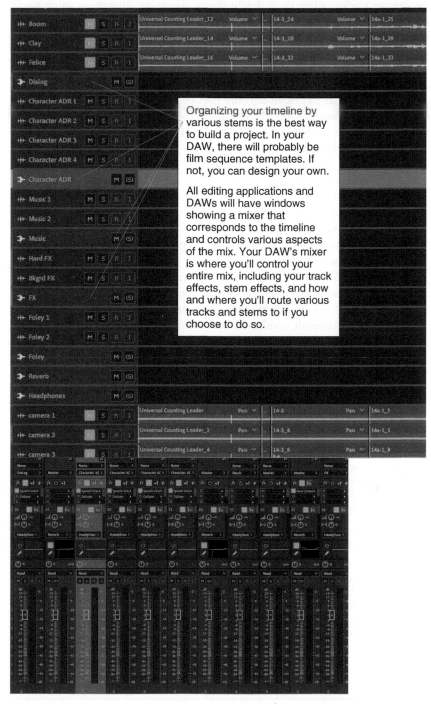

Organizing your timeline by various stems is the best way to build a project. In your DAW, there will probably be film sequence templates. If not, you can design your own.

All editing applications and DAWs will have windows showing a mixer that corresponds to the timeline and controls various aspects of the mix. Your DAW's mixer is where you'll control your entire mix, including your track effects, stem effects, and how and where you'll route various tracks and stems to if you choose to do so.

Figure 15.1 A basic sound design/mix template.

mute camera tracks rather than delete them. There are instances when you'll want to have the camera track available, so leave it intact but place it at the bottom of the timeline so it won't get in the way of sound editing.

Now let's talk briefly about the structure of the timeline. These groups of sounds represent the major groups in a sound design mix. Think of them as the major food groups. Note that in Table 15.1 Dialogue and Character ADR (Automated Dialogue Replacement) are part of the same overall group but why not keep them separate? After all, it's likely they will be treated differently in terms of the kinds of processing they might need.

Other tracks explained:

- "Reverb Submix" (This is a master sub channel that you feed any of the individual channels to, and any of the submixes, if you want to apply reverb to a group of tracks simultaneously. For example, say you have a lot of different battlefield shots going off in the distance that require reverb; you could send them through a reverb stem to give the sounds a global sense of distance emphasized by the reverb.)
- "Headphones Submix" (This is self-explanatory: if the actor is doing an ADR session and wants a specific mix this gives you separate control.)
- "Tracks 17–20" (where I dump the camera tracks).
- "Master" (your overall combined output). Note: your master track is not actually a "track" per se, it's merely the sum of all your tracks.

This set-up might not be the way many sound designers or mixers work, and it's probably a little oversimplified compared to how a Hollywood sound postproduction workflow might go. Sound editing on big films is splintered into all these

Table 15.1 Basic track and submix layout for a typical sound design project

Dialogue 1	Character ADR 1	Music 1	Hard FX	Foley 1
Dialogue 2	Character ADR 2	Music 2	Background FX	Foley 2
Dialogue 3	Character ADR 3			
Dialogue 4	Character ADR 4			
Dialog submix	Character ADR submix	Music submix	FX submix	Foley submix
Includes all location dialogue production tracks	Includes ADR tracks (Automated Dialogue Replacement, voice over)	At least two music tracks for the purposes of crossfading but some mixes might have many more	Hard FX (such as explosions, punches, glass breaking, doors opening). Background effects like ambient noise *that is not part of the location tone*	Foley sounds that are created by an actor that will have to be synced up.

Note: FX – sound effects

different areas and then finally brought back together and "mixed down" to a final composite soundtrack – stereo in smaller budget films, 5.1–7.1 in bigger budgets works. It would probably be considered a little prosumer, and many sound editors might view having so much on the timeline at once to be clumsy. But for our low-budget independent film purposes, it's great, because it puts us in the driver's seat. You could of course choose to sound edit various stems separately then bring those tracks into a master mix. I strongly recommend not just relying on a "submix" stem, and having the ability to access the individual tracks of the stems.

Submixes flow to one *master* fader to give you more control over the various groups of sounds. You can solo just the dialogue tracks, mute the music, etc. You can raise or lower the gain of any of the submixes, or choose to process submixes globally. For example, you might want to use a multiband compressor on your dialogue before sending it to a final mix. Or you might want to add reverb to your entire music submix, or to pan your ambiences (background effects) to one side. This gives you control over the stems.

TECH TALK – There are a few more technical reasons as to why you should keep your submixes separate. First, if you ever go for foreign distribution you'll have to deliver three separate stems (dialogue, music, sound effects). This makes it easier for the foreign distributors to replace the dialogue with their country of origin's language. Second, if you're making a teaser, trailer, or any other promotional video of your movie, you'll need to have your music split out from the rest of the movie. This is because if you cut a trailer you'll be splicing pieces together and the music will be jumping around. This set-up allows you cut without any music and then layer over music that will have its own rhythm.

So now we have the set-up we're going to do a couple of simple dialogue edits that will lay the groundwork for more sophisticated sound editing later.

I auditioned the sequence with just the Left/Right Mix and it sounded pretty good. I could've done a better job picture editing because I don't like the delivery on one of the lines. But that's not our job here – picture editing, hypothetically, is long gone at this stage.

The Left/Right Mix is perfectly usable, but there are significant variances in the ambient noise that takes us out of the moment, out of the story – and I haven't tested to see if there's any phasing between the radio microphones. When there is a lot of traffic noise, I tend not to use the location mixer's Left/Right Mix because you're piling on traffic noise from multiple microphones.

Table 15.2 is a reminder that you don't necessarily want to use combined radio microphone tracks with boom tracks because you could be piling on noise. There is a "cutting dialogue to the bone" technique whereby you literally slice the words out of all the noise as far as possible, then noise process the remaining dialogue. After this, you might be able to combine microphones, but I usually only do so in quieter background noise scenarios.

Table 15.2 Chart showing how noise accumulates with multiple location tracks

Boom	Radio microphone 1	Radio microphone 2	L/R mix
Traffic noise	Traffic noise	Traffic noise	Cumulative traffic noise
Dialogue	Dialogue	Dialogue	Cumulative dialogue

Now I have to build my timeline for sound editing. To do so, I have a wide variety of tools at my fingertips, as I'm sure you have with your DAW of choice. While there is a lot that can be done to sound by the sound designer, I want to start us off thinking traditionally when a picture was cut and "locked" and soundtracks were edited, all in preparation for the mix. Nowadays, with the ease of digital technology, you can start mixing as you sound edit.

So let's do a little dialogue edit and then lead right into a submix that the mixer can either choose to use or disregard for their own dialogue mix. I use a hierarchy of tools to build a dialogue submix. These are:

1. Select microphones (nothing to see here; I'm using the boom).
2. Remove unwanted speaking like the director yelling "action" (me) – sounds which the editor should have taken out (me also). (However, those "left in by mistake" will introduce us to the technique of tone extensions via a mix paste.)
3. See how many tone changes you can fix with simple A/B checkerboard editing sleight of hand changes. This sometimes means how you blend each transition with enough overlap and try to smooth everything out to the ear, enough to mask shot and background noise change.
4. Point 3 above requires you split or checkerboard your tracks and put "like" clips on the same track and leave enough room for overlaps. (Note: some dialogue editors will split by character, some by character *and* like track. I start simple and just go by ear and shot changes. Remember, the goal with your dialogue edit is to make the shot transitions – and changes in microphone position and hence variances in levels of background ambience – invisible to the ear.)
5. Now start to look at overall levels and see if you can balance them.

These next steps can also be done in the dialogue submix, or you can wait until the final mix.

6. Do some equalization (EQ).
7. Do some basic compression.
8. Add backgrounds to provide another *continuous* background noise to help smooth everything over. I opted for birds and maybe a lawn mower/ sprinkler, but we'll see how that plays out.
9. Do some overall compression on the submix of dialogue if you think the dialogue is pretty close in levels, etc.

Once we have our little dialogue mix we'll do some adding:

10. Add some Foley (canned for now).
11. Add a little canned music.
12. Do a little mixdown.

Figure 15.2 shows a basic layout for a film sound edit and mix providing ample storage tracks for camera sound.

All DAWS will have audio to video layouts that can accommodate all stages of the sound postproduction process. Notice all the extra tracks created below the stem areas which provide ample room to store tracks and clips you might not be using but might use later.

All DAWS will have history tabs where you can not only *undo* tasks but rearrange the order in which they happen. This matters because in sound postproduction the sequence of what follows what can be as important as what you are doing to a piece of sound.

Figure 15.2 Basic layout for a film sound edit and mix before dialogue tracks are set up checkerboarded.

I created three extra dialogue tracks and stemmed them to the dialogue submix. Now I'm ready to move things around. I've identified two distinct like sounding clips (not surprising, I'm using two shots). So a simple A/B split will suffice. I'm putting Felice's shot on one split and Clay's on another, based not on character but mic position. When moving your dialogue to the A/B dialogue tracks it's best to *copy* the clips instead of just moving them. This way your original dialogue tracks stay in place in case something goes wrong.

To remove me saying "action" on the track I'm using a technique called "Mix Paste." Most DAWs have a version of it. It is revolutionary in dialogue editing. I sample a clean piece of ambience, that is, location "silence," sound that is just background and blends in, the kind we tend to tune out in everyday life. Once I had a clean piece of background noise, I copied over my talking and replaced it. Most DAWs will provide mix/paste tools that can help make adding and balancing room tone easier.

Basically, what you're looking at (see Figure 15.3) is my DAW's version of a specialized tool that can help with dialogue editing; in this case it's called "Mix

Copied Audio: This is the clean "silence" noise I copied from my location track.

Existing Audio: That's what I want to replace.

Invert Copied Audio: This is to help you with an old trick of extend room tones if you don't have enough. You cut and paste strips of it together and reverse every other one to mask the similarity of the tone. This sometimes works and sometimes doesn't. My experience is you're better off with clean tone straight away.

To use this tool you'll need to copy audio or find clean "silence" or room tone on the location track. When you are sound editing you can store multiple clipboards of room tone by default. Just like with any editing process you can insert the new: ripple down the other audio and overwrite it (which replaces it). You can also overlap which combines both audio files (the old and the new) in proportion to the scale of each you selected. You can set the crossfade amount and "loop paste" up to three times.

Figure 15.3 A mix/paste processor designed to help edit room tone and balance background noise in dialogue tracks.

Paste." It's named as such because it helps to take room tone and paste it back into location dialogue with a lot of control of the parameters.

Other processes besides dialogue editing might benefit from such a tool – maybe editing Production Sound Effects, where you capture the sound of, say, an actor's shoes in production and you might want to tweak them a little bit to remove surround noise and make them sound cleaner.

But this little panel (see Figure 15.3) screams "tone extensions" fixer, that is, it can help extend and modify room tones of location dialogue that gets cut, removed, or jumps around due to shot/microphone changes. Working with an ambient noise editor takes experimentation and practice. If you can't find clean noise you can always try to use your location room tone. but finding it in the original dialogue set-ups will always be best.

Find the mix paste application on your DAW and learn how to use it. It is truly miraculous in terms of fixing dialogue tracks, but it takes practice and experimentation. If you wish to bring in your own room tone you can hit browse and find it in your file folder or via your media browser. In my film, the first cut was only one character talking, so I used one side on both tracks but noticed they were identical. I therefore opted for a mono mix on each character.

When overlapping in a checkerboard by default I start with a single frame overlap on each side and do a tiny fade and see how that plays. What's vitally important in dialogue editing is that it's *equally important that you pay attention to the transitions from cut to cut as you do to what plays in between them.* And what you're listenening for when you listen to transitions is that you don't want to hear them. You want to make them invisible. That is the goal. If a single frame with an identical fade doesn't suffice then you can start trying different transitions. You might extend one side of the checkerboard longer than the other with a long slow fade up or try different fade shapes.

So my attempt to smooth out the transitions from just checkerboarding and transitions is okay but is not enough.

Scrub your transitions

Figure 15.4 shows where I started to do little fades from cut to cut on overlaps and then listened to see where I needed more nuanced fades.

After I'd set up an A and B dialogue edit, I scrubbed the transitions – *listen and watch the meters.* I felt there was too much traffic energy in the cut to Clay (Joe Veale). That was pretty consistent throughout this short scene. The fast and dirty fix was a quick "car by." A car by is what it sounds like; you take a sound clip of a car and throw it underneath the transition and it will "mask" the change of energy in the background traffic noise.

I could also have experimented with the length of the transitions, namely, extending the length of the fade up so all the energy of the traffic on Clay's shot doesn't hit you at once. Also, if the clip is not in full sound swing until Clay talks, his talking might mask the change in energy. But again, masking alone is not going to cut it in the long term. What I'm looking to avoid is an *abrupt*

Begin building the checkerboarding A/B dialogue tracks by copying like clips and moving them into their own tracks leaving the original tracks in place on the bottom. Then do a first basic single frame overlap fade and see how that sounds. After this is built, do more nuance cross dissolves and fades based on the needs of transition to transitions. You must get into the habit of really listening to what is going on in the transition and solve each and every transition with its own special fade/dissolve etc. It's also good practice to do everything possible with cuts, fades, and dissolves before resorting to processing to help smooth shot-to-shot transitions.

Here's a transition where the bottom clip has less ambient noise then the top one, so I let the top one fade up a little longer.

There must be clean silence or room tone over each head and tail of transition.

Figure 15.4 Build your dialogue checkerboard with small overlapping fades first.

change in the energy of the background noise when the shot (and microphone position) shifts. I can't do noise reduction because the signal-to-noise ratio isn't big enough.

So this seemed to be the default way I'm used fades in the A/B cuts. Clay's shot was the top one, and because the traffic had a little more energy I faded into it a little slower. What is critical to watch out for is that point where *both sound clips are playing*, because this is an area that can overload the energy of the background noise. Making these transitions work is, in part, the bread and butter of dialogue editing.

Go through these transitions and see if you can make one shot to the next smooth. Scrub each transition and watch the meters, *especially when both clips are hitting*.

To my knowledge, there's no way to automate creating these A/B cross fades. You can automate and bank up different fades and dissolves and apply them at the sound edit *or* picture edit level. But this is manual labor and an

art. It will take practice. I've developed decent chops over the years, but it's still very labor intensive.

The physics of the transition is simply this: as the energy of one shot is leaving, the other has to replace *and* by *prolonging* the incoming higher energy shot you can *fool the ear*. It's all about fooling the ear. It's aural sleight of hand, or more appropriately, sleight of ear.

I opened up the tail of the top clip too much and found the beginning of more unwanted dialogue on the other side. You must end before the curve of the fade touches any part of the signal (dialogue). And remember, sound is not picture; it slopes in and out on a curve so you'll have to listen. Fades and dissolves have nasty ways of reconnecting to hidden dialogue.

On Felice's track I made a mark at the first spec of her vocalizing. Then I pumped up the ambient noise. Remember, the invisibility of the transitions doesn't have to be perfect and you're setting it up for the mix. But for now, let's do a little submix so we understand what that process is.

Dialogue submixing

There are a variety of tools at our disposal that can be used at the submix or mixing stage. These are the primary ones:

- track EQ
- clip EQ
- track compression
- clip compression
- noise reduction
- amplitude adjustments including normalization, limiting, expanding
- panning (sending signal to either side of the stereo spectrum).

Track EQ/clip EQ

Equalization, or "EQ" as it's called, is a giant topic in sound production and going into it in-depth is beyond the scope of this book. Suffice to say, the ability to get it right in the mix is an art in itself. I spoke with Dominick Tavella who won an Oscar® for sound mixing *Chicago* (which also won Best Picture) and he told me that he spends a lot of time going through the EQ of the dialogue to make sure each character sounds like the same character throughout the picture. I thought that comment was fascinating. Even though you have great professional actors, top-level location sound recordists, the mixer has to be concerned about making the actors "sound like the same character."

So what is EQ? We saw in Chapter 2 that sound is comprised of frequencies. The human voice has a certain range (male and female, with variances). The job of EQing is to try and make the voice sound pleasant to the ear (even if the voice belongs to a ghoulish, evil character like Freddie Krueger – rest assured that Freddie's voice, while scary, is pretty even and consistent throughout). In other words, creepy scary Freddie always sounds like creepy scary Freddie.

In respect of track EQ/clip EQ, most DAWs have pretty much the same capability to use the processing tools either on a clip or a track basis. Remember, if you wish to process every clip separately it eats a lot of the computer's processing power. You also run the risk of processing clip to clip unevenly. You can, of course, "cut and paste" the processing of the master clip onto the other clips in much the same way you would process visual effects on your timeline in your video editing app.

Or you can use track EQ, and if you need to make adjustments there are ways to tweak what has been applied in a subframe-by-subframe way. Let's take a look at some of the different kinds of EQ readily available on most DAWs for the low-budget filmmaker.

Notch filter

This filter has a variety of applications but the primary one that is of interest to us is its ability to "notch out" certain unwanted frequencies (like hums) at a select frequency range across the board. For example, you might not have a fastidious sound mixer, as I did, who turned off the refrigerator; in which case you'll have a distinctive hum from the refrigerator on your dialogue track. You can notch it out because it's so specific and it sits in a certain "notch" of the frequency scale not close to dialogue. All DAWs provide notch filters that have "presets."

The notch filter presets for my DAW (Audition) are very specific and tend to be the ones you want to get rid of quickly, like a refrigerator or "Sibilance Softener" or a DeEsser. Sometimes saying an "s" hits the microphone and causes it to sound weird. The notch filter can fix that. Notice how some of the presets are musical references because each musical note is a specific frequency.

On your DAW play around with the notch filter and see how it works and what its limitations are. Also remember that as in all such filters, if you create a good preset and feel like you'll use it later in the project you can save the preset.

Graphic equalizers

In ancient times (the 1970s), a coveted device was to have a big, clunky graphic EQ connected to your stereo. You'd use it to slide up or down different frequencies according to your liking (this never made sense to me, because you were changing the sound of the professional mastered record).

There are graphic equalizers everywhere – on your car stereo, your smart phone, etc. A graphic equalizer effect boosts or cuts specific frequency bands and provides a visual representation of the resulting EQ curve. Unlike the parametric equalizer (see below), the graphic equalizer uses preset frequency bands for quick and easy equalization. This can be useful if, say, you're mixing an indoor dialogue scene and you run some outside traffic that's supposed to be coming through the windows. The building and windows will block off specific frequencies, but will do so in a consistent way. You can dial down the high ends to emulate how it would sound if you were in the room. The classic example using a graphic equalizer is to make a voice sound like it's coming from a phone. You get this effect by emulating the

frequencies that actually tend to come out of the tiny phone speakers, limiting the frequencies that are audible on the target track to a very narrow range in the "mids" – between about 400 Hz and 4 KHz.

You can use an EQ for this, or you can use frequency filters like the one found in DAWs like Adobe Audition (called an FFT or fast fourier transform filter). There's some seeming redundancy in what the FFT filter does and what the notch filter does.

The graphic equalizer gives you control over different bands. You can space frequency bands at the following intervals:

- one octave (10 bands)
- one-half octave (20 bands)
- one-third octave (30 bands).

Graphic equalizers with fewer bands provide quicker adjustment; more bands provide greater precision. Play around with your DAW's graphic equalizer.

Parametric equalizer

A parametric equalizer is probably the most important type of EQ that a mixer relies on for making dialogue sound great. The reason for this has to do with how a parametric equalizer works. Its design allows for *total customization of the tonal equalization* across the entire frequency spectrum.

What does this mean? Well, consider that there is nothing more subtle, beautiful, and nuanced than the human voice. This is in part due to the rich variances a voice can have. So, to tweak the human voice and make it sound great involves a nuanced effect. And, unlike the graphic equalizer, which provides control over a fixed number of frequencies and bandwidths, the parametric equalizer gives you total control over frequency, bandwidths, and gain settings.

A parametric equalizer is a great tool for EQing dialogue. Oscars® are given to sound mixers for EQing dialogue, which is a big part of the overall sound mix. I'm not going to lie; I prefer to have a seasoned professional mix my dialogue. But I have done it for my own films and had good results. It's like playing an instrument – it takes a lot of practice to get good at it. It takes talent and years to develop an ear and technique and, if you're like me, you want to finish your film and make the next one.

But as an independent filmmaker who might be stuck sound editing *and* mixing your own film, there are some basic things you can learn to make your film sound more professional. Let's look at the design. Most parametric equalizers work in a similar fashion so I'm just going to reference this one from Premiere Pro/Audition. First of all, in the middle there's a blue line with six different graphic points and to the right is the dB (decibel) scale and underneath the frequency scale. This scale represents the range of human hearing. Notice the "HP" and the "LP" and the left and right of the blue line, respectively. This stands for high pass filter (HP) and low pass filter (LP). The HP cuts

off everything below 40 Hz, which is near the low-end cut off of the human voice (about 85 Hz for a male and 165 Hz for a female). So, theoretically, you can set a parametric equalizer on your master dialogue submix to cut all frequencies below 85 and not have to worry. The LP filter works in reverse: it only allows frequencies below a certain level.

TECH TALK – The HP filter which you can set to cut off everything below say 85 Hz is pretty similar to what a low cut filter on a microphone or recorder will do. The trick is to learn whether to use it on set or wait for postproduction. The answer has to do with whether or not applying at the location recording phase will allow you to achieve better signal to noise ratios *and* better overall frequency range in the dialogue you record.

All DAWs will have parametric equalizers that work much the same. But this overview is merely scratching the surface. Again, you're going to have to practice with the parametric equalizer on your own DAW to understand what I mean, but let me try to explain how it works and why it's so important for dialogue EQ. This EQ is designed to "sweep" your dialogue so you can find problematic frequencies and dial them out, or down, at least.

To fine tune this process you need to understand what the "Q" is in the box. Q (sometimes referred to as "quality") is the width of the EQ-band you are adjusting. But it works a little counterintuitively. What do I mean? A *low* Q-value would mean you are adjusting a *wider* range of frequencies (often preferred when boosting), while a *high value* Q would narrow the area down (typically used when sweeping through the dialogue to find and lower odd-sounding frequencies). You'll need to loop a piece of dialogue and create a tight Q of around 30–40 and then drag it all across the voice spectrum until you hear an unpleasant sound. After this you can drop it down –10 dB (or more depending on your EQ). Again, you can do this on the track *or* clip level. The same goes for the frequency band #3 (in this case 825 hertz) but in this instance we're *boosting* the frequency.

So, these are the basics of EQing that I'll apply in a minor way to this submix and then, later on, more extensively. (Bear in mind that most re-recording sound mixers will ask you *not* to leave any effects processing on your sound files when they are delivered as they prefer to apply all effects processing themselves, to the liking of their own ears and when every sound in the soundtrack landscape is present.)

The parametric equalizer allows you to customize the parameters of the frequencies you are trying to lower or raise. This is ideal for dialogue. It also allows you to "sweep" through your dialogue and identify unpleasant frequencies which you can then dial down – or you can dial up certain ones for effect.

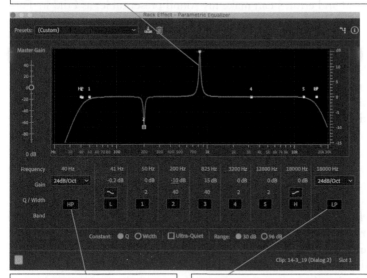

A high pass filter allows an instant cut-off of low frequencies that could interfere with dialogue.

A low pass filter does the opposite of a high pass filter; it cuts off frequencies above a certain level. An application could be, for example, to make it seem like someone was talking in another room and the sound was coming through the walls.

Figure 15.5 An example of a parametric equalizer.

Play clip dialogue 1 *before* processing
www.michaeltierno.com/link-7

Play clip dialogue 1 *after* processing
www.michaeltierno.com/link-8

Play clip dialogue 2 *before* processing
www.michaeltierno.com/link-9

Play clip dialogue 2 *after* processing
www.michaeltierno.com/link-10

Compression

Compression is, again, one of those processing elements that takes a long time to understand and become proficient in. My skills have gotten better over the years through trial and error. I can make my sound presentable, as I did in *Turn Back Night*. It is as important to know *when* to use compression as it is *how* to use it. It is quite involved and only a cursory introduction to compression is possible within the scope of this book. But there are some very basic things about compression that you should know as a low-budget filmmaker.

Compression is simply this – you are shrinking or *compressing* the dynamic range of your signal. What that means is if (in *Turn Back Night*) Clay and Felice are talking and their dialogue is moving up and down in an 8 dB range (say –20 to –12), that might be considered too wide to be presentable to the human ear via electronic speakers. So, when mixing, you might opt to shrink the range of their dialogue *without* changing the feeling of the dynamics of their speech to the human ear.

And there's a secret to what compression actually does when it's done right: *compression helps retain the aural experience of a big range in levels of dialogue without speakers having to reproduce a big range, which can be too broad to sound right and will undermine the experience to the listener.* A good analogy is to understand that real sound in real life is "three dimensional" – using compression is helping to turn the three-dimensional sound to two dimensions without it sounding flat. To become good at it you have to experiment and practice. I've learned about compression from fumbling around with it over my filmmaking career, and I've learned that a little bit goes a long way.

So, let's look at a compressor; these are, again, pretty typical in any DAW you may choose. This is what comes with Adobe Audition, which I use, and is about as generic as a compressor can be. I've seen them in Logic Pro X, Pro Tools, Avid, Premiere, Final Cut Pro X, Davinci, etc. They do the same thing. There are some more advanced functions I won't go into, but these are the basics:

- *Threshold:* The decibel level you want the compressor to "kick in" and start working.
- *Ratio:* After your sound goes *over* that threshold, what ratio do you want to compress down the sound? For example, you see the threshold is set at –10 and the ratio is 4:1. This means that for every 4 dB the signal goes over the threshold (–18.6), it will reduce the amplitude to 1 dB. In the example shown of a compressor (top image in Figure 15.6), if the incoming signal is –6 with the threshold set to –18, the incoming signal will be 12 dBs over the threshold. So, if the signal over the threshold is compressed at a 4:1 ratio, those 12 dBs will be crunched to only 3 dBs (12/4) then added back to the –18 for a grand total signal of –15 dBs.
- *Attack and release:* This parameter in a compressor is more advanced and might require seasoned ears to understand how to use it. Attack and release

allows you to control the amount of time in milliseconds the compression effect takes to work once the threshold is hit and it kicks in, and also how long it takes to release once it drops below. Normally I use the defaults.

You have to practice using a compressor and certainly practice on the tracks I provided for you (see the links on p. 136). It's something I tend to apply later in the process. The last thing to notice is "output gain," one of my favorite sliders on the compressor (I'm not a loud volume freak). Output gain allows you to put back some of the gain or "presences" of sound that you might have diminished when doing your compression. The reason I like this so much is that when you bring back some gain to the well-compressed audio in a dialogue clip you really get to appreciate the magic that is compression. Because you haven't changed the *aural feeling* of a lot of range in the dialogue, it's easy for an audience to process via hearing it through electronic speakers.

There are a few more kinds of compressors. In keeping with the trend towards more automation in postproduction, some DAWs (and video editors such as Premiere and Final Cut Pro) offer more automated compression targeted at the human voice. One is called "speech volume limiter." It's called other things in other DAWs – the one I discuss below is from Audition and Premiere Pro.

Speech volume limiter

The new trend in DAWs is to offer more automated fixes for dialogue tracks. The "speech volume limiter" is available on most DAWs and editing applications under a variety of names.

You set the "target volume level," which means the level you want to bring your dialogue up to, or the normalizing level. Say you set it to an RMS (root mean square) level of –12. This means that it's going to process the sound with an *average* of peaks up to –12. Target dynamic range allows you to control how much noise you let in. The suggested range is 45–65 dB, which means that everything below that noise floor won't make it into the sound. This is automated compression; you should find it in your DAW and experiment. Because it's using RMS Normalization, you might bring up a lot of noises as well – again, balance it using target dynamic range to control noise. (This is why the other sliders work in conjunction with the first one, the target volume level.) As always, you can save your presets or choose presets.

Dialogue compression automation is available in all DAWs and editing applications. Find the one supplied with yours and start to test it with various dialogue clips.

Multiband compressors

Finally, for our overview of compression we're going to look at a very common kind of compressor called a "multiband" compressor. This can be used either on individual tracks, on stems, or even for throwing on an entire mix to bring it up

to broadcast levels, because it can process different frequencies in the spectrum of the entire soundtrack and apply different amounts and qualities of compression to different frequency bands. It's a very sophisticated processor and I've only really used it as a final processor with a preset called "broadcast." Most DAWs supply a compressor that has built in settings such as broadband. But feel free to experiment with the version on your DAW.

Figure 15.6 shows three different kinds of compressors found in DAWs – single band, speech volume limiter, and multiband.

Demo compression examples

In my specimen clip from *Turn Back Night,* I applied the single band compressor on each track of the two clips that had been set up in an A/B dialogue split and used a high pass filter to cut out unwanted noise. Then I swept through and removed some other problematic sounds including some bassy sounds on Clay's lines using a parametric equalizer. I still heard some sibilance on Felice, so I took some of that off with a notch filter merely on the clip.

Now to attempt a little bit of track compression. This is not my normal workflow but for the purposes of the book it's a good time to talk about track compression. I looped areas of the track and played it back, listened, and looked at the meters and see where I might want to apply a little bit of compression. To do so, I first asked the question, "Where do I want compression to start kicking in?"

In the first seconds of Felice's dialogue, I noticed it was a little bit low. Instead of boosting the amplitude, I set the compressor to kick in at about –22 with a 4 : 1 ratio (a standard default because that seems to be where the widest *variance* of range in the dialogue comes into play). It sounded good, but then I needed to bring up Dialogue 1 (Clay's track to match). I set this track to kick in at –18 and with the same 4 : 1 ratio of compression (which means for every 4 dBs over –18 it reduced it down to 1 dB louder than –18, or –17.) The output gaining was lower because Clay's voice on the track had a little more amplitude (4 dB output – or "makeup gain" as it's sometimes called).

Now to listen back to the clip without track compression.

Play sample 1 *without* track compression
www.michaeltierno.com/link-11

Play sample 1 *with* track compression
www.michaeltierno.com/link-12

Finally, before we leave this little dialogue submix, I wanted to throw auto compression using speech volume leveler, just to see what happened. But I placed it on the dialogue *stem* so all the dialogue would be affected.

Basic single band compressor

Speech volume leveler

Since compression always involves some sort of gain reduction, compressors give you the ability to add "output gain" to help make up for what you might have lost. Also, sometimes it's better to do amplitude adjustments via compression because it's easier to make the levels sound better without over-adding gain.

Multiband compressor – this offers compression at various bands of frequency. It can work when applied at any part of the mix, but I like to use it on the track or even the "stem."

Figure 15.6 Single band, speech volume limiter, and multiband compressors.

When I called it open it opened on a "default" preset and the "target volume level" was –12 dB (RMS). Again, this means we're aiming for a movie level of dialogue that will be normalized up in an average way (RMS). However, I played it back and it was too aggressive, so I chose "careful" and applied it.

Play the clip
www.michaeltierno.com/link-13

This concludes a basic overview of a dialogue submix. I prefer to do a sound *edit* first and do the mixing elements later (EQ, compression, etc.) in a master re-recording mix after all the sound editing has been completed. But some of you might want to dialogue submix as you go along.

Noise reduction

I'll now give you a quick introduction to noise reduction using scenes 29 and 38 from *Turn Back Night*. Scene 29 is just radio microphones and 38 uses a boom and radio microphones. Both were filmed on the street in noisy conditions. It's not that I had to use noise reduction, but I wanted a little room to work with in both instances, that is, I wanted better signal-to-noise ratio, something noise reduction can help with.

Every DAW has noise reduction and some are more powerful than others. Every editing workstation such as Avid, Final Cut Pro X, and Premiere have their versions of noise reduction. There are also stand-alone plug ins like iZotope's RX Suite, Waves' WLM, Audionamix IDC, or CEDAR DNS-1 that can be very expensive but also very powerful.

I'm going to assume you're stuck with using a built-in noise reduction processor like the one that comes with Adobe Audition. It's pretty powerful but it's not a thousand dollar iZotope plug-in. The same rule applies to all such processing – use it carefully. Noise reduction tends to be a little "aggressive."

While there are many kinds of noise reduction processors they tend to be subdivided into two primary kinds: those that are intuitive about what is signal and what is noise and does the processing for you, and those where you get to select what the noise is and customize your noise reduction process.

Here are some of the main types of noise removal processes:

- *Denoise (the software learns the noise).* This processor listens to your sound and determines what is signal and what is noise. Most nonlinear editing programs (NLEs) or DAWs will have a version of this. This process tends to work with a spectral graph approach and determines what is noise and filters it out. I tried it out on the noisy street scene with just radio microphones and it worked well. In my DAW, the Denoise processor was immediately able to determine what to filter out: the traffic noise. Of

course, there is a little loss of some of the voice frequencies which could perhaps be brought back up via EQ.

TECH TALK – This is where the sequence regarding what is done first in terms of processing history is once again critical. Doing the noise reduction first gives me a little room to tweak the frequencies of the voice afterwards. This is all the more reason why, on DAWs, processes can not only be undone but rearranged.

Play sample *with* denoise
www.michaeltierno.com/link-14

Play sample *without* denoise
www.michaeltierno.com/link-15

There are five frequency settings Adobe's denoiser can focus on: all frequencies, low, mid, low and high, and high. I chose low for the traffic and it worked pretty well.

- *Adaptive noise reduction.* Most DAWs will either handle noise reduction on an individual or a track basis. Some of the more powerful noise reduction plug-ins can handle multiple tracks at the same time. My DAW has a version of this called "adaptive noise reduction." It's processing heavy and I don't really use it a lot. If you're looking to run noise reduction on a timeline there's always a way, but I tend to stick to individual clips.
- *Automatic click remover.* iZotope has a powerful click removal feature for use with Pro Tools, Logic Pro X, etc. Most consumer DAWs will have something to help remove clicks or anything that hits a microphone with energy like wind, or a "plosive" (speech that makes noise on the track) – the act of saying the word caused air to hit the microphone and make a noise.
- *Auto phase correction.* Many DAWs have accommodations for fixing "phase" issues. This can happen if somehow the lavaliers and booms together cause "phasing" due to voices hitting microphones milliseconds apart from each other. Faulty equipment or microphone cables that are very different lengths can cause phase issues. It's not common so I'm not going to say any more about this here.
- *Dehummer.* Recording sound is an electronic process. Sometimes cables and machines create "noise" that gets burned into your audio. This is called "line noise." Think of the sound when you touch a live guitar jack. A 60 Hz hum is a typical one. A dehummer can literally pick out that noise and remove it, and nothing else. Refrigerators create distinctive hum as well.

- *Dereverb.* Reverb and/or echo that prints onto dialogue has been notoriously hard to get rid of. Now, there are dereverb modules in DAWs and plug-ins. Reverb and echo removal is complex processing and not always easy to do. But if you record and pick up some reverb to a natural environment that produces it, you can try to remove it. Stand-alone processors tend to deal with this, so it's best to avoid using this process; if you do, be careful – it's easy to create artifacts when doing so.
- *De-rustle.* Some DAWs and plug-ins have de-rustle modules that have algorithms to look for clothes rustling caused by lavalier microphones. This is very powerful stuff. If you don't have this luxury you can try classic noise reduction.
- *Sound removers/noise reduction.* Sound remover and noise reduction modules are present in almost all DAWs and plug-in packages and mostly give you the flexibility to work in a multi-track sequence or at clip level. Unlike a denoiser (which intuits the noise itself), you have to "teach it" what the noise is and create a custom "filter" to remove the noise. The trick is not to overdo it and create artifacts; with any sound remover/noise reduction module make sure you listen to the "noise only" function. If you hear enough frequencies of the voice coming through it means you're overdoing it.

A word of caution about this part of the process: make sure you get *only noise* when building your noise print – not noise with a cough or noise with a footstep or part of a word. Noise means background ambience that the machine can recognize and then turn into an instant filter to get rid of that noise. Noise reduction modules will have "output noise only" selections for you to audition the noise and listen to see how much dialogue is slipping through. It will also process out that part of the frequency spectrum and hence remove some of your dialogue. When listening to your "output noise only" you want to hear little or no dialogue.

TECH TALK – An error many filmmakers make when starting out and applying noise reduction is *trying to get rid of all the noise.* If your track comes in and lends itself to a lot of noise reduction, that is great. But sometimes you can fix dialogue tracks recorded in noisy environments by just pushing back the *energy* of the noise and giving you more room to work on the dialogue (hence creating better signal-to-noise ratio).

Noise reduction with multiple microphones

The snippet of scene 29 in *Turn Back Night* where we did some noise reduction was only with isos (radio microphones). Let's experiment with noise reduction in a little bit more complex situation (and with a lot more noise).

Scene 38 used two isos on Jane and Radio Voice, and a boom. To begin with, I muted left/right mixdowns.

When I listened to the boom track, I realized it was not all that useful in itself. I tried a strategy of denoising all three tracks and blending them. First, I created a stereo bus on the timeline and routed the three tracks into it. While some DAWs won't allow denoise on multitracks, a workaround is to route your microphones into a bus and denoise through the bus. The reason I didn't just take the left/right mix and denoise on these tracks is because I want the separation of the microphones to play around with. There would be too much cumulative noise with all the microphones picking up their own background noise.

This is a juggling act, a balance you must do with noise reduction so as not to ruin your dialogue. Using the "output noise" feature I played around with the sliders and found that the sweet spot was using only 8 percent of the noise reduction. But note that by just using 8 percent it pushed down the background noise a full 4 dBs – and did so with minimum loss of the audio quality. I was able to route the different dialogue tracks through a bus into a submix so the denoising could be applied to all the tracks. Figure 15.7 shows two kinds of noise reduction processor.

Play sample before denoising
www.michaeltierno.com/link-16

Play sample after denoising
www.michaeltierno.com/link-17

If you want to go with this strategy and do a legitimate dialogue submix, you would see how you could bring out the voices a little more with EQ. This exact same principle can be applied regardless of what kind of noise reduction you are using. Once you have defined what the noise is, you still need to carefully figure out how much to apply to push away the energy of the noisy ambience. There are spot reducing tools available in every DAW, but they take some practice to use.

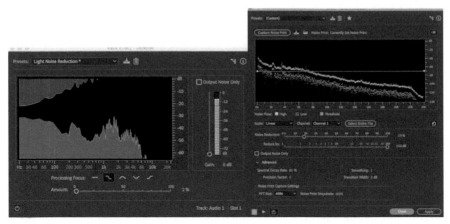

Denoiser Noise print reduction

If you compare a typical denoiser (on the left) to a typical noise reduction module (on the right) you can immediately see that the denoiser involves less work for you to do. It's a very simple parameter you can control by selecting the amount of noise you want to process out by the percentage you want, and also which range of the frequency spectrum you want to "focus" on (hence the "processing focus" selections). The Noise Print Reduction module is a more complex process: you discover what the noise is by finding a clean sample of "noise only" and then tell it to remove that noise. It gives you more parameters. Notice that both allow you to "output noise only" – you should always do this as it will alert you to whether or not you are also processing out dialogue frequency and, if so, by how much.

Background noise alone before denoising

Background noise after denoising at 8 percent

By only applying denoising for 8 percent, I was able to push down the background noise a full 4 dBs – did so with minimum loss of sound quality.

Figure 15.7 Two basic kinds of noise reduction processors.

Sound effects

Now that we've done basic sound editing and submixing of the dialogue tracks it's time to touch on other sound effects you can add to a sound design. There are many categories of sound effects and we'll break them down and look at the subcategories.

Foley

This included anything that has to be synchronized to a picture, such as footsteps, punches, clothes rustling, doors opening, etc. Foley is created by Foley artists (cousins of actors) and they are experts at watching the screen and recreating whatever sound is *not* dialogue. Bear in mind that some synced sounds like doors opening and car doors slamming can work fine canned; these are referred to as "hard effects." I tend to think of Foley as sounds *created* by a human being who is watching the picture while they do it.

PFX – Production sound effects (natural sounds or "nat sound")

Natural Foley (or PFX – production sound effects) is also captured on the production tracks. These sounds can sometimes be usable, but bear in mind that production Foley effects are not recorded in isolation – the mixer can't pull up or bring down the PFX without bringing up all the subsequent noise from the location recorded with said PFXs. For low-budget filmmaking, I'm a big believer in doing as much as possible so as *not* to disturb the natural Foley sounds that are created on a set. Of course, if the director must talk between dialogue that's fine; it's worth it if her direction is important. But, more often than not, natural sound picked up by the boom (and sometimes, though less often, lavaliers) works perfectly in low budget.

Canned Foley

Canned Foley, which you can find in sound effects libraries, can also be useful; they require skilled editing (and mixing) to make them work. Sometimes low-budget filmmakers won't have the time or resources to get Foley artists in the right recording environment. You can use a mixture of PFX *and* canned Foley if that suits your budget or schedule requirements – but you have to carefully edit and mix them if they are to work.

Returning to *Turn Back Night*, I found *heels on concrete* that I threw on the timeline. Then I marked the exact spot where Felice's steps are using the time code. Your DAW's timeline will produce what's known as "snap to markers," so when you open your footsteps you can drop them right in then cut and paste and move things around so they line up. Canned footsteps tend to be recorded with variances of amplitude for each footstep, which is exactly how they'd sound in real life. So you'll have to cut and paste and get creative with them.

We don't see Felice's feet, but I'm going to give her shoes on concrete to make her feel businesslike and official, because that's what this whole break-up scene is about. Even though we don't see her feet we see the movement of her walking, which requires as much accuracy as actually seeing her feet hit the street. Figure 15.8 shows precisely where I marked on the timeline to let me know where the "sync" marks of her footsteps were, so I would know where to put the canned footsteps.

The canned footsteps are a decent starting point but can't replace real Foley, which is customized by professional Foley actors who watch the screen and create the nuances of the Foley sounds to exactly match the picture.

On your timeline you can mark where each footstep hits and then line up the footsteps with the sounds that you can visually read in a clip of canned footsteps. You will have to edit them because they won't perfectly match out of the box.

Figure 15.8 Adding canned footsteps.

To make this canned Foley work I had to go into each footstep, line them up perfectly, cut and paste and move some around, and do a mini-mix so they work right. The canned Foleys will have variances in amplitude of the foot strikes as well as different rhythms of walking – in other words, they will require editing and mixing.

As usual, you will need to solo the Foley stem (or the clip you're trying to Foley) and loop it and just hear it isolated. Remember – the footsteps should *sit* in the mix and be felt more then heard. They are recorded loud to give you good clean signal to start with, but will later be mixed down to a lower level to feel more natural compared to the other sounds in the scene.

It's a known fact that going through the trouble of doing Foley with whatever means you might have may separate your soundtrack (and by extension) your production value from other low-budget films. I recently re-watched one of my all-time favorite films, *Galaxy Quest*. In keeping with the notion that repeat viewings help you to be able to deconstruct different aspects of how film you love works, I noticed that the excellent Foley that accompanied the actors as they walked around the spaceship helped to keep me in the heads of those characters cast in a real spaceship. That said, don't underestimate the importance of Foley in helping to sell the psychology of the actors in the environment they are supposed to be in.

Take the time to do this correctly – whether that means creating real Foley, editing and treating PFXs separately, using canned Foley, or some combination thereof.

> TECH TALK – It's customary for Hollywood sound editors to cut all the natural Foley out of the location tracks and put them on separate tracks called PFX (production effects) tracks. There are many reasons for this. First, if the natural Foley is to be used (this is rare in Hollywood) they still want them on a separate track/stem so they can treat them separately. Second, they are available for reference if the Foley artist/recordist and/or Foley editor needs them. Finally, they can be preserved for M&E (music and effects) tracks for foreign distribution; although this is not a common practice, it's not unheard of. The dialogue track is completely replaced in foreign language versions of films, and with them go the natural Foley. It's nice to have the natural Foleys preserved on a separate stem if the M&E editor wants to use them.

Foley with Foley artists in studio

Foleys artists are often actors, dancers, etc., who have found another way to make a living. They are adept at watching a picture and making sounds to match it. It takes a lot of skill, years of experience, and a real Foley environment to make it all work – not to mention a skilled Foley mixer and editor.

If you are fortunate enough to have access to a real Foley stage, use it. If not, you'll have to create an environment amenable to recording Foley. You can make some very cheap footstep environments called "Foley pits" using cat litter boxes, wood, gravel, etc. The rest will require you to use your imagination. The main thing you'll need is a place to record and a screen to watch playback.

Hard sound effects

Gun shots, explosions, crashes, doors opening, stab wounds, etc. are all sounds that have a synchronous element to them in terms of us seeing precisely when they hit. But they don't require Foley to get them right. They can be created and cut in by a good sound effects editor. It's customary to place the sounds in from recordings or create them while watching the picture to get the sync right, but it's not really considered Foley. It's perfectly okay to create some isolated sounds outside while watching a picture because a sound effects editor can cut it in later.

Sound effect cue sheets

Sound effects editors live and die by cue sheets, a discipline that sadly is not used enough in the film school system or in indie films. But why not use them – they doesn't cost anything. Now that you've gone through the trouble of learning how to set up time code in your OMF you'll see how it's really used. Time code is used by *all* sound postproduction artists as the universal reference. It's usually written in frames as subframes are applied on the spot and not necessarily written out. You can Google sound effect cue sheets (you'll get multiple responses) and use any one of them. The main things you need are:

Table 15.3 Sample sound effects cue sheet

Sound effects cue sheet	My film on a budget		Page 1 of 3			
Reels 1	**Comments**		**Date/version** October 24, 2017			
Cue #	**Time code starts**	**Time code ends**	**Details**	**Recorded takes**		
	01:00:03:23	01:00:03:25	Short laser hit			

1. reel #
2. cue #
3. starting time code of the cue
4. ending time code of the cue.
5. a description of the cue.

One very big advantage of having proper cue sheets (with correct time code) is that it makes it easier for sound effects creators to work independently and when they deliver all their goods (or work) to the mixer everything is in sync.

So do a Google search for versions of cue sheets, but make sure they have the basic information on them. There are different kinds, obviously a cue sheet for Foley will be different than one for ADR.

Speciality sound effects

This section is about sound effects, one of my favorite parts of the whole sound postproduction process. You get to be creative and build multifaceted layered sounds, which also greatly influence the tone and vibe of the picture. Of course, when recording any sound effects you'll need to determine if all your mixing will be done at the end or whether you will be submixing in the process.

I want to explore a few special effects (of the sci-fi breed, the most fun kind, with a close follow-up, horror). The scene is when Radio Voice (RV for short) appears to Jane for the first time. I made a few little visual glitches, which is typical of a simple hologram effect. I set up two glitches which have a "sync" element to them. Then I built the effect on the timeline and duplicated some FX tracks. (When you need more tracks in a stem set up, duplicate the previous track in that stem and then get rid of the media on the track; this way you'll keep all the stem routing information intact and won't have to recreate it.)

Remember that because of time code I can do these effects in bits and pieces and drop them back into the master editing timeline or the master sound post-production timeline using the time code.

To create this simple effect I'm using "imaging" modules which are part of many sound design effects packages. The ones listed below come from Adobe Creative Cloud:

1. Imaging Module Production Element: Title – Ambient Distortion
2. Imaging Module Production Element. Title – Electronic Feedback Digital
3. Imaging Module Production Element. Title – Ambient Distortion Reverse
4. Science Fiction Sci-Fi Energy Swell.

The first three sound effects are obviously from a family of like sounds and can be used separately or in conjunction. As mentioned previously, most modern sound effect packages will have similar loops. The first one will be used as a foundation; the second two will be used to underscore the glitches. And instead of cutting them in and out I want them to *waver* in and out.

I'm going to use a very simple volume envelope to achieve this. This will also be a way to introduce you to envelopes – a powerful way to tweak your sound edits and mixes, albeit high-end tech stuff you'll have to learn. I'm also going to compress it all together in the stem to help it jell as an effect.

Envelopes

Envelopes are to sound effects editing what keyframes are to motion graphics in most editing applications. On the sound clips of editing platforms you keyframe right *on* the sound on the timeline or on the effects panel when you drill down on it. Envelopes take every parameter of a sound processor and turn it into something that can be controlled via a keyframe that runs alongside the effect in the timeline. So, in essence, it's more organized.

A disclaimer: I don't think many of us mere mortals are using envelopes all that much, but it is something that is available in DAWs and you might come up with interesting applications.

So, to keyframe I need to mark off the places where there's a little glitch in the hologram.

What I did here (see Figure 15.9) was use the top effect (Ambient Distortion) as the foundation. Then the Electronic Whoosh Reverb #2 was spliced to have another pulse directly below it that runs through at the same volume. I decided to use the envelope to accompany the electric sounding hits below it (see bottom image in Figure 15.9) Finally, I processed it all through a compressor since it is coming out of the radio and released the threshold so the sound would float in the air.

Open folder 2
www.michaeltierno.com/link-18

All this might sound a little complicated but I am only scratching the surface and trying to whet your imagination about how sound can be controlled and manipulated. You'll have to continually experiment, as I have, to find techniques that work for you.

Use markers and keyframing moments on the timeline to match events in the picture edit, which can then be copied onto the sound edit timeline to correspond to keyframes you create on envelopes to alter aspects of effects to match picture.

Figure 15.9 Using timeline envelopes and keyframing to control sound effects levels to correspond to visual cues.

16 Let's talk more deeply about dialogue editing

This chapter is aimed at those of you who are making a dialogue heavy film but can't afford a professional dialogue editor. The goal in dialogue editing is to make the location recording invisible to the audience's ears and smooth out the dialogue to make it an enjoyable listening experience. Shot changes (and hence microphone position changes), which create different energy levels of background noise and room tones must be smoothed out.

Shooting that takes place at different times of the day can sound different on location tracks, even within the same scene. If, for example, you shoot a scene that takes four hours to get in the can, starting in the morning when street traffic is minimal then by the end of the scene it's high noon and there's a lot of traffic, the background sound or room tone may not match the earlier shots (I use the term "room tone" to refer to background ambient sounds that are recorded with dialogue, whether the recording takes place outside or inside). This happens all the time.

But, to the audience's mind, the scene is taking place in a matter of seconds, so if background noise changes shot to shot they will subliminally sense what is going on. This will break the movie spell and "take them out it," so to speak.

Also, the dialogue editing process must change unwanted sounds including dolly sounds, boom operator sounds, clothes rustling, wind, airplanes, air conditioners, directors talking to actors, etc. All of these unwanted issues have to be removed or smoothed out. In order to do this, there is first dialogue editing preproduction.

The two primary dialogue editing workflows

Workflow #1

The dialogue editor will select (and occasionally combine) microphones and split sound clips and move them to A and B, providing enough heads and tails for fades and dissolves to be created via overlaps. They will also fill in room tone extensions, eliminate unwanted set noises such as clothes rustling, directors talking, boom noises, etc., and deliver all of this to a re-recording mixer so this person can do the heavy lifting of equalization, panning, amplitude leveling, noise reduction, compression, and mastering for release formats.

Workflow #2

The dialogue editor does all the above and then carries out the tasks a re-recording mixer normally does and delivers a dialogue submix to a re-recording mixer to continue building the final mix, including amplitude adjustments, equalization, and normalization.

Whichever way you go it's my belief that the dialogue submix is the foundation of your entire mix and should be treated as such.

Preproduction for dialogue editing

A brief digression – Rebuilding time code sync references

If you recorded with tentacle sync and your sound and picture are locked, you can skip this. Or maybe you used hot sticks and changed your underlying camera clip time code, or even used old fashioned slates but changed your underlying camera time code to match your sound before you sync up so everything is okay. If so, move on to the dialogue submix section (p. 152).

But if your camera clip time code isn't changed to match the production sound time code I want to help you avoid a sync nightmare. If you're like me, a passionate filmmaker who wants to rush to sync up dailies and dive in and start editing – beware. If you didn't change your camera footage time code to match your sound footage, you might have a sinking feeling (pun intended) down the road that you're not absolutely certain about your overall sync. And the deeper you go into postproduction, the harder it is to fix. The reason you'll need to do this is shown in Figure 16.1.

Some might say having both time codes available is overkill, but it gives me peace of mind to be able to see both. That said, you'll need a Digital Audio Workstation (DAW) and a transfer process that will transfer the metadata that shows the production time code. Editing workstations and DAWs handle metadata time code differently; however, the sound file designed to transfer over metadata containing production time code information is a BWF (Broadcast Wave File). Some sound editors now prefer AAF (advanced authoring format) transfer over OMF (open media format) when sending information to a DAW because AAFs can transfer BWF files with all the metadata.

If you find yourself in a situation where you need to go back to your picture editing workstation and create production time code after the fact the next section describes how to do it.

> SOFTWARE AGNOSTIC – My editing application is Premiere Pro, but the principles described here are applicable to the process of dialogue editing regardless of your editing workstation.

A tale of two time codes. While there are many kinds of time code used in production and postproduction, in dialogue editing there are two primary ones. The first is *clip-based time code*. The one below shows the underlying time code generated by the initial production/location sound file that the camera clip either recorded from a tentacle box or has been changed to match based on the sound file's metadata. In postproduction, both camera and sound files are merged and locked together in sync. The second time code (on the right) is *timeline sync reference*. This lets you know where you are on the master timeline in the project. This timeline time code will be the master time code used by Foley artists, music supervisors, composers, and sound effects editors. Some picture editors will only use the master timeline sync, but it's a good idea to have both production and timeline sync visible because you'll always know you're in sync if there is any doubt. Also it helps because if Automated Dialogue Replacement (ADR) needs to be added it's good to have the production time code reference visible to build the ADR with.

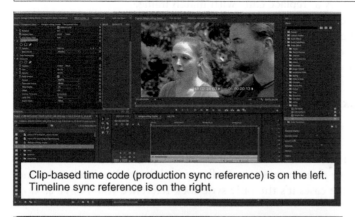

Clip-based time code (production sync reference) is on the left.
Timeline sync reference is on the right.

To change underlying time code while editing you'll have to go back to the original footage and change it. Sometimes, this can mean reconstructing your merge files and rebuilding your timeline. (This is more about picture editing, but it's related to the whole sound postproduction process, so I want you to be aware of it now.)

Figure 16.1 Clip-based time code and timeline sync reference.

How to generate production time code on an already edited timeline and replace the footage

Find the original source files (the camera and sound files separately) in their raw, pre-merged state. You'll need to use your finder. In my editing workstation, Premiere Pro, once you've "merged" sound and picture it's too late. So you have to go back to the original files.

Then call up the camera clip in the source monitor and resync with the sound clip time code, using either your hot sticks references or your original sync pre-merge. In other words, use the production time code from the sound resync and re-merge the file and name it with the exact same shot number information. Open the new merged clip in the source monitor of the editing workstation. I then try a "replace edit" with match frame.

You'll see that this is all the more reason to sync everything up right in the beginning, by using location time code and establishing the underlying clip time code. This might seem like the biggest pain in the neck but it's worth doing it. Now we can move onto dialogue submix organization.

Dialogue submix organization

Lock your tracks

The first thing you want to do is make sure you lock your tracks. Locking tracks means you can move them in sync vertically up and down the timeline but not horizontally. In some cases it's the only sync lock reference you'll have so do it early.

Set up your timeline

First, we need to construct the dialogue editing timeline and container tracks correctly to facilitate our dialogue submix. I admit it's taken me a while to get used to thinking like a sound editor/mixer and be comfortable with building a wide range of soundtracks down the page so to speak, sprawling tracks all stacked up. It feels counterintuitive: when we cut picture it's good to have minimal tracks and keep the soundtracks to a minimum as well. Some picture editing programs even contain multiple channels of the location sound – a single container track to make it easier to cut until you're ready to split the channels for sound editing.

Some workflows will have the picture editor cut using the stereo mix and then use time code to rebuild all the isolated tracks either at the picture cut stage (ready for export to a DAW) or after the export in the DAW. My preference is to have every channel of sound already on separate tracks if possible.

Constructing your dialogue editing timeline

So we've sent our picture and dialogue to our DAW of choice. The next thing to look at is how to build the tracks. You'll need to select a film/video

postproduction template which will have a set prebuilt, including submix bus routings. Remember to turn off any processing that might be prepackaged in the template.

Here is how I set up for my dialogue submix:

Track 1 – Premiere Pro mix:
This is the stereo channel that houses the complete mixdown of the entire timeline including the camera sound *and* the second system sound.

The next two tracks represent the location mixer's set up:

Track 2 – location mix L
Track 3 – location mix R

These contain the location mixer's mixdown of the entire mix from the set, including the isolated boom microphone and the two radio microphones that will come in on separate tracks.

Then the "isos" or isolated tracks:

Track 4 – the boom (location boom)
Track 5 – Jane's radio microphone (set radio microphone)
Track 6 – Radio Voice's radio microphone (set radio microphone)

This is a replication of my editing timeline set-up, minus the camera sound that I ditched for this exercise for convenience. However, as I've stated previously, you might want to keep it and move it below, just in case.

TECH TALK – BEST CODEC FOR YOUR DAW

There used to be a lot of concern over making sure you had an optimal "video codec" that your DAW could work with. While this is an important consideration, my experience has been that DAWs have become more and more sophisticated and can play many movie codecs. However, if you're working with a large resolution sized video codec you might want to make a *proxy* movie to play in your DAW. My current DAW (Audition) is able to work with ProRes 422 but things change rapidly. Industry standard Pro Tools has its own requirements for video codecs. In general, exporting to a 1080P mov. file, or even a 720P, will work anywhere provided that the frame rate doesn't change in the export/crossover. Don't be afraid to use a low res movie codec for sound editing purposes. I prefer to export a separate movie and import it back into the DAW rather than relying on an editing workstation like AVID or Premiere and send the movie information internally through the software. In my opinion, that is asking for trouble; you have to get into the discipline of being able to separate out your sound and picture and deliver them separately.

The dialogue editing track build

The tracks that follow are a newly created map designed so we can move sound clips in sync in a checkerboarded pattern that will make it easier to mix. Remember, in picture editing you tend to think horizontally. In sound editing you think vertically and horizontally.

Track 7 – dialogue A Jane boom (1)
Track 8 – dialogue B Jane boom (2)

These are checkerboarded A/B tracks for Jane's boom.

Track 9 – dialogue C Radio Voice boom (1)
Track 10 – dialogue D Radio Voice boom (2)

These are checkerboarded A/B tracks for Radio Voice's boom.

Track 11 – dialogue E Jane radio microphone
Track 12 – dialog F Radio Voice radio microphone

These are just individual tracks, for now, to hold the isos when needed.

Track 13 – PFX 1 Jane radio microphone (production effects 1)
Track 14 – PFX 2 Radio Voice radio microphone (production effects 2)
Track 15 – PFX 3 boom

I pulled any sound effect created on the set that might be relevant like footsteps, clothes rustling, etc. Bear in mind you can only pull PFXs (production sound effects) if they are intertwined with dialogue.

Track 16 – additional room tone 1 (if needed)
Track 17 – additional room tone 2 (if needed)

Checkerboarded A/B tracks.

Track 18 – hold 1 (work track or place holder tracks to move things around onto)
Track 19 – hold 2 (as above)

Checkerboarded A/B tracks.

 This is my basic dialogue editing structure for this sequence. I can save it as a template and call it up if I am doing dialogue editing and have a similar structure. In my specimen film *Turn Back Night* there are a lot of similar sequences where Jane and Radio Voice are alone in the scene speaking to each other. This means that if I start with a template built from such a scenario I can either use it as is, or simply add to it. This should allow me to plug in a lot of my scenes as is from the editing workstation because my location mixer keeps sound channels

on the same tracks where possible. Even in bigger, more complex scenes with added characters, the mixers will often still try to keep lead characters in the same position. Also, a dialogue editing template will not only carry over your track structure, but will also contain track names and submix routings, etc. Most DAWs work better if you add additional tracks to a template *before* you import a new, more complex track structure/scene.

Figure 16.2 shows a sound editing/mixing set-up with many tracks, providing enough room for the sound editor to treat individual tracks and steps separately as needed. Many sound designers work down the page as much as across, and don't worry if there's a lot of empty track space because this will provide them with the most flexibility.

It's typical for dialogue editors to use many tracks to build a good dialogue edit. What's important is that tracks are organized by "like" clips, that is, clips of location recordings that have to be treated in the same way. I chose to split Jane's boom and Radio Voice's Boom and then created separate tracks for each of their isos (radio microphones). It's also a good strategy to copy the clips you want to move into the dialogue track and leave the originals intact below so they will always be there in case you need them.

Figure 16.2 Some sound editors prefer many tracks and a lot of space to provide for flexibility in treating separate clips and tracks.

Now, it might be a little daunting to think you're going to need 18 tracks of dialogue when you might have been comfortably working with 1 stereo track in your editing platform. But you're no longer editing picture – sound editing, down the line, is as much vertical as it is horizontal.

Dialogue A and B hold Jane's boom and C and D hold Radio Voice's. The reason I laid it out this way is because it allows me to put like sound takes on the same tracks, enough to split them for overlaps. I used dialogue E and F for radio microphone takes that have a lot of wind noise and need to be treated separately.

I also created an PFX 1 and PFX 2 for radio microphone production effects and a boom PFX track so I can "pull out" natural Foley and other effects from the dialogue tracks if I want to treat them separately or, as they do in Hollywood films, replace the majority of them. Remember, don't erase anything from your timeline. Just copy the piece and move it into place and then mute it in its original position. This is in case you lose the piece after it's been moved – you'll always have the original.

I've also created checkerboard room tone (1 and 2) and checkerboard holding tracks. This way, I always have enough room to have the handles or extra sound to make sure there's enough for the cross fades and dissolves.

TECH TALK – It's a good idea to have access to *all production sound* when doing your dialogue submix. You might think you've exported what's on the picture editing timeline with great handles (at least 1 second on each side). But there just might be something you want to replace that you didn't realize until you got into the dialogue submix phase.

The general rule is one kind of recording per track. An analogy I've heard is to think of each different recording as though it were its own instrument. And remember, the ease you are trying to create is no longer the ease of a smooth picture cut, but the *ease of the sound mixing*.

The steps to a dialogue submix – A sample workflow

Outlined below is the workflow I've developed over the years and, in part, picked up from different dialogue editors I've known and mixers I've worked with. It's not engraved in stone and is just a sample workflow. It's designed to give you a glimpse of a possible approach to doing a dialogue submix – but feel free to modify it to suit your needs, sensibility, and filmmaking style.

First, you need to build the checkerboard and mute everything else you're not using. To do so, copy the clips from the master tracks and leave them place muted.

If you decide to combine microphones – you want to, say, use both the sound from a boom and from a lavalier – you'll need to make sure they are not out of phase. All DAWs have the capability to test out phase alignment and give you ways of testing it. Figure 16.3 is an example of a simple phase metering and phase analysis tool.

Phase metering and phase analysis should be used if you're attempting to combine microphones like a boom and a radio microphone. All DAWs have phase analysis and metering and ways of fixing out of phase sounds.

Figure 16.3 Phase metering and phase analysis tool.

Do overlaps a single frame at a time with linear fades first, just to see where you're at. Next, cut the tracks and try to cut them so the room tone changes are the least conspicuous. Do this before doing anything else.

Now go back and make more in-depth fades dissolves, tone extensions, room tone edits, etc., and get it as close as possible to being smooth and having the shot changes invisible. The more in-depth fades and dissolves can involve bringing in a track with louder room tone more slowly. After you've done your best to make the edits and evened out the shot changes it's time for leveling changes or amplitude adjustments.

The basics of amplitude adjustment is when you bring the actor voices to the levels you want them at, regardless of whether it brings up the location noise more or accentuates room tone changes from shot to shot.

Then you could try a light noise reduction pass. Go through to the problematic shot-to-shot transition and see if a little bit of noise reduction will help separate the dialogue (signal) from the noise. Remember, processing sound is the least desirable approach. Don't rely on it. Think of it almost as a last resort, but okay. (At this stage of the sound editing process the point is to not completely eliminate noise, but to try to push it down somewhat.)

See if you can add any specially recorded room tone, or room tone pulled from a shot, into the shots that you treated with noise reduction.

Equalize the dialogue by track (because we're putting like sound clips onto like tracks). Okay, this is the end of the process. Now, see if a little compression can help (we'll review this in more detail later, see pp. 163–165).

GEARHEAD ALERT - Sound edit with good near field monitors, not ear buds, headphones, or display audio – preferably ones with good bass response because a lot of room tone lives in lower frequencies and these monitors won't hide the discrepancies in room tone shifts shot to shot. Speakers with a frequency response of 38 Hz–30 kHz should be okay. In short, beyond basic track structuring, don't sound edit and mix with headphones – always listen through speakers.

Step one – Building the checkerboard: selecting microphones

I'm editing a few combined scenes together for the purposes of this chapter, but typically in dialogue editing you'll edit one scene at a time. This scene (or, more correctly, sequence) has the same two characters in it, there's some PFX and loads of changes in ambiences. So, my first task is to play the scene and spot them and get a game plan. This is what I notice:

A lot of the boom is usable except for the third and fourth clip in the sequence where there was a lot of wind noise that is too overpowering. So I split the boom where each character talks. If both characters are talking over one another I go with the strongest voice.

Where I notice problematic sound clips (noise in two of the boom shots), I move a radio microphone version on the character's radio microphone track. My plan is to either opt for the radio microphone alone or add a little bit of the boom and the radios together, but this is more complicated and I'll explain later (see Chapter 21). While setting things up by track takes a little bit of extra work, it will make mixing (and/or submixing) easier.

TECH TALK – TRACK EFFECTS VERSUS CLIP EFFECTS Something that was harder to do in the old analog days was to process an individual clip and re-record it. But now we have the capability to process at the track level *or* the clip level it doesn't mean we should always use clip level processing. I save processing at the clip level for very unique and difficult sound problems I need to fix on an individual spot. Working at the track level provides for more efficiency and a better guarantee that your effects will be applied more uniformly across a certain kind of track, which presupposes a certain quality to the sound of that track. Processing clip to clip will tax the RAM (random access memory) of your computer and you run the risk of uneven sound.

I'm going to get back to the main scene from the beginning of the clip and start auditioning microphones. The first thing I'm going to do is to create simple checkerboard dialogue receptacle tracks so I can move my dialogue selects to them in preparation for further splitting.

Knowing where everything is when you set up your picture edit will help you keep organized in your sound edit. The checkerboard I set up gave Jane's boom

an A and a B, Radio Voice's boom an A and a B (separate from each other) for four tracks. Then I created two tracks, one for each of their radio microphones, two PFX tracks, two room tone tracks, and a holding track just in case.

Once I'm satisfied with the selection of all my microphones, the next step is to start to connect the handles so there are smooth transitions from cut to cut, hence setting up to create cross fades and fades.

There are a few general principles I use when opening up handles for fades and cross fades. Start with the smallest unit you can. In my case, it's usually a linear fade for each frame. I always start with one frame on "each side" of the cut.

Always try to have the overlap handles on ambient noise (room tone). Try not to cross fade or fade on a word or a breath. You might not realize it but while not always "heard," breaths are "felt" by the audience, and if truncated they might unconsciously disturb the viewer. We don't want to disturb viewers any more than they seem to be disturbed these days.

NOTE – You can have two pieces of sound on the same track crossfaded into each other, but the room tone/ambience must have the same energy shot to shot or else the audience will notice the change. So, hold off bringing sound cuts to the same track until you're convinced the room tone is the same. Most DAWs will cross fade when you drag one side of a sound clip onto another. This is one of the many reasons why sound editing is easier in a DAW than in your editing workstation.

To begin, I create single frame "handles" or overlaps for each sound clip. By expanding the timeline so I can see them clearly. I then listen to each transition and the first thing I'm listening to is how each cut or *transition* sounds to my ear. I'm listening only for transitions at this point.

The top image in Figure 16.4 shows where the labeling of tracks can begin – in the picture editing stage. The bottom image shows that, when you move your project to a DAW, you'll have the opportunity to work in frames or sub-frames which can be useful when sound editing.

Before we go any further, I need to talk a little more in-depth about fades and crossfades.

Note that the scene numbers that are set up in your original picture editing will carry over to your DAW. In this scenario the blue channels (1–4) are from the Atomos recorder. Channels 5 and 6 are left and right of all the microphones. Channel 7 is the boom and channels 8 and 9 are Jane's radio microphone and Radio Voice's microphone, respectively.

Frames and subframes in sound editing

Even though my smallest unit of sound editing tends to be a single frame, all DAWS can work in subframes. You have to be aware on your timeline what a frame delineation is. You need to be aware of the timeline divisions so you can make whole frame selections when creating overlaps. Note that each white line represents a single frame, and your DAW will probably default to move one frame at a time with the arrow key. But DAWs can move in subframes so make sure your DAW specs match your picture editing specs, especially in how the timelines match.

Figure 16.4 Labeling your sound tracks in the picture edit stage.

An overview of fades and crossfades

There are many different kinds of fades and crossfades applicable to dialogue editing.

Linear fades

A linear fade will generate a change of amplitude that, in general, will work for many sound transition situations. It's the most basic of all fades and, when on the tail of one sound clip and the head of another, it forms a cross fade.

Logarithmic fade

A logarithmic fade is an even, smooth transition of amplitude slowly and then quickly – or the reverse. This can have applications if you need to smoothly bring a clip up or down then drop it out quickly as a word of dialogue is beginning.

Cosine fades

Cosine fades are shaped like an S-curve, changing volume slowly at first, rapidly through the bulk of the fade, and slowly at the finish. It's similar to the logarithmic fade but will revert to the slower transition time at the end only if a quick piece of sound is introduced and then is gone.

Cross fade

This is a fade where the sound from each different clip is sustained a little longer so the transition is smooth. Combining two fades on both sides of a cut is usually how we get a crossfade. It is often used in dialogue editing. Most DAWs will allow "auto-cross fading," so that when you put two sound clips next to each other, then overlap one on to the adjacent one, it will crossfade.

Exponential fade

This type of fade matches the sounds that occur in nature. This would be used if there was a specific kind of fade of something that requires decaying of sound over a period of time, like the sound of a bell.

Equal power fade

This is a crossfade where one side is fading out and the other side is fading in. It's used a lot in music.

For dialogue editing we're going to focus on the first four of the fades outlined above. Keyframing on the timeline can be used as well when needed. Going through the edit from cut to cut I started with simple linear fades, not worrying if there was a conspicuous change of sound energy from cut to cut. Where you cannot connect shot to shot with clean room tone, leave it for now.

Watch your tone – Different aspects of handling room tone when editing dialogue

Changes in room tone energy from shot to shot

After you've gone through the procedure of splitting tracks, you'll hear changes in room tone and amplitude levels. Different microphone positions will cause different amplitudes of room tone as in some cases the source (traffic, people in the park, birds) will be more "on axis," while in others it will be less so.

In the case of my film, *Turn Back Night*, Holly Ann (Jane) has a strong voice. This is no surprise: she is also a wonderful singer and would sometimes warm up singing off to the side. But before I look at levels I have to deal with replacing, extending, and evening out room tone, where possible. It's best to replace missing room tone or create "tone extensions" in the picture edit, but that's not always going to happen.

The first place to look for room tone is *in the shot itself*. Usually (though not always), the best place to find good clean tone is at the beginning and end of the shot. But sometimes, if there is a long pause, you can find a good clean piece. And I mean *clean*. No breaths, no body sounds – nothing to stand out. Figure 16.5 illustrates the amount of tone to pull out.

Pull out as much clean room tone as you can find

There's no set amount, but in my experience usually the more you can pull out the better. A few seconds, at least to start with, can usually be connected to make longer tone if needed. Always try and pull it from your actual production dialogue tracks first; if that fails, then resort to room tone.

Figure 16.5 Amount of tone to pull out.

Connecting copied tone and reversing it to extend it

Sometimes, in order to extend tone sound, editors will take a tiny piece and put it down and then paste the same piece but in reverse, and do this multiple times. I find that it sounds unnatural in most cases.

Room tone from one microphone/one shot at a time

If you are blending microphones choose only one of the shots from which you want the room tone to be heard. For example, when I combine a radio microphone clip and a boom clip the boom is noisier, but I still like the quality of the voice the boom captures. So I'll remove the room tone in the lavalier and then combine it. In a few cases in *Turn Back Night*, the radio microphone added some frequencies that perhaps are fighting with the wind noise. In the first cut the room tone energy of the first shot drops a little bit. Figure 16.6 shows how to carefully handle each transition of dialogue tracks that have been checkerboarded, including what kinds of overlapping fades will best make the transitions smooth to the ear.

I added a 3+dB (decibel) boost just to make sure it's going to work. Adjusting the amplitude (not to final mix level status) made sense to me at this point. I did the same to Jane's next shot as well. The next shot of Jane's dialogue had a lot of wind noise from the boom. I preferred the quality of the voice in this shot so I still used it. I tried a little bit of noise reduction, not so much to remove it, but just to push it down a little. It worked. I was then able to bring up Jane's line by 3 dB.

In one of Radio Voices lines, "Studies show it's better for agents to have a flesh and blood partner," his voice dipped down a little bit in the words "flesh and blood partner," so I isolated that part of his dialogue and pumped it up 3 dB. It worked.

Figure 16.7 provides a detailed snapshot of dialogue editing and handling tone extensions.

I stopped at 00:00:28:14, which starts off with Jane and Radio Voice running by the fountain and will be a little PFX mix.

I have now done the basic edits for my dialogue submix. The next step is to try and do a little bit of *track EQ* (track equalization). On each of the tracks I applied a parametric equalizer and using a high pass (HP) filter I cut off everything below 80 Hz. This helps to push down a lot of the rumble of the surrounding noise.

Once I'd set up the EQ for the basic tracks, I could do a little processing at the clip level to fix individual problems. At around 00:00:06:14 was Jane's line, "but this is a trick assignment and I need to be unencumbered." I swept through the frequencies and found some unpleasant sound and ducked it down a little bit. Then I made a tiny adjustment on the gain through the clip EQ master gain control. A demonstration of this can be seen in Figure 16.8.

My solution was to extend Jane's boom and I got lucky because it was smooth. Radio Voice's voice was pretty low and not as noisy so it worked. I layered in that extra room tone over his radio microphone. I also noticed a little "pop" from one shot to the next and I tried soloing tracks to see which side it was coming from. Occasionally the energy change is so severe you'll hear a pop, so you should solo each track to find it where it's coming from. Neither side revealed the culprit, so I decided it was the actual transition.

I tried to pull open either side of the cut only to find dialogue and not clean room tone.

I found enough clean room tone and layered it underneath some of the shots where it had dropped out, especially the radio microphone shots.

Figure 16.6 Detailed snapshot of dialogue editing and handling tone extensions.

> I also ducked down the loop of room tone because it's a tiny bit repetitious. But I soloed it to see what level it was playing at. I'm constantly soloing tracks to see how they compare.

I found one little annoying noise in one shot that I was able to erase using a spot erase tool. Again, use this sparingly because you don't want to take away voice frequencies.

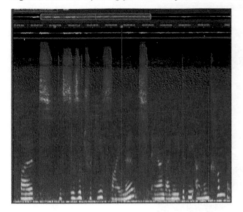

Figure 16.7 More fine tuning of dialogue tracks.

Compression

Compression is a powerful tool in sound design. You can go through shot by shot and apply compression to individual clips, or you can apply compression on the track level. That said, there is another way to apply compression to your entire dialogue submix, which is by applying it to the entire dialogue stem.

To do so, I use a *multiband compressor* (see Figure 16.9). All DAWs offer a multiband compressor as opposed to the single-band compressor which processes only one frequency range at a time. That, of course, has its uses, especially when trying to tweak dialogue.

Bear in mind that compression involved a lot of processing, so use it sparingly. Much like our gear testing in Chapter 6, it can help you identify problems in your dialogue submix. You can watch the scene, listen, and make adjustments.

I went ahead and added a parametric EQ to individual clips and made them sound as good as possible.

Figure 16.8 Track and clip EQ.

If your DAW has "presets" you can try these as well. I tried the "Broadcast" preset and it helped. If you tweak your bands, know what you are tweaking. The sliders in my multiband compressor change the overall "threshold" of the dB at which the compressor for that frequency kicks in.

Finally, in order to help smooth out submix I'm going to ambient noise. I found the perfect one "Ambience: Children Group Playing Distant 01." It's perfect: it has "air," it has other voices, and some noise to help smooth out

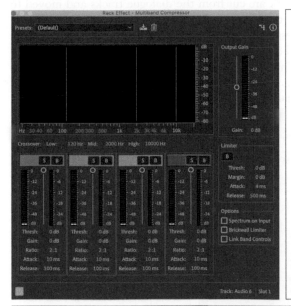

A limiter is often used in conjunction with a multiband compressor. This is because if you choose to adjust the output gain globally across the entire file and even just one of the frequency spectrums peaks due to raising the master output gain, your sound could distort. As a remedy, a global limiter is supplied to prevent this by putting a ceiling or a "limit" on a level the sound might hit. Also worthy of note is that if you use gain on the individual band level or output band, this raises the technique of gain staging. (An in-depth discussion of gain staging is beyond the scope of this book but it's something to be aware of when mixing your film.)

The advantage of a multiband compressor is that is subdivides sound based on frequency bands, which then allows you to manipulate and compress different parts of the frequency spectrum. If you are going to use a multiband on a dialogue stem, try to use it alone before any other compression processing. Remember, using keyframe and envelopes you can apply a multiband compressor to an entire stem (or track) and then tweak any parameter to treat individual clips, or even spots in clips, differently. Many would argue that a multiband compressor is best applied to a final mix because it is so nuanced and comprehensive, but I have found they work well on dialogue stems and tracks. They tend to come with presets that seem to suggest they are meant for final compression of a master track output to comply with broadcast standards.

Figure 16.9 A typical multiband compressor.

the transition. This comes out of the box as a "stereo ambience" and you can leave it that way or convert it to mono. If it's an ambience that is meant to envelope the scene and help smooth things out, I'd leave it as an ambience.

Dealing with PFX

The final aspect of dealing with a dialogue submix is what to do with all those groovy PFX (production sound effects).

At 00:00:28:13 (on the DAW's counter), I copy the footsteps and pull them into the PFX tracks. Since it's a change in perspective, I have to do something with the added ambient sound. I'm feeling a little lazy so for now I'm going to try an amplitude envelope or keyframing and see if it works.

Figure 16.10 shows how PFX are cut from the dialogue tracks and moved to their own tracks. They can then be treated separately, and this can include applying a multiband compressor to them to make the sound more even.

This chapter has provided an overview of dialogue editing and has gone into a little more depth than Chapter 15. Like all things filmmaking and sound design, you have to practice. Use the practice scenes in the book and shoot some of your own location dialogue and dialogue edit it.

The PFX have been copied and moved to the PFX tracks (from the boom and character isolated [iso] tracks). These tracks will be treated separately. There are a lot of good breathing sounds of the actors (from running) and there are different aural perspectives of Foley sounds on the isos compared to the boom Foley. On these isos, when the perspective changed due to shot changes and the actors ran to a different area of the park, I needed to treat the room tone changes. I could split each character's isolated track to separate tracks and, using keyframing, lower the amplitude of the cut when the scene location changes.

I also wanted to make sure no adjustment needed to be made to the multiband compressor given the location/perspective changes from shot to shot. While this is more sophisticated submixing, it is something you could experiment with and even use keyframing or "envelopes" to adjust some of the compressor's processing parameters as the shots and scene change, to correspond with changes in location/perspective.

A multiband compressor can be helpful when there are separate dialogue tracks and PFX tracks as these sets of tracks will have different dynamics and compression needs.

Figure 16.10 Track structure and submixing PFX in a dialogue submix.

17 Automated Dialogue Replacement

Sound editing that requires looping or "comping"

Automated Dialogue Replacement (ADR) is a process whereby location dialogue which is not usable due to noise on the set and/or poor recording is replaced by being re-recorded in a studio environment. The actor watches the screen and tiny segments of a scene are played back and looped so the actor can listen to their location dialogue and try to recreate the performance. It happens often in Hollywood films and seasoned screen actors are usually very skilled at ADR. I personally like to avoid ADR, but it's impossible not to need a little now and again.

To demonstrate a very simple ADR session I'm going to use the same little scene in the park from *Turn Back Night* (as used in Chapter 16) and ADR one line myself. I live 500 miles from my lead actors and it's not convenient for me to get them to do one line of ADR, so I'll do the line myself for demo purposes.

Recording considerations

Environment

First things first – you're going to need a place to do the ADR. Ideally, you'll need a padded booth with a computer to playback the clip. It's also preferable to have a big screen TV or a giant computer monitor because the actor must have a close-up view of their lips so they can match their performance perfectly. You'll also need a good sound card, preferably one with preamps to power a good condenser microphone for the session.

Microphones

You'll need to select a good microphone to do the ADR with. You can use your all-purpose indoor short tube cardioid. For microphone purposes I'm going to return to my handy-dandy Røde cardioid microphone. It's very inexpensive and will serve a variety of purposes, including plant mics and indoor dialogue, Foley, and ADR.

You might be wondering, "Shouldn't I use the microphone that we shot the film with?" The answer is, it depends. If you are thinking of reusing a supercardioid shotgun microphone in an extremely controlled environment without reflections off walls and ceilings, yes, you can, that could work. It could save you some final mix headaches: if you opt to change microphones and compound this by

switching to a booth recording environment, it could be hard to get the sound to match the location dialogue tracks in postproduction.

Doubling up with your radio microphone

If the primary way you recorded your location dialogue that you are now replacing was with radio microphones, then by all means double up your actor with the same radio microphones and have them in the final mix. You stand a better shot at getting them to sound the same.

Microphone stands

Invest in a good microphone stand and a wind screen. You'll usually want your actor to stand when they do ADR, regardless of whether or not they were standing in the scene. Standing gives actors greater control over their vocal instrument. It might seem counterintuitive, but have them stand at all times when doing ADR even if the scene has them sitting.

Headphones

This is a case where *everybody* needs to be wearing headphones. All the actors, the recording engineer (if not you) and you, the director.

We've all watched big budget films that contain a line of dialogue thrown in off camera as an afterthought, and often it doesn't sound quite right. There are many reasons for this (actors are not robots – it might have been hard to get exactly into the head of the character six months later when the ADR was being done). It could be that a different microphone was used in a different environment, all adding into the line and standing out like a sore thumb.

A good wide music stand

Believe me, this might sound like overkill but nothing ruins an ADR session faster than actors having to turn pages to read off lines to record. A good wide music stand allows them to spread out a few pages at a time.

Type in your ADR dialogue like subtitles or karaoke lyrics

You could type in your ADR dialogue to be re-recorded as dialogue on the bottom of the screen, much in the way you see subtitles in foreign language films or in a Karaoke monitor displaying song lyrics. It's a lot of work but it's another way to go. Make sure you time it so the actor gets to see the dialogue a second *before* they have to say it.

Don't forget to direct the actors

While ADR recording is a very technical, exacting process you should also be prepared to "direct" the actors much in the same way you would on set. They will need direction to know they are saying the dialogue right. Don't hand it

over to someone else to direct them – make sure you are there and guide how they say the lines.

A chance to redo a performance

When I was doing ADR for my first film, *Auditions*, we were bothered by the delivery of one particular line. The actor was almost too angry and there was no other take. So we redid it and had him tone it down a little bit. It worked. It's not something to rely on, and can only be done in very specific appropriate spots.

Setting up for an ADR session

Whenever you do any sound effects editing, Foley creation, or ADR recording it's best to set up cue sheets to do so. They contain generic information including:

- Time code start – "One Hour Time Code" refers to the master editing time-line. If you wanted to go crazy you could also include "Clip Time" code but I don't think it's necessary.
- Cue – the cue number, or which cue are we on. It's a good idea to list them, like a shot list, so you can keep track of how much you have to record during any given session.
- Character(s) – what characters are in the scene.
- Dialogue – the actual line that is going to be replaced.
- Recorded takes – to keep score of how many you've done so you know what to expect on the timeline and have a place to make a note on the take. You could come up with a system: G = Good, NG = Not Good; or a number rating, 1–10, with 10 being the best.

Table 17.1 provides an illustration of a sample ADR cue sheet.

Table 17.1 Sample ADR cue sheet

ADR cue sheet		ADR test		Page 1 of 3			
Reels 1		**Comments**		**Date/version** October 24, 2017			
Time code start	**Cue**	**Character**	**Dialogue**	**Recorded takes**			
01:00:00:23	1	BOY	OHH WOOW, AHH, AHHHH				
01:00:04:17	2	BOY	Ok, what do ya want from me?				

Figure 17.1 shows an actual ADR session in progress using Logic Pro X which automates the looping process as well as recording take after take without erasing the previous take. This allows for ADR editing to piece together the best performance from multiple takes.

Loop recording/comping allows you to record the same line of dialogue over and over again into a "take folder" to be used for a feature called "quick swipe comping." The take folder is a container that rests on a single track, and after the first recording in cycle record takes are stored in this "take folder." You can either use one of the whole takes in the take folder, or you can make a composite of selections from any or all of the takes. Not every DAW loop records with comp features, but we'll see below (p. 173) a way to simulate this.

For ADR and Foley it's easier if you record with software that "comps" or records take after take in a loop without erasing the previous take.

Figure 17.1 A snapshot of a loop recording (comp) in progress using Logic Pro X.

SOFTWARE/GEAR AGNOSTICS – SOFTWARE FOR ADR

To do ADR right you need to be able to loop record in a very specific way, and not all DAWs have the capability to do so. Pro Tools is industry standard and if you can afford to work with it by all means do so. There are still things that Pro Tools does better than other software (such as displaying multiple kinds of time code right on the track itself so you can match it to the clip time code in the window burn if need be.)

To my knowledge, the most affordable comping software on the market is Logic Pro X. This is predominately music production software, but it has postproduction sound capabilities. To use it, you need to open a "music for picture" template.

The looping process allows you to record over and over again with exactly the same amount of "lead in" or "cue" that can be signaled by a countdown beep. Automation plays a big role in this technique – hence the name, "Automated Dialogue Replacement." It's a very technical process and the actors have to get into a very specific rhythm to do it effectively.

In the film *Turn Back Night*, I wanted to redo the line of Radio Voice saying, "Studies show it's better to have a flesh and blood partner." I felt as though he swallowed the last few lines. So I re-recorded it and was then able to select the first part of the line from "Take" ("Studies show") and then the rest from "Take 4" ("it's better to have a flesh and blood partner"). I was then able to composite them together and had a single piece of audio that I could drop back in the timeline. When you work on a bigger film it's better to have all your time code ducks in a row, but I'm just showing simple experiments here.

I can sometimes use a single take as is, or edit pieces of different takes and "flatten" or merge them into one take. It's a good idea to do the compositing in the DAW you used to create the ADR, because it might be harder to do it with individual tracks once you move it to, say, Final Cut Pro or Premiere or Audition. But don't despair. There is cheap way to kind of simulate the comping process.

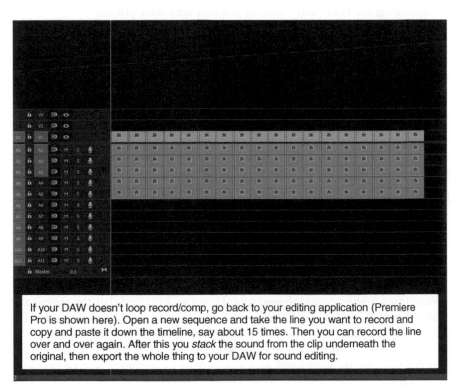

If your DAW doesn't loop record/comp, go back to your editing application (Premiere Pro is shown here). Open a new sequence and take the line you want to record and copy and paste it down the timeline, say about 15 times. Then you can record the line over and over again. After this you *stack* the sound from the clip underneath the original, then export the whole thing to your DAW for sound editing.

Figure 17.2 Tierno's loop record/comping technique on the fly.

My cheap way of ADR recording, shown in Figure 17.2, is a fix when using a software platform that doesn't loop record and comp at the same time. If you do it this way, you at least have the advantage of getting the actor into the automated rhythm that is required for a good ADR session and then you can line up all your takes and select the best one or edit a composite of a few of them. It might sound tedious, but it beats starting and stopping to record ADR. Try it.

After you've recorded and edited your ADR it might all work perfectly on the timeline, or you might have to do a little bit of further work to make it perfect. Human speech is a very nuanced tool. To say a line of dialogue exactly the same way – or in a way that perfectly, rhythmically fits the visually sync of the picture – occasionally needs some manipulation to match. Sometimes a technique called time stretching is deployed to help out. Time stretching extends or shortens how long a word or sentence takes to play *without* changing the pitch of the voice. But it takes practice to use it inconspicuously.

ADR can be done without the added expense of going to a big sound recording facility, provided your recording environment is not noisy and added reflections are minimal. The booth microphone image from Chapter 4 (see p. 22) is positioned in a place without a portable mini-sound booth and does a great job of simulating the booth environment at a very affordable price.

That's a stretch – Stretching and shrinking ADR for final matching

So you've recorded a take and it either fits and matches perfectly with the lips of the actor (and the underlying reference sound) or it's a tiny bit off at the end. If the latter is the case you're in luck – there are tools that can help you tweak the sound just a little bit to fit. You'll have to search your DAW for "time remapping," but they all do it. Bear in mind that it's a fair amount of processing so test it, and mostly likely you'll need to do it sparingly.

For now, I'm going to drop the composite piece back into the timeline because we're going to need to do a little dialogue editing (ADR style), and I'll introduce some location captured room tone to do so.

So the next step is to export the composited sound clip I made of the ADR, drop it into the timeline, add room tone, and hope it blends with the location dialogue, as seen in Figure 17.3.

I then added some of the room tone that I edited from the scene and the canned park ambience and slipped it in. However, I noticed that the timing was still a little off so I used an "Automated Speech Alignment Tool." Using this tool, I was able to adjust the ADR in line with the reference track.

Recording and editing ADR is challenging and takes time to become good at. But you can try your hand at it if you need to replace a line or two – or even more.

Figure 17.3 Use your location dialogue as a reference to align your ADR dialogue.

18 To Foley or not to Foley ...

The next part of sound postproduction that works best with looping and comping is Foley. I've heard it said that having well done Foley in your film separates quality films from more amateur ones. What Foley does, in my opinion, is to keep us in the head of the characters, and in the moment. Without Foley, we might lose the sense of the characters on the screen, and as soundtracks in films have become more and more layered a good Foley track can help us stay focused on the actors.

FOSSIL RECORD – Foley was not something that was automatically a part of sound films once sound film broke into the mainstream. The main focus of location sound in the early "talkies," as they are called, is the talk or dialogue. There were a few Foley effects here and there but when you look back at the older classical Hollywood "talkies" from the 1930s and 1940s they are conspicuously devoid of Foley. Foley evolved slowly over time and if you're a fan of movie history, as I am, you'll notice that as the years progressed through the 1940s, 1950s, 1960s, and up until the present day, Foley sophistication grew with production value. But for a long time it was pretty consistent in that, for a serious budget Hollywood or independent film, a full-scale Foley treatment would be done to make the film competitive in the marketplace.

There is another secret as to why you should go to the trouble of doing Foley for your film – it gives you options to emphasize sound elements which are really just story elements in your final mix. Let give you a perfect example of a great use of Foley. One of my favorite music films is *Immortal Beloved*. It opens with a scene where the characters are loading up the coffin containing Ludwig van Beethoven onto a horse-drawn cart. The scene has a lot of ambient noise, but the sound editors and mixers made the sound of the coffin and its handles very present in the track. It didn't have to be that way; it could have been lowered and made to be just "felt" rather than "heard," a distinction sound editors often use. When a sound effect is just "felt" it's lower in the mix and really blends in. But in this scene, you hear the casket being placed on the cart – probably in a way you wouldn't if you were standing in the yard watching. It helps to draw your eye and your mind into what's important in the scene.

Even if you have a lot of PFX (production sound effects) that you're perfectly happy with, the chances are your location sound won't provide everything you need and so it's best to plan to add some Foley effects. Also, PFX invariably come with different levels of location noise and that limits control of these sounds in the final mix.

Foley overview

Foley are sounds that are recorded to match specific sync sounds on screen. Any sounds, from footsteps to doors slamming, or chewing, are Foley. Some Foley can be done with canned effects (we'll talk about this in Chapter 19 which discusses general sound effects).

But, as an independent filmmaker, I want to give you a little taste of how you might be able to do some Foley creation on your own if you don't necessarily want to use canned Foley.

In my opinion, for independent film you can get away with a lot of canned Foley except for footsteps, clothes rustling, eating and drinking, etc. So here's how you can set up a basic Foley studio.

There are three kinds of Foley – footsteps, movement, and hard effects. To consider each in turn:

1. *Footsteps.* These are the king of Foley sounds. They require the most skill and creating them in your film can really help differentiate it from other low-budget independent work. In Chapter 15, I showed you how to use canned effects, and they can work. But they aren't always going to cut it. Also, your PFX (production sound effects) sometimes won't be clean enough to use. So it's good to get into the habit of creating Foley.
2. *Movement.* This includes clothes rustling, sitting down and getting up from chairs, chewing, drinking, swallowing, smoking, etc. Note: Breathing can be added but is often part of the dialogue tracks.
3. *Hard effects.* Examples include: packing a suitcase, scrapping ice off a car, frying an egg, opening and closing a drawer, etc. Certain hard effects might be created by a Foley artist or a filmmaker can choose to use canned hard effects. It depends on what is needed. Needless to say, the canned sounds usually won't match as well as syncing to an actual picture, but sometimes they work fine.

Let's take a look at how you would treat PFX in dialogue (see Figure 18.1).

I went ahead and pulled out clips of sounds that had PFX and moved them to the designated PFX spot in the dialogue submix. This afforded me two opportunities. First, it allowed me to treat them as separate entities within the submix; second, it isolated them for recording Foley if I wanted to replace them.

The next step is to set up *loop record/comping*. You can refer to Chapter 17 (pp. 172–173) to see how to create a makeshift loop recording/comping set up if your Digital Audio Workstation (DAW) or editing platform doesn't do so.

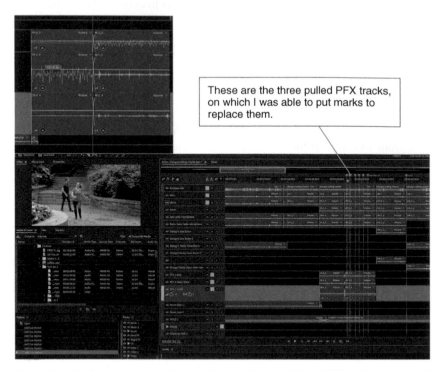

These are the three pulled PFX tracks, on which I was able to put marks to replace them.

Figure 18.1 Dialogue editing includes pulling production Foley (PFX) to their own tracks.

Other considerations for Foley

Room type

You'll need to use a padded sound-enforced room much like the one where you would do Automated Dialogue Replacement (ADR). Carpeting helps because it will eliminate reflections off the floor.

Microphones

In general, microphone considerations when recording Foley are similar to those when recording ADR: Do you use the same location microphone or not? Again, it depends on your recording environment. If you have some room reflections, don't use a lively shotgun supercardioid. But matching microphones from location recording isn't as critical, because most PFX you record on set is incidental. For my test I'm going with the Røde cardioid condenser microphone.

Monitoring environment

You'll need a big computer monitor or TV screen so the actor doing the Foley can watch what they are recording. The engineer recordist will also need headphones.

Software

Just as in ADR, you'll need something that *loops* and *comps* recordings, like Pro Tools or Logic Pro X.

Props and surfaces

To Foley you're going to need a lot of tools to help you create sounds. There's a lot of YouTube videos, but in my experience the heart of a Foley space is building the surfaces to recreate footsteps. It's very hard to cut in canned footsteps to be believable. So, my energy would first go into building the various footstep surfaces, and then I'd gather everything else I need to do the other Foley sounds.

Guerilla Foley method

There is another method that an Academy Award winning sound effects editor once disclosed to me. You'll need a small handheld recorder such as a Zoom H4N PRO and an iPhone or a phone that can play video.

Record the video in a loop and connect it a number of times, say 10–15 times. Give the Foley artist a pair of earbuds and set up the microphones. Show them the video with one hand and record the Foley with the Zoom microphones with the other. After you've recorded your Foley with this method you can open them up as well as a timeline with a *handclap sync* and do the same makeshift looping/comping process described above (see p. 173).

Building your own Foley studio

There are a lot of great websites and books that discuss how to build your own Foley studio. You can start small and try out Foley recording to help out in places where PFX don't cut it and where canned Foley will not work.

In essence, I think the key to building a Foley studio is to be realistic and know what you're capable of. You don't have to have a big studio – it's independent film and it can be scaled down. But having robust Foley tracks when you go into your final mix can help your film stand out from the pack.

19 It's all for effect

An overview on the creation, uses, abuses, and editing of sound effects in film

Overview

We covered the creation of sound effects in our sound design overview in Chapter 15. We've also covered a major category of sound effects, Foley, in Chapter 18. I'd now like to talk about other kinds of sound effects we can use in independent film.

> FOSSIL RECORD – Sound effects in film have their roots in radio. Radio shows would have actors acting out a narrative and then sound effects were used to help create the reality of the scene in the minds of the audience. It was customary to create the sounds live during the production to give a more energized feeling. This ultimately led to sound effects in movies as we know it; obviously the technique has grown immensely.

I'll first outline the categories.

Foley

As discussed in Chapter 18, Foley are sound effects, created by a Foley artist, that are synchronized to an image on the screen. These include clothes rustling, footsteps, punches, etc.

Hard sound effects

Explosions, car doors opening, and helicopters flying past are hard sound effects.

Background (or BG) sound effects

These are not synced to a picture and fill the aural field in more of a continuous way. People talking in the background (or "walla"), the sound of a crowd in a restaurant, or an air conditioner all are background sounds. These sounds are also known as atmosphere or ambiences.

Design sound effects

These are more in the sound design category, and are not sounds that are natural. Horror and science fiction tend to use these sounds. Often they can replace or work with the musical score. These sounds tend to evoke emotional responses in audiences.

There are thousands of websites that feature sound effects for purchase or that are free. There are so many different ways to categorize them it can be overwhelming. So, to make things easy, I've compiled a list of sound effects available free through Adobe called (cleverly enough) "Adobe Sound Effects." It covers a wide range of sound categories (outlined below). While not exhaustive, this list of categories is adequate for me in about 80 percent of cases. I'm not one to go out and make a lot of effects. And it's free if you use them with their software (Adobe has a licensing agreement regarding use of its sound effects – visit www. adobe.com/products/eulas/ for information).

So let's look at the categories a little more.

Ambiences 1 and 2

These are general background ambiences for atmosphere, which range from straight ahead air conditioners and crowds in restaurants to nature scenes with rain, birds, etc. These come in handy when you're trying to "fill in" a background and help smooth it out a little bit. They aren't hard to create yourself if you have a recorder, a good microphone, and some time.

Animals

This is self-explanatory – everything from frogs chirping to dogs barking, etc. Bear in mind that animal sounds have a certain Foley aspect to them in that they often have to be synced to picture. For instance, if a cat meows in the picture you have to make sure the meow you have matches your cat and what the cat's mouth is doing. This is why it's always good to get some sort of reference sound on the set, even if it's the weakest camera sound. That sound will literally be gold.

Cartoon

Cartoon sounds are those that are associated with the zany visuals that exist only in the world of the cartoon. It covers a wide variety of sounds from cartoonish human voice effects (evil laughs) to some Foley-type sounds (balloons rubbing, party noise blowers).

Crashes

This can be any loud sound like a garbage can dropping on a pavement, glass breaking, bottles breaking, etc.

Drones

This is my favorite category. A drone is a relatively modern sound effect in that it pertains more to the *sound design* mindset where sound effects can be very atmospheric and almost like music. In fact, some composers work very closely with the sound design team in a coordinated fashion so as not to fight with each other aurally. Drones themselves are sonically very rich and can be combined with other drone sounds. They can do a lot by themselves to help create an interesting sound field. Some drones are little pieces of score/sound design that fall somewhere in between sound effects and music. Many seem to have been created with musical synthesizers. There are even some effects that take human voices and process them as synthesizer tones. Some names of note are "Drone Production Element Deep Menacing Dark Evil" and the likes. You have to hear them to understand them. And if you're thinking a big use of these kinds of sounds are in horror films, you are correct.

Emergency Effects

Emergency Effects are an interesting combination of different kinds of effects – everything from "Emergency Band Aid Ripping Off Patient" to "Emergency Fire Truck Honk Air Horn" and "Emergency Human Female Voice Hospital Calls All Doctors to the ER." As you can see many of the sounds pertain to incidents related to hospitals, emergency rooms, ambulances, police and firefighter activity, etc. As with most hard sound effects, many can be Foley but some are for non-sync situations.

Fire and Explosions

This is self-explanatory, but they seem to tend toward bigger kinds of sounds.

Foley

This set of Foley sounds are of the non-footstep type. Footsteps have their own category as they are the most important Foley in your aural landscape. These Foley sounds are any kind of sync sound that *could* be created by a Foley artist but are canned for you, everything from "Foley Bells" and "Jingle Sleigh Bells" to "Foley Coin Drop on a Wood Platform" and "Foley Wood Shelf with Wheels Rolling on Cement." All of these sounds will be in conspicuous sync with picture.

Foley Footsteps

This category is self-explanatory; the collections are vast and varied, containing all kinds of shoes, pavements, and volumes of sounds.

Horror

Every kind of body stomp, demon yell, monster chewing, and human scream are collected here.

Household

This category consists of things that happen around the house: blinds opening and closing, book pages being turned, blenders blending. You get the picture.

Human Elements

These are sounds made by a human being – everything from farting to whistling to yawning.

Imaging Elements

Imaging Elements are similar to "Drones" but not as consistently "low frequency." There are a lot of "Electronic Whooshes" and "Electronic Whooshes Reverse." These, too, are sound design heavy and can be combined with each other, or with Drone sounds. They aren't as "musical" as the Drone sounds but can serve as substitute music cues if needed. They tend to lend themselves to horror and science fiction film sound effects needs. Bear in mind that imaging elements can also be layered together to create original, complex sound effects.

Impacts

If you need the sound of a bat smashing a TV, beer bottles smashing against a wall, or a body falling in the dirt, gravel, pavement, or grass, this is where you'd go.

Industry

This category is home to noises made by industrial-type things such as cars, trucks, tools, machines, construction sites, etc.

Liquid and Water

Here you'll find any sound made by water across a wide variety of applications – dripping into buckets, out of faucets, etc.

Multimedia

The intention of this category might take some thinking. It seems like it's a lot of special effects and stings and flashes. It's a curious collection that seems to be another variation of science fiction type sounds, but they tend to be short.

Noises, Tones, DTMF (*dual-tone multi-frequency tones*), and Tests

This is a collection of noises and tones that can be used for a variety of purposes, including to calibrate equipment, generate and create sounds from scratch, filler noise, etc. Phone dialing and dial tones are included here.

Production Element

These are synthetic sounds that are similar to those in "Imaging Elements." Broadly speaking, I would say these sound more conspicuously computer generated and are possibly of a higher frequency.

Science Fiction

Even though several of the above categories have a lot to offer for science fiction filmmakers, these sounds seem more specifically geared toward science fiction. They include alien growls and hisses, communication sounds, laser hits, and of course, plenty of saber light whooshes.

Sports

This category consists of anything related to sports from a duffle bag dropping on a pavement to basketballs being dribbled, etc.

Technology

This applies to sounds that you might make *using* technology, such as a DVD player tray table sliding out, a cell phone vibrating, etc.

Transportation

Anything pertaining to sounds made by vehicles, every kind imaginable, is included here. (Note: the sirens of police and fire engines are more abundant in "Emergency Effects".)

Underwater

Here you'll find sounds recorded underwater – everything from the sound of motorboats to sharks, etc.

Weapons

If you need to find bullets for your WWII battle scene, this is where you can find just about every kind of bullet and gun sound imaginable. There are also sounds of guns being loaded and shells hitting the floor. But it's not all bullets – there's ax hits, sword sounds, etc.

Weather

These are sounds pertaining to weather, such as weather ambiences and Foley footsteps on snow, etc. They include shoveling snow, earthquakes, tornadoes, etc.

My summary can't compare to you actually auditioning the sounds and getting a sense of what can be found and where.

TECH TALK – Sound effects come in all kinds of configurations based on what you need from them. These different formats include mono, stereo, or surround sound formats. A lot of simple effects like gunshots and footsteps tend to be mono because you don't need much more from them than to sound off at a specific point in the mix. Ambiences (like traffic noise, city streets, etc.) can either be mono, stereo, or surround. I like my ambiences to be in stereo because then they can fill out a stereo mix.

Indexing your sound effects

It's important to be able to access your sound effects and to have an easy way to hear them to decide if you like them as you're editing (or "audition" them as it's called). It's also very important that you come up with a good organizational strategy, because a film project can have hundreds of sound effects and you don't want to get lost or create chaos in your file structure. You should be able to access your sound effects library from the media browser section of your Digital Audio Workstation (DAW). Most sound effects collections come already "indexed" to some extent, that is, they are subdivided into different categories and in alphabetical order.

Sound effects that come from a collection

If you have a folder of canned sound effects and wish to merely *point* to this collection, there is no need to copy these effects into another folder. However, I always copy the individual sound effects into a new, designated folder (as part of the main project file folder) because I like to be able to move things around quickly as well as have an easy backup strategy. But as long as you plan to edit while having access to the main sound effects folder you're pointing to, by all means do so – there's no need to create extra work and hard disk needs.

What this means is that you won't need to create a separate file to copy your sound effects into. You can just point to sound effects and use the sounds in your timeline. So, if I have Adobe Sound Effects on my hard drive and it stays in the same place during my sound edit, I don't need to create a separate folder. But bear in mind – if you try to edit on another computer your sounds won't be there unless the folder of sound effects is on this computer. If you want to be safe, you can copy each sound effect and put it into its own file and import the sounds into your project that way.

Creating sound effects from scratch

If you have a burning desire to create your own sound effects, go for it. You'll need a recorder, a microphone, headphones, and your imagination. While there are many different kinds of sounds you can capture, I want to focus on two primary ones.

Do a test – Record a moving car with multiple microphones

When I was a kid, one of my favorite cinematic scenes was a good car chase. *The Seven-Ups* has one of the best. Even though I was only 14, I knew that the sound of the car was a big part of the effect of the chase. In fact, the sound effects helped *sell* the car chase. But the sound effects editing and mixing was extraordinary. I don't know the specifics, but you could hear the engine and the car rattling, and the wheels screeching. This was probably done with multiple microphones so in the mix you'd have more control over the different frequencies and where to place sounds.

A good, simple test is record the different parts of a car with a couple of microphones. Place one near the hood, one near the exhaust, and one inside the car. Record all three sounds, sync them up, and see if you can blend them together to make a composite sound.

Creating sounds for things that don't exist – Using sounds in nature and the environment in creative ways

Sound effects artists are very creative and a big motivating factor in their efforts is to be able to deliver uniquely created sounds for every project they work on. It's a double-edged sword because it's time consuming and can be costly. But if you use canned sound effects they can sound, well, canned. You have to develop your ear and your sound sense to know what you can (and want) to get away with.

To keep up with the demand for quality in filmmaking, sound effects artists will go into nature and the environment and record all kinds of sounds and then repurpose them to be other things. The most famous example of this is Ben Burtt who created sound effects for the early *Star Wars* films. To get the sound of the lasers firing he went into the field and recorded striking a taut bridge wire with a wrench. He then brought back the sounds, manipulated them, and raised the pitch until they had usable laser sound effects. Bear in mind, he was creating a sound for something that, to my knowledge, didn't exist: Storm Trooper laser gun shots. He couldn't just go into a library and find them, he *had* to create them.

A simple experiment – Creating a multilayer car sound

If you need to use the sound of a car, you could just take a canned sound from an effects library. Or you could create your own. And in doing so, you could

place the microphone at an optimal place in the garage or on the street to capture the sound. Or you could create a multilayered sound so that, going into the final mix, you'd have access to different parts of the car sound to emphasize different things.

Let's say you need the sound of a Toyota Camry starting up and driving along and you don't have that canned sound effect. You'll want to record an actual Camry.

There are a million different kinds of sound you could record, but I'll zero in on the Toyota Camry sound. You should record it in multiple ways. First, record it with a single microphone from the interior of the car. Then record it from outside the car with a single microphone. Another consideration is: Do you record it starting up and running in a garage or on the street? It matters because the reverberations will be different. In either case, you have to get great signal-to-noise ratio but the frequency response will be different.

Next, record the car using multiple microphones. You could place one right near the engine and another near the exhaust.

Using sound effects for things that do exist

When you select sound effects for things that do exist, try to be as specific as possible. Don't just throw the sound of any car to represent a car sound – try to find the exact make or model (or as close as is reasonably possible) to the car you're trying to place a sound effect for.

The same goes with using canned sound effects to fill in for ambiences like traffic noise. Don't use sound recorded in Times Square, New York city and use it for a suburban intersection. I know it sounds obvious, but you'd be surprised....

Workflow for sound effects

The following is a workflow suggestion for spotting, creating, and placing sound effects in your film. You will eventually evolve your own process, but here is mine:

1. Spot your film for sound effects. This process is similar to marking your timeline for Foley. Use your timesheet and timeline time code and first of all figure out what hard effects need to be placed, starting with synchronized effects like door slams, etc. Mark your cue sheet.
2. Create cue sheets that correspond to the marks you create. You might want to play it once with the dialogue submix, and once silently.
3. Review your library and determine what original sound effects need to be created. You don't need to have sounds sync perfectly when you audition them on the timeline. Just throw them in and make a list of what you think works and what you'd like to create.
4. Create any original sounds that are needed.

5. Place additional Foley and other hard effects.
6. I find that any sound that is conspicuously synced to picture is the hardest, and the one I like to get over first. Those that are connected to human beings – like forks hitting plates, taking off a coat, or sitting on a coach – are the hardest, after doors opening, glass shattering, etc.
7. Drop in your ambiences.
8. Sometimes a good ambience will tighten up a scene and bring a lot of aural unity and coherence to it.
9. Place sound design sounds. These are your drone sounds, atmospheric sounds, etc. These sounds are often non-diegetic, which means they occur *outside* the narrative and aren't perceptible to the characters in the film. They are often very musical and can function as music cues. As mentioned above, they can take the place of music or work with music. This is why, in a sound design heavy film, the composers will often work in tandem with the sound designer so as not to compete with each other.

Processing sound effects

Creating a sound effect is rather like making a little mini-movie. You have to find the sound source, record it, edit it, and finally mix it. If you're layering a few sounds to create a sound effect, you might need to use compression and EQ (equalization) to make the sound right. For example, if you're trying to create a scary alien monster growl you might need to use the sound of a lion and an alligator roaring together and lower the frequency of one of the sounds, compress them together, and then output them into a single finished sound effect.

Which brings me to our next chapter, everybody's favorite, music!

20 Music – Getting it right and left

Who doesn't love music? Music is one of the most important aspects of the aural experience of a film, yet so many filmmakers don't feel comfortable creating and/or producing it or can't afford a composer by the time they reach the stage of postproduction.

I understand the feeling; by the time you get around to that part of the process you are usually so burned out by the project and your resources are depleted, which makes it hard to give this crucial part of the sound process the attention it deserves. I'm fortunate in that I'm a musician and composer and I know my way around Logic Pro X, a very powerful scoring program. That said, it's nice to have a composer to work with who knows what they are doing. It's potentially a wonderfully collaborative part of the process.

But let's talk first about you, the independent filmmaker having to finish your film with little or no budget for score.

Creating music for the non-musician

You don't have to be a composer, or even to hire one, to have some basic, effective music in your film. So let's look at how to handle music at the various levels.

Uses of music

This section outlines the main uses of music in film.

Underscore

This is the most traditional concept of music in a film, a score. Basically, it means a composer took the locked cut of the film, spotted it with the director, and made notes. Then, using time code, they will write underlying music to support the emotional and psychological journey the director is trying to take the audience on.

This skill involves a trained composer who knows not only how to write music but music for film. It's a specialized branch of composing and even some fantastic musicians or those who are great at general composing have a hard

time scoring a film. Perhaps it's because a film composer's job is very specialized: the music isn't being created for its own pleasure, it has a job to do, which is to unify the emotional journey of the film.

Having original music created for a film can either be done by a composer who also produces their own music via electronic instrumentation or who hires various musicians to play parts they have written, or some combination of both. For the purposes of this chapter I'm going to assume we're talking about a one-person band composer who conceives of, writes, plays, produces, and finishes their own music in an electronic home studio set-up.

A big part of the composer's job is to help unify strands of the film that, without music, might not seem to be part of the same film. The composer's role is also very important in helping to underscore and support the overall tone of the film. In general, film scoring, in addition to being an art in itself, is very technical. A trained composer will know how to turn a timeline into a "meter" and then write cues based on this information. In other words, a composer must turn film timeline information into musical information before they actually compose. This is why all Digital Audio Workstation (DAW) timeline has the capability to be expressed in minutes, seconds, and frames, or musical divisions.

I'm sure some composers don't necessarily work in this way. They might just play loops of the scenes they are scoring over and over and sketch out ideas. But in order to make sure their underscore perfectly supports the emotions of the scenes some technique must be deployed.

Cues and stings

All musical compositions for film are considered a "cue," even if it's an extensive piece spanning many minutes over a few scenes. I tend to use the term "cue" for a shorter piece with a circumscribed time frame that has a concise job, and "sting" for an even shorter piece of music.

Shorter pieces of music are used to quickly emphasize an emotion or a scare or a thrill. Cues can be created from scratch by a composer or you can use pre-canned cues. Apple Loops provides a multitude of free music in the form of cues that come already orchestrated or with a band playing them, or in individual instrumentations that can be used alone or combined with other instrument tracks. This requires some musical skill, but through software technology and automation it's not as hard as it might seem.

Music beds

Music beds are what I also like to call "program music" – music that is happening in the narrative space of the film, perceptible by the characters in the story. Music beds are the easiest to find royalty free, although those available on Apple Loops tend to not extend beyond 1 minute. You can purchase just about any kind of music with a one-time license and compositions that are in public domain (such as classical pieces) are very affordable.

Prerecorded songs as cues

One of the most interesting uses of music, in my opinion, is the way Martin Scorsese uses popular rock songs in his films (*Goodfellas* is of particular note). He doesn't use actual score but popular songs to work with, and against, what we're seeing. He also sometimes uses period rock music as a way of helping us feel the mood of the time in which the historic crime drama unfolds.

The music doesn't always completely sync up to what we're seeing – such as the long outro of "Layla" at the end of *Goodfellas* when the authorities are uncovering all the dead bodies of the gangsters that the Robert DeNiro character had executed. In some ways, the contrast of the song with the crimes we see the results of is more disturbing then it would be if we had an underscore that *matched* the emotions. It's the fact that "Layla" is a relaxing piece of music – and this tone contrasts sharply with the emotions we experience from witnessing the dead bodies in the sequence, making this part of the story the epitome of disturbing cinema. This leads me to another category of music in film.

Music to work against the film

Sometimes music is used as score but to undermine what we're seeing and supposed to be feeling. The technical aspects of such score is handled in exactly the same way but the end results are different. This approach often causes the audience to be distant from the film and become a little more cerebral. A good example is Jean Luc Godard's *Alphaville* where, at times, the score seems overblown and overly dramatic in the wrong places. Spike Lee's use of music in *Do the Right Thing* is similar; it seems to be running counter to the film almost as a commentary.

Musical songs in a musical as part of the story

Because I'm trying to be as comprehensive as possible, I have to mention music in musicals, which functions very differently than in non-musicals (everything else). To create a musical you'll most likely need someone who can write songs and specifically songs that *move the drama* of the story forward. It's been said that the musical form is the hardest one to "get right." Having done a musical I can attest to this fact.

Know your rights (or, actually, *their* rights)

If you try and secure popular music – or any music that someone else has recorded and distributed – you'd better know what you're getting into. There are different kinds of copyright:

1. *Publishing rights.* These are the rights to the composition, the song, the piece, etc. This has nothing to do with the actual *recording* of the music. For

example, when Michael Jackson purchased Lennon and McCartney's entire catalog, he was purchasing the publishing rights, not the rights to monies that would flow from album sales.

2. *Synchronization rights.* These pertain to the actual recording in question. In other words, there is copyright that belongs to a song writer because they wrote the song, *then* there's synchronization rights for the actual recording. If you wish to use a prerecorded song or piece of music you must clear both sets of rights.

3. *Publishing rights for music in the public domain.* Yes, that's right, even if you find a piece of, say, classical music and the composer has been dead for hundreds of years you might think you can just take their music, hire a pianist to play it and that's it. Not so easy. Sometimes even if the composer has been dead for hundreds of years, a modern music publishing company may have *published* the piece and could lay a claim on their published version of it. It happened to me. I had a pianist play "Images" by Debussy for my film *Nocturne, The Girl Who Played Debussy* and the publisher of the sheet music of the version we used wanted a fee to use it. I was too tired to challenge it, so I dropped the recording.

For music in the United States and Canada, there are several major licensing houses you can check with to find out everything about licensing a song for your film: Broadcast Music, Inc. (BMI), American Society of Composers, Authors, and Publishers (ASCAP), Society of European Stage Authors and Composers (SESAC), and The Society of Composers, Authors and Music Publishers of Canada (SOCAN).

The workflows

"The composer is doing a lot of the work" – A simple experiment

Before I get into the workflows for music creation for film, I would like you to try a simple experiment. Next time you're watching a film, pay attention to how music helps *smooth* over various transitions, connects scenes, creates tone, etc. If you don't want to spoil your experience of watching a new film, do this with an old film you love. An example that immediately comes to mind for me is the final sequence in *Shawshank Redemption*, where the Morgan Freeman character goes through all the paces of his post-prison life all the way through to the point where he finally retrieves the buried money and delivers it to Tim Robbins in Mexico. Throughout this segment there is thematic music that really helps connect the scenes, keeps the tension and pace going, and helps the entire end of the film to flow.

Once you identify a piece of music in a film that has this effect in the work, watch it again and (as hard as this is) try to imagine the section of the film *without* the music. Often, when I do this, I'll say to myself, "the composer is doing a lot of the work," that is, the composer's score is really helping the segment feel cohesive.

I wanted to share this simple experiment with you to help you understand what it is a composer will be doing when you work with one.

Traditional – Working with a composer

The basics of all film music creation workflows will have a lot of commonality, regardless of which way you go. If you're lucky enough to be able to find a composer you can afford, here is what you need to do. You need to set up your film using the OMF (open media format) time code instructions in Chapter 14. Then you need to spot the film with them. If you have a composer who is seasoned and on their game, they will have ideas about *where* you need music as well as what music should be written. This is a crucial part of what a composer does for a director: helping them decide where and when to use music, not just what music to use. As mentioned earlier, your composer might be a one-person band or may hire musicians to play on the soundtrack. Either way is fine, but here is a general rule I like to live by: I'll only work with a composer who can at least produce a version of the score themselves electronically, in some form that I can hear before committing to it.

TECH TALK – EDITING A COMPOSER'S MUSIC TO FIT YOUR FILM

I've saved this information for the mixing segment of the book because often you don't realize you need to trim music until the final mix. This could happen because all the sound elements might have come together in a way where, finally, you hear the whole thing and you didn't hear what you really need from the score until this stage. So you maybe need to trim a composer's score a little. Perhaps you need less of it than you thought, or wish to move a little bit of it around.

That's why it's good to be clear with the composer upfront that you might have to edit their music. But be mindful – if you do plan to edit score, make sure you know what you're doing. If you're not sure how to cut music, maybe the composer can do it for you. It's a specific skill to be able to cut music; you have to have at least a little knowledge of music. You can't disrupt beats, etc.; you have to be careful where in the musical phrase you cut. A non-musician has a higher chance of cutting music in an odd place.

Finally, *always get clearance in writing to use your composer's music for your film!* This is as important as getting releases from your actors. You don't want a composer deciding at the end of all your hard work that they don't want you to use their music. The release should include your ability to use the music in the film and in any promotional or marketing pieces including trailers, teasers, advertisements, behind the scenes shows, etc.

Temp music or "temp dub"

Temp music is simply anything your heart desires you throw on the timeline. It could be a Beatles song, Frank Sinatra, or Hans Zimmer music from films he

scored. Whatever your fancy, if the music you're borrowing helps you communicate your vision of what *you think* the music should be, by all means throw it down on the timeline.

You should by now realize you're probably not going to be able to afford popular songs, or any popular music regardless of the genre. But at least when you give the film to a composer, they'll have some insight into how you see music at the moment in the film, and some idea as to how you see music functioning in the overall design of the picture and audience experience. Don't hold back on this part: the sky's the limit!

Organize your picture editing timeline

If you haven't broken down your timeline and organized your sound edit by stems, now is the time to do so. To repeat, stems are when you separate out your three primary layers of sound – dialogue, effects, and music – so as to have control over the different parts of the mix when needed. The reason this is so important is that you must be able to deliver three individual stems to your composer so they can alternate between hearing your temp music and then turning it off so it's not distracting when they are trying to score. If the composer wants to do their own little mix, that's possible too. Always include a complete mix of the film to make their lives easier. Note: An easier way to set up to send tracks to a composer is to export one pass *without* the temp music, and then *just* the temp music. Then the composer can throw them all together on the timeline and be able to turn off the temp music so it doesn't distract him/her.

They might want to isolate certain drone-type sound effects (discussed in Chapter 19) and see if they can score *around* these sounds, or consider whether their score might eliminate the need for such effects, or possibly fight against them. Working with a composer will help you appreciate how collaborative the filmmaking process is, right down to the scoring and final mixing.

A sample of music used in *Turn Back Night*

To make our lives easier, I'm going to try and use the three primary musical elements (underscore, cues, and music beds) in one little section. I'm also going to try and integrate them all, so we can go beyond the technical and into the conceptual.

I'm going to take an early scene in *Turn Back Night* when Jane goes to the vehicle to get her assignment. When she turns on the radio she has to select "masking music," which is set up by the agency (a simple mask that can't be detected, just in case there are is anyone listening in).

First, I set up a cue sheet (see Table 20.1). I'm reusing the same template that I used for everything else. This can help because when you create a master cue sheet it's easy to get everything on the same page.

Table 20.1 Sample music cue sheet

Music cue sheet		My film on a budget		
Reels 1		**Comments** Scene with Jane and Radio Voice in the car		
Cue #	**Time code starts**	**Time code ends**	**Details**	**Description**
1	01:00:36:16	01:06:58:21	Music bed	Jane turns on radio
2	01:02:25:04	01:02:37:05	Drone production element	Jane hallucinates
3	01:03:17:10	01:03:56:23	Music bed from TV	Lisa 600 kills agent
4	01:03:17:10	01:03:56:23	Drone production element	Lisa 600 kills agent
5	01:04:15:03	01:04:30:12	Composer score	Radio Voice appears
6	01:04:42:03	01:05:00:01	Music bed	Lisa 600 infomercial

On the cue sheet I note what's canned sound design "music," what are "music beds," and what needs score. I see a little 15 second cue #4. It's where Radio Voice shows Jane the hit job that Lisa 600 commits on her terminating agent.

This little segment from *Turn Back Night* demonstrates the various uses of music and how the different musical elements work together. Most of these cues were prefab except for #5 which required a composer. But from this little bit of cue sheet there is valuable information I would give to him or her. Basically, all the music beds (cues #1, 3, and 6) have very different jobs but will not be played at the same time in the final mix as they will interfere with one another aurally and create dissonance. #1 is "mask music" the CIA requires Jane to play in case anyone is trying to tap in on her conversation. #3 is a cue that takes place in a hotel and comes from a TV and can be over-the-top thriller/action music that then gives way to cue #4. The over-the-top thriller/action music can meld into the piece of canned score I used (Drone Production Element). When Radio Voice appears (cue #5) this too can reflect the over-the-top thriller/action music and comment on the action, perhaps helping to *underscore* the comic tone.

But there is something else going on. The cues are working together to give a hint as to what is really happening in the story, communicating subliminally that all is not as it seems. Not only will music *themes* be brought back but different uses of the various kinds of music (score, cues, beds) will also recur to subliminally help get the audience ready for the drama that will unfold. So music doesn't only underscore what we're seeing and supposed be feeling, it can be predictive of the entire dramatic arc and tone of the film.

Music – Mono, stereo, or surround

Most of the musical pieces you'll work with on your timeline will ultimately be in stereo. However, if you work with the information in Figure 20.1 and wish to build a piece of music from various instrument parts, these might start as mono and then be *mixed* into stereo and finally either outputted as a single stereo strand to be dropped back into a timeline, or left in the timeline mixed in stereo in anticipation of the final mix.

This is very basic musical composition but it might have a slightly tough learning curve for the non-musician, but if you're a modern independent film-maker you'll be used to learning about all kinds of things technical pertaining to finishing your films. Why not go beyond just dropping in music cues (although that often works) and actually plot out your score with a basic technique such as a real composer would start out with?

Many of the DAWs and music loop packages that are available to filmmakers are designed to be used even if you don't have that much musical aptitude. For example, some of the loop packages come with different instruments that are *related* to each other and when dropped together on a timeline can form a single piece of music that can easily be mixed and outputted to be a complete strand of score. You could even drop the different tracks of the score into the lower part of the timeline in case, during your final mix, something is not right with the overall sound and you need to tweak instrument levels in your score.

Sample of music beds available through Adobe Audition as part of their free Sound FX bundle, and of Apple Loops available through Logic Pro X. Both offer royalty free music that can be used as is, or edited and manipulated on a music or film timeline for more elaborate music creation.

All DAWs have the ability to convert your time display from time code to musical "bars and beats." In other words, you can go cue by cue and turn each cue into a metronome setting, and then beats (a metronome setting in music is the click that counts the beats throughout the piece of music).

After you've done this, you can figure out what tempo you want to set your cue at. Then you can create a separate file and change the tempo of music tracks that you derive from loops or music beds. There are ways of altering the BPMs (beats per minute) using global time stretching tools if you want to go deeper in working with the loops. Many of these loops are meant to work together in that way.

Figure 20.1 Toggle between counting frames and counting musical measures on your DAW's timeline.

21 Putting it all together
Sample sound edit/mix

Now I'd like to present a run through of my process of a little sound edit and mix description, albeit in a scaled-down way, using a segment from *Turn Back Night*. Previous chapters and samples have gone through parts of this process, but I wish to use this chapter to emphasize what the final mix is and also how to output the results. On the website (www.michaeltierno.com/sound-book) you can find the raw files for this chapter as well as a few extra ones so you can practice final mixing if you so desire. But first, everyone's favorite subject all things postproduction: workflow.

The workflow

Way back in Chapter 9 we positioned the act of recording location dialogue as asset gathering for your final mix. Well, now we're at that final stage the re-recording process. And while we've reviewed the sound editing process in other ways in various chapters, I want to repeat some of it again so you can see the whole thing from A to Z, as it were.

OMF export done properly

Obviously, we're assuming the film clip and location tracks dropped into the timeline will have gone through the complete OMF (open media format) processes, are properly time coded (clip-based and timeline-based time code) and have then been locked in sync, including the rough sound mix for the clip from the editing timeline and the video track. Make sure the 2 pops line up (front and back) and you're good to go. Also make sure your frame rates match and everything looks okay.

Play back the project and listen to the rough tracks *and* the editing timeline mix – they should be in sync.

Mixing template set up

The next thing is to make sure the mixing template is set up into the various different stems including:

- dialogue stem or submix (with a subset of ADR tracks and voice over tracks if needed)
- effects stems (including additional ambiences, hard sound effects, Foley)
- music stems (holding all music, including music beds, score, etc.).

The directions to set this up are described in a Chapter 15.

Now the individual tracks will be set up within the stems to accommodate:

- dialogue A/B tracks (includes cutting and moving production sound effects to a new PFX track within the dialogue stem)
- recorded foley
- editing Foley in
- adding additional room tone into the dialogue submix
- adding atmospheric sounds
- exporting submix stems for composer
- editing in final score
- the mix and output of final film.

These processes are described in more detail below:

Dialogue submix

First, I created my template for the dialogue submix. It included the following tracks:

- Boom Jane
- Boom Lisa
- PFX 1
- PFX 2
- Room Tone 1
- Room Tone 2

I then dropped all the location tracks to placeholder tracks at the bottom of the timeline under the master output so it's easier to see what I'm doing. Using my option "drag" function I then *copied* the various clips of sound that I needed back to the designated tracks leaving the originals intact. Remember, use your original location tracks as the pool of tracks that you draw from; but you are merely cloning everything leaving the original intact.

Basic dialogue A/B editing structure

I chose to use the boom microphone for the main characters and split it into A and B, based on whose talking (in this case, either Jane or Lisa). I then copied the PFX from these boom tracks and moved them to their PFX tracks.

I returned to the boom A/B tracks and used a "cut to the bone" technique and found the places where there was only talking; I added silence to the surrounding track. This works if there's minimal background noise in your dialogue tracks. In this case, there was a projector sound that the boom picked up.

I did some EQ (equalization) on each of the pieces of dialogue using a parametric EQ. I did this on a track basis because the A/B boom (Jane and Lisa) sounded pretty uniform throughout. Of course, if I want to tweak a parameter of the EQ somewhere along the track, I could use envelopes or keyframing and spot alter any EQ parameter. This method ensures a more uniform mix.

My main goal with this EQ was to duck out some of the room noise that seems to leap out whenever they talk (the rest of the take is silence, because I cut to the bone and added in silence). To duck down the room noise, I went back to the original take, printed some of the noise, and used noise reduction to push the noise energy down.

Recorded Foley

I recorded a little Foley for the end when the two women embrace each other and added that in. My Foley recording set up is extremely modest: a quiet room with a microphone, a computer, and a TV to watch the scene.

Editing Foley in

I found I needed very little, so I edited it to match the picture.

Adding additional room tones

I added a loop of city traffic in mono and cut out everything but the low frequencies. This was because the sound would be coming through walls, windows, and curtains and would tend to be muffled. This was done with a simple notch filter.

Adding atmospheric sounds

I added a Drone Production Element sound to come from the screen (and panned it hard left, the direction the screen is in the shot).

Exporting submix stems for composer

I outputted everything to the composer in three stems (dialogue, music, effects) and gave them to him so that when composing he could hear the music I wanted, but then duck it out. I got back a little bit of score and added it in.

Editing in final score

I edited in the final score on two stereo music tracks, and also stacked A/B to provide for crossfading. I found I wanted the music to be a tiny bit thinner in

the mix, so I used a notch filter to cut some of the bass out of it (but very little). Usually, your composer will provide you with a score that does not need to be tweaked – but sometimes you have no choice. You might want to run it by them if you're altering their recording in any way.

Final mix

Now, every single sound effect has been edited and is in the right place. The dialogue has been A and B rolled and crossfaded, etc. The Foley has been edited in, the sound effects are where they are supposed to be, and the score is right where you need it. So, you're ready to mix and re-record (whatever that means in the digital world).

The final mix is a process whereby all the sounds in the film are blended or *mixed* together to make one composited soundtrack. A good analogy is to think of the different kinds of sounds different instruments in an orchestra make. They are all playing the same symphony, but they play different parts that come together sonically to make a single piece of music.

The technician/artist who performs the final mix in a Hollywood film is usually what's known as a "re-recording mixer." The term "re-recording mixer" comes from the old analog days when sound needed to be re-recorded from the sound edited tracks onto a brand new analog track. What we do in today's digital domain is similar; we "output" the final mix and everything is recorded onto a new digital file, so in a sense it is "re-recorded." The major difference, of course, is that because everything is now digital, there's no generational loss.

Back in the day, big productions suffered little quality loss despite the fact that sound was transferred from one analog tape to another, hence from "generation to generation." That's because the original recordings were so good it didn't matter very much if a tiny bit of sound was lost due to the transfer. In the hands of a good sound engineer/re-recordist, the process added to the analog warmth that some of them long for these days.

Re-recording mixing is an art in itself and an in-depth exploration of it is beyond the scope of this book, but I wanted at least to introduce you to the process. Like all of these processes I'm exposing you to, if you're awareness of them increases this, armed with some knowledge of what to do, can go a long way in making you an overall better filmmaker – if you're willing to roll up your sleeves and practice.

This process or, as it's called, the final mix, is my favorite part of the film-making process because it's at this time that the film becomes a film in its most exciting state. So what happens in the final mix. First, take the opportunity the hear a sample of all three stems individually and together.

Play dialogue stem
www.michaeltierno.com/link-20

Play effects stem
www.michaeltierno.com/link-21

Play music stem
www.michaeltierno.com/link-22

Notice how when all the stems are played back together there is a very pleas-ant balance of sound in the speakers. It's aurally a very pleasing harmonic hum that is maintained through the clip (and finished film) and this balance of sound consists of a blend of room tones, ambiences, music, dialogue, etc. Everything has been balanced out and even in terms of sound, starting with levels.

Levels

Dialogue is at the heart of any film mix and if you get it wrong you'll lose your audience fast. And while we've reviewed what good recording levels are, *final output* levels are a bit more sophisticated, mostly because you want a final mix to have consistency. Below are the basic output level guidelines for each of the stems:

Basic output levels
Master mix level: −10 dB to −14 dB
Dialogue: −12 dB to −15 dB
Music: −18 dB to −22 dB
Sound effects: −10 dB to −20 dB (with occasional spikes up to −8 dB.)

TECH TALK – Output level standards is a very technical subject, a rabbit hole beyond the scope of this book. Those indicated above provide a good guideline to start with. You will want to test the results in/on the various playback mediums to make sure everything will sound good.

Notice the dialogue level is recommended to be −12 dB to −15 dB. In my view, this is why people will suggest keeping location dialogue at −12 when recording on set: It's going to be at normalized to −12 for distribution output anyway, so why not start out that way? But this final level for dialogue is a level recommendation for final mix, whereas at the location dialogue recording stage there were other considerations: signal-to-noise ratio based on environment, machine noise in devices, etc.

Normalize dialogue

I used "Peak Normalization" and normalized the dialogue stems to −12. If you're trying your own mix you can use "RMS Normalization," but I find this does a lot of odd things to background noise and doesn't always render a usable track for a final mix.

Panning and placement of dialogue

There are two ways I can place dialogue in the mix. I can either pan the dialogue to be equal left and right, or I can place all the dialogue center (which is my preference).

Pan specific lines hard left or right

If there is a shot where a character is "off camera," calling out from, say, the right side of the screen, you might want to pan their line hard right. But in general keep the dialogue pans simple, as I did. Don't try and follow characters on the left or right of the screen – it will undermine the evenness of the mix.

Room tone placements

I panned the mono room tone of the city traffic to come from the right side of the frame. The air conditioning room tone I panned center as well, because it's supposed to help cover some tone changes in the dialogue.

Compression of the dialogue mix

I applied a little bit of compression to each of the A/B dialogue tracks because it felt as though Jane's voice was a little quiet and I wanted to bring it up to have more presence. The level of Lisa's voice also came in louder. This is an intense moment in the film, so I wanted to make sure it's quite "in your face," so to speak. I applied a single band compressor to each of the dialogue tracks, but made it kick in where Lisa's voice was going with regard to level and used the slightly compressed version to bring it more in line with Jane's. Then I used output gain to raise the whole thing up a little.

Now the rest of the mix

Here is one workflow I've tried:

Bring the rest of the levels and pannings to the right place

Once the dialogue mix was done, I wanted to bring up the levels of everything else. This included the added Foley, the drone sound effects I brought in, and

the little bit of score. I panned the Foley (the sound of the actresses' embrace) a little bit to the right, since the image of them embracing is more toward that side of the screen.

Once these are all balanced as per the industry standard guidelines I mentioned above (see p. 201), you can play around with EQ tweaks and/or any compression.

EQ to the other tracks

I EQ'd the Foley just a little bit because I thought it sounded like it had too much bass. Perhaps the microphone was a little close when we created it.

I then EQ'd the Drone Effect because it sounded a little bassy to me as well, and consequently dominated the mix. But I didn't want to change the underlying sound so much, in case I ruined its flavor. I also did a little compression on it, because it's an expansive sound and I wanted it to seem like it was emanating from the projector.

Normalize the effects track

As indicated in "basic output levels" (p. 201), using peak normalization I normalized the effects stem between −10 and −20 and listened to how it blended with the rest of the mix. It sounded good at around −15 so I left it there.

Normalize the music track

To comply with outputting standards, I normalized the music tracks to -18 and found they worked well there.

Playback in real time and make final tweaks

I played the piece back a few times in different environments, including through my iPhone, my TV, my earbuds, and ultimately my near field reference monitors and made notes for final tweaks and adjustments.

TECH TALK – If your stem creation is done correctly you can use all three in your final output on your editing application as you won't have to change amplitude. Or you can use the entire mixdown which will be a replica of the stems. *Don't* use both the stems *and* the mixdown together. That would cause over modulation.

What happens now?

EQing, compression, noise reduction, pans, and leveling is done. And instead of re-recording and creating generational loss you simply print an outputted file without generational loss because everything is being digitally cloned.

Outputting

Your Digital Audio Workstation (DAW) will have ways of outputting and you should have a few options. You can:

- output the entire stereo mix
- output the individual stems
- output the individual tracks.

These are the main output variations you need to concern yourself with. I chose to output the entire mix in stereo and then the three stems I'd set up (dialogue, effects, music). I dropped it all on the timeline and synced it all up with the 2 pop. Then I had my master mix in my editing timeline along with stems if I wished to cut a trailer. Remember, it's good to have the separate stems available for making trailers because if you cut the trailer with the score baked in, the score will be cutting off in unusual places and will not sound right.

I was also ready for foreign distribution because when my film needs to be made ready for another language, they simply drop the dialogue track and dub over new dialogue. This is another reason to have the PFX tracks pulled because they can be dropped into a Foley stem and at least you'll have them for the foreign sound mix. If you leave them in the dialogue stem they'll be gone when the original dialogue track is dropped and will need to be replaced by an M&E (music and effects) editor, an expensive process. Note: Mixing in surround sound (5.1, 7.1, etc.) is another way to output sound that has already been mixed in a surround format (but surround sound is beyond the scope of this book).

Listen to the results of the final mix.

www.michaeltierno.com/link-19

This is a snapshot of my final mix. I was able to duck out the drone and other sounds, and when the music cue came in I only had the dialogue and the music playing. Figure 21.1 shows a set-up of a simple final mix timeline and below it the corresponding "mixing board."

Figure 21.2 shows a typical DAW's outputting dialogue box where you can make selections regarding how, specifically, you want to output your soundtrack, including whether you wish to output separate stems and if you want a stereo output, etc.

A typical daw mixing board

Every DAW (or editing application) will have a mixing board. These can be connected to outboard controllers for ease of use. They will include ways to set up your submixes, patch in effects, etc. Learn to work with your mixer in your editing application or DAW.

Figure 21.1 Set-up of a simple final mix.

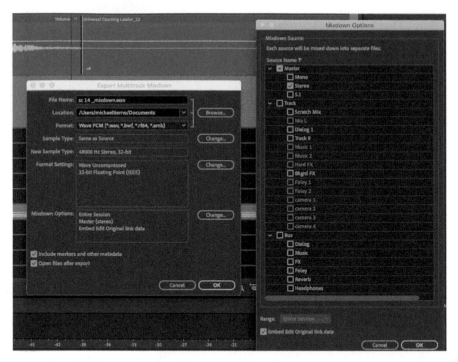

Figure 21.2 DAW output dialogue box with mixdown options.

End note

Thanks for taking this journey of film sound for low-budget filmmakers. I hope my passion and knowledge of the subject has been conveyed to you in such a way that you feel up to the challenge to creating professional level sound for your films, regardless of your budget. Achieving great sound starts first and foremost with a mindset. You need to deliberately do everything it takes to get great sound, in the same way you'd work hard on a script, on finding the perfect actors, getting great cinematography, etc.

I realize that you might have to do almost everything yourself, and this can be overwhelming. I believe it's probably good at some point in your filmmaking career to experience doing lot of jobs normally delegated to highly skilled (and paid) technicians, craftspeople, and artists. Learning as much about the sound production process as you can now will help you when you do get to hire skilled people: you'll know how to direct them. Learning sound can also help you find employment in the film and TV business. It's a known fact that it's a tiny bit easier to find employment in the sound arts compared to other disciplines in filmmaking because, frankly, not as many people enjoy working with sound as, for example, yours truly.

By all means read more on the subject – look at YouTube videos, visit Lynda. com, etc. But more importantly, *make films*! That's the only way you're going to learn how to achieve great sound in film. And I hope this book does for you what reading the manual did for the Tom Hanks character in *Saving Private Ryan* – that it gives you some theoretical book knowledge to save you time and trouble in the battlefield of location sound recording and sound postproduction.

Remember: Just as you can't plow a field by churning it in your mind, so you can't learn to make films by reading books. So get out there and make films.

As always, keep the faith – and make films that you love!

Index

Page numbers in **bold** denote tables, those in *italics* denote figures.

9780367354244